Women at Michigan

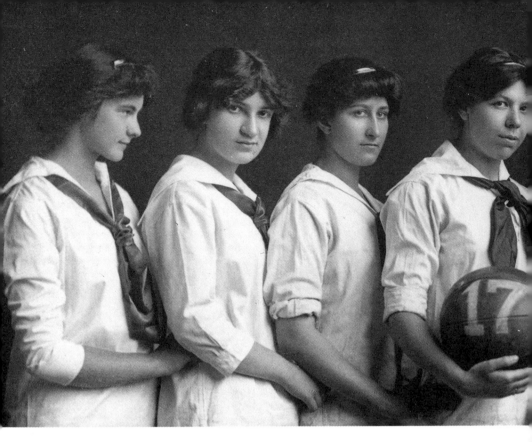

Women at

by Ruth Bordin

Foreword by Martha Vicinus

Introduction by Kathryn Kish Sklar and Lynn Y. Weiner

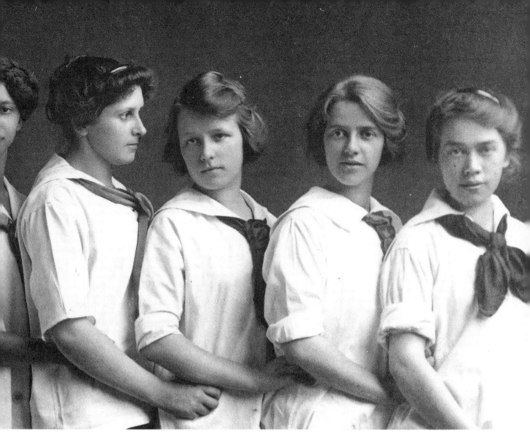

Michigan

The "Dangerous Experiment,"
1870s to the Present

Ann Arbor The University of Michigan Press

Copyright © by the University of Michigan 1999
Published in the United States of America by
The University of Michigan Press
Manufactured in the United States of America
∞ Printed on acid-free paper

2002 2001 2000 1999 4 3 2 1

A CIP catalog record for this book is available from the British Library.

Library of Congress Cataloging-in-Publication Data

Bordin, Ruth.
 Women at Michigan : the "dangerous experiment," 1870s to the
present / Ruth Bordin.
 p. cm.
 Includes bibliographical references and index.
 Contents: Pursuing the cause — A most hopeful experiment —
Change and redefinition — Women, war, and crisis — From the age of
conformity to the stirrings of dissent — Change and resistance —
Victory or accommodation.
 ISBN 0-472-10871-9 (cloth : acid-free paper)
 1. University of Michigan—History. 2. Women—Education (Higher)—
Michigan—Ann Arbor—History. 3. Women college teachers—Michigan—
Ann Arbor—History. 4. McGuigan, Dorothy Gies. Dangerous
experiment. I. Title.
LD3280.B67 1999
378.774'35—DC21 98-40109
 CIP

Published in cooperation with the Center for the Education of Women
and with the financial support of the Office of the President,
University of Michigan.

Contents

Foreword

Memoir of Ruth Birgitta Anderson Bordin

Martha Vicinus

I met Ruth Bordin in 1982, my first winter teaching at the University of Michigan.[1] I was still in culture shock, having discovered that I was the first woman full professor in the English department. We met at a round table to discuss feminist history. When I mentioned the casual misogyny of an elite institution and the signal failure to hire senior women, Ruth Bordin suggested that I read Dorothy McGuigan's slim history of women at Michigan, *A Dangerous Experiment* (1970). Later as I came to know her better, I realized how forceful and complicated her response to me had been. We quickly became friends, sharing our research and drafts as we toiled through archives that revealed an amazing wealth of feminine leadership throughout the nineteenth century. Nearly twenty-five years older than I, Ruth remained throughout her life a role model for me and many of my generation. We were inspired by her tenacious pursuit of a scholarly career, without the goad and support of a regular academic job. I have frequently told others that I hope to have as rich and productive a retirement as Ruth's; she continued to research and write up to her death.

Ruth's husband, Edward Bordin, a professor of psychology, always encouraged her scholarship. During the last months of his life he insisted that she undertake what became her final publication, *Women at Michigan*. When her health failed Ruth made every effort to leave a manuscript that another scholar could complete; the book appears through the initiative of Carol Hollenshead, director of the Center for the Education of Women. Ruth's manuscript was edited by Laura Calkins, assistant research scientist at CEW and the Bentley Historical Library. The result is a wonderful introduction to the advances and setbacks women students and faculty encountered from 1870, when they first entered the university in an official capacity, to the present.

Ruth was the daughter of a modestly well-off business family from a small town in Minnesota. During the last decade of her life she wrote several chapbooks, describing her early life amidst a close-knit Swedish Lutheran community when times seemed simpler and ethical choices more clear. She was educated at the University of Minnesota during the heady days of 1930s campus activity, graduating in 1938 with a B.A. in history and then an M.A. in

1940. Her desire to continue for a Ph.D. was thwarted by her well-intentioned advisor, who was certain that a woman could not combine scholarship with the responsibilities of a wife and mother. Ruth never quite forgave him and to the last regretted her failure to obtain a Ph.D., but she loved archives and never ceased to do research and to write, even when newly married. During Ed's years at Washington State University, she was asked, following the premature death of L.V. McWhorter, to finish *Hear Me, My Chiefs! Nez Perce History and Legend*. Ruth wrote the sections on battles with the U.S. military as well as editing the collection as a whole. The dean of the graduate school at Washington State refused her request to be coauthor. It was an experience that haunted her later efforts to obtain credit and recognition for her scholarly work.

Nevertheless, Ruth refused to be daunted and continued to pursue learning opportunities. As an undergraduate she had taken several history and political science courses on what was then known as "the Far East," and in 1938 she had been awarded a national fellowship to visit Japan. Her M.A. thesis was "The Franco-Japan Entente of 1907." When her family spent seven months in Japan in 1955, Ruth, with characteristic enthusiasm, studied Japanese and immersed herself in postwar interpretations of Japan. She later turned her knowledge to good effect by helping her friends Richard Beardsley, John Hall, and Robert E. Ward prepare their groundbreaking study *Village Japan* (1959), a multidisciplinary study of a single village. She also served as an assistant for projects ranging from family history to domestic architecture. Her remarkable intellectual curiosity flourished under the challenge of learning so many different subjects.

In 1957, when her two daughters were teenagers, Ruth began to work as a curator at the Michigan Historical Collections, the forerunner of the Bentley Historical Library. During her decade of work there, she published a few short pieces, describing a specific collection or analyzing a family or locale. She also received her first major commission, the sesquicentennial *The University of Michigan: A Pictorial History* (1967). The project came out of her incomparable knowledge of the university's holdings—a knowledge which she later put to use in preparing *Women at Michigan*. In addition, she coauthored, with Robert Warner, *The Modern Manuscript Library* (1966), a short introduction about who should collect, what and how to collect, and the problems of preservation and use of manuscripts. Although now dated, for many years it must have been a trustworthy guide for novice local history librarians.

Plagued by poor health through the mid-1960s, Ruth decided in 1967 to leave the comforts and restrictions of a curator's job to teach part-time at East-

ern Michigan University. The University of Michigan's nepotism rules made it impossible for her to work at the same institution as her husband, and she could not look nationally. She had applied to EMU for work in 1965, writing:

> I am actively looking for some kind of part-time teaching job for next fall, having definitely decided that a full-time twelve-month curatorship at the Michigan Historical Collections is more demanding of my time than I am prepared to live with gracefully. I want more time for my research and frankly I also want to teach. The present period of shortages seems as auspicious a time as any to make the attempt.[2]

Ruth enjoyed the varied teaching opportunities Eastern offered her, as well as the freedom to take up new scholarly tasks. Her knowledge of and capacity to master so many different areas of history made her an invaluable part-time lecturer. In 1974, during her husband's sabbatical, she spent a year in Washington, DC, and used her time to lobby Gerald Ford and the Michigan legislators to donate their papers to the University of Michigan's new Bentley Library. By the late 1970s Ruth found herself among a generation of Michigan wives who faced something of a backlash at Eastern Michigan University against the many University of Michigan graduates and wives who worked there; a concerted effort was made throughout the 1980s to hire nationally. At the same time, she was increasingly involved in her own research projects and the activism at Michigan by faculty wives and women faculty.

In 1979 Ruth stopped teaching, becoming a full-time, unpaid "research affiliate" at the Bentley Library. Nevertheless, she was still unwilling to give up her dream of a regular faculty position. In 1981 she applied to Indiana University and the University of Arizona for a position in public history. Her application letter shows the same honesty, self-irony, and determination to forge her own way as her earlier letter to the Department of History at Eastern Michigan University:

> I will probably not fall within your usual range of applicants for one reason, my age. As is easily ascertainable from my date of birth, I am sixty-three (and in excellent health!). While I have actively practiced my profession all my adult life, I have also raised a family and accepted the usual obligations of wifehood considered normal by my generation, obligations which drastically limited my mobility. My husband is now close to retirement, my family obligations much reduced, and I am seeking employ-

ment, for perhaps five years, with a new and demanding challenge. The fact that my potential service would be drastically limited in number of years by my age could have advantages in these days of budget uncertainties.[3]

Ruth received a form rejection.

But the Bentley had just become part of a consortium of research libraries that were microfilming all the known papers of the Women's Christian Temperance Union (WCTU). This collection was to become Ruth's greatest inspiration and to transform her career. Between 1979 and her death in 1994 Ruth wrote six book-length studies and participated in a major oral history project, helping to interview a whole generation of postwar Michigan politicians. After one false start, a 250-page study of Emma Hall, the first director of the first girls' reformatory in Michigan, Ruth's scholarly career took off. A small grant from CEW made it possible for her to give a paper at the Fifth Berkshire Conference on Women in June 1981. She would return to this prestigious conference many times, as well as numerous other national conferences. In 1981 she published *Women and Temperance: The Quest for Power and Liberty* (reprinted in 1990), followed by her important study of the leader of the WCTU, *Frances Willard: A Biography* (1986). Still willing to mine her long familiarity with local archives, she accepted the commission to write *Washtenaw County: An Illustrated History* (1988), but she soon returned to her first success, the history of educated women reformers. In 1993 she completed *Alice Freeman Palmer: The Evolution of a New Woman*, and at her death she had drafted *Women at Michigan*. It is an amazing achievement, especially when one remembers that her health was not good after major heart surgery in 1983.

What made this extraordinary flowering possible? Ruth herself spoke often about her generation's inability to craft independent careers. She looked enviously at my generation who had with so little effort taken Ph.D.s and become tenured professors. While she recognized the social and legal limitations that had been imposed on her generation—"the usual obligations of wifehood considered normal by my generation"—she chafed against them. But I would argue that her freedom from the constraints of a career often (though not always) gave her remarkable talents more scope and opportunity. Her life and work have had an impact on a wider range of people than solely professional historians. The most vivid chapter in *Women at Michigan* documents the vital role faculty wives played, informally and formally, as well as the heady founding days of the Center for the Continuing Education of

Women (CCEW), as it was then known. Ruth was an active member in the Women's Research Club and in CCEW, and she knew well the importance of a nurturing environment for struggling scholars and returning students.

In her introduction to *Women and Temperance*, Ruth describes Frances Willard's enormously successful leadership of the WCTU as "a classic case of the right person, at the right place and time to fulfill her personal goals."[4] Ruth felt that she had never been given the chance to be the right person in the right place, but for me that is precisely what happened when she became a research affiliate at the Bentley Library. To quote her introduction again, "In another age Willard might have chosen another cause, but the marriage of the WCTU and Willard was certainly made in heaven and happy for both of them" (xvii). At another age Ruth would surely have chosen another scholarly home, but the marriage of Ruth Bordin and the Bentley Library was happy for both of them. Freed from concerns about a formal career, sitting amidst archival material no one else had seen, Ruth blossomed. She was aided, of course, by writing at the right time; by the 1970s temperance was again taken seriously as an American reform movement, and feminist historians had renewed interest in women leaders. The time was right for a thorough reconsideration of the single most popular and influential women's organization of the nineteenth century. *Women and Temperance* was widely reviewed by scholarly journals, the popular press, and theological magazines; Ruth was, at last, taken seriously as a historian. The reprint in 1990 testifies to the lasting importance of this book.

Encouraged by the success of her first book, Ruth naturally moved to a biography of the charismatic Willard before returning to her cherished Michigan archives to write a biography of the university's most famous nineteenth-century woman graduate. Alice Freeman Palmer began her adult life with a brilliant career as a history teacher and as president of Wellesley College. But marriage to a Harvard professor left her marginalized in academia. Ruth's life took the opposite trajectory. After being denied a traditional academic career, she found her metier in "retirement." Following years of isolation, she was finally in touch with leading women historians, giving papers at major conferences, and reviewing manuscripts for major journals and presses. Ruth's intellectual curiosity and enthusiasm endeared her to all of us. Fortunately this success did not come too late for Ruth to enjoy it, even if she remembered the years of neglect and diminution.

If *Women at Michigan* has "bite" and more than a dose of irony, it is because Ruth herself had experienced so many of the conditions she describes here. The result is a book that avoids falling into the celebratory or chroni-

cling onward and upward improvement. Instead, we find unexpected victo-
ries, setbacks, and unnecessary defeats. Women students have had rich and
exciting years at this major research institution; faculty wives, women faculty,
and women administrators have devoted many years to making it a more open
and fairer institution for all. Like any human story, *Women at Michigan* is still
unfinished; there is still work to be done, whatever our current gains.

*Martha Vicinus is Eliza M. Mosher Distinguished Professor, Department of English,
and Professor of Women's Studies and History, University of Michigan.*

NOTES

1. I am grateful to Francis X. Blouin, Jean Campbell, Martha Hillyard, and Carol
Hollenshead for their comments and memories of Ruth.

2. Ruth Bordin to Donald Drummond, 3 February 1965, Box 1, Ruth Bordin Papers,
Bentley Historical Library, University of Michigan.

3. Ruth Bordin to Lewis Perry (Indiana University) and to Paul Carter (University of
Arizona), 2 January 1981, Bentley Historical Library, University of Michigan.

4. Ruth Bordin, *Women and Temperance: The Quest for Power and Liberty,
1873–1900* (Philadelphia: Temple University Press, 1981), xvii.

Preface

Carol Hollenshead

I first met Ruth Bordin in 1992, when Jean Campbell, a founder and long-time director of the Center for the Education of Women, brought us together for lunch to discuss Ruth's dream to write a new history of women at the University of Michigan. Ruth wanted to build on Dorothy McGuigan's *A Dangerous Experiment: 100 Years of Women at the University of Michigan*, published by CEW in 1970. Ruth also sought to expand understanding of women's experiences at Michigan and illustrate how Michigan's rich history relates to women's access to education nationally. Ruth's enthusiasm and intellectual excitement were contagious, and by the end of lunch we agreed to present the project to the University of Michigan Press.

Ruth worked diligently on *Women at Michigan*; one by one she sent chapters to CEW for word processing, and the manuscript grew. Although Ruth's health was poor, her excitement and dedication to completing the book never wavered. The last chapter of the manuscript arrived at CEW not long before Ruth's death. Quite literally, she worked on revisions of the book until the day she died.

Without the concerted effort of many people, *Women at Michigan* would not have reached publication. CEW staff turned Ruth's typewritten pages and handwritten revisions into clean text, searched tirelessly for photographs and documents, checked and double-checked facts and references. Anne Frantilla and others at the Bentley Historical Library spent untold hours unearthing documents, verifying dates, and going the extra mile. Historian Laura Calkins smoothed out the rough edges of the manuscript, completing the revisions Ruth had begun. LeAnn Fields and the staff at the University of Michigan Press saw the manuscript through the many ups and downs of the publishing process.

Readers of the book will bring their own perspectives on the history of women at Michigan. For Ruth, the late nineteenth century truly represented a "golden era" for women at Michigan, one that reverberated far beyond the confines of Ann Arbor. For Kitty Sklar and others (including myself), the early 1970s were a time of foment and struggle, of heady ideas and fast-paced change, of both unity and divisiveness. Whether it was the admission of women in 1870 or the filing of a sex discrimination complaint a century later,

the success of the University of Michigan's pioneering efforts to increase access to higher education for women has resulted from the combined push of those within and outside the academy. For more than 130 years women have led efforts to bring about institutional reform: organizing petition drives, forging new intellectual paths, raising funds, lobbying politicians, protesting and picketing, creating new programs and policies, filing complaints and lawsuits.

Their efforts have not been in vain. Young women today take for granted that any academic path—from classics to physics and engineering to women's studies—will be open to them. A wide range of programs and services are available to women faculty, staff, and students. University scholars actively pursue a rich diversity of research on women and gender issues that are supported by both university and external resources. Women occupy visible leadership positions in the institution.

Despite all of these gains, at Michigan as elsewhere, much remains to be done before women reach full equality in academe. Ruth's hope—shared by all who worked to get her book into print—is that the history of women at Michigan will serve to inform the vision of those changes yet to come. It would also be Ruth's hope that her book will inspire others to carry on the work she so loved and, in so doing, enlarge our collective understanding of women's diverse worlds and their struggles to transform them.

Carol Hollenshead is Director of the Center for the Education of Women and Chair of the President's Advisory Commission on Women's Issues, University of Michigan.

A Dangerous Experiment Revisited

Ruth Bordin

How does one follow an icon? In 1970, to celebrate one hundred years of women at the University of Michigan, Dorothy McGuigan, the holder of two Michigan degrees and winner of five Hopwood awards as an undergraduate, wrote *A Dangerous Experiment*, a commemorative publication on the history of women at the University of Michigan.[1] The publication was sponsored by the University's Center for the Education of Women (CEW; then called the Center for the Continuing Education of Women), where Dorothy McGuigan worked.

Women in academe one hundred years after Michigan's experiment began were still not taken very seriously. Although Dorothy McGuigan was the author of *The Hapsburgs*, which had been translated into several languages and received national and international attention, *A Dangerous Experiment* found no commercial or university press willing to serve as its publisher. It was printed by the Center for the Education of Women and confined to slender dimensions, a little paperback whose binding was so fragile that when University of Michigan regent Eugene Power opened a presentation copy given to him by CEW director Jean Campbell and cofounder Louise Cain the book came apart.

Despite its improvised binding, *A Dangerous Experiment* was not destined for an ephemeral life. In 1970 the field of women's history was new, the history of women and higher education virtually untouched. The works of Barbara Solomon, Helen Horowitz, Barbara Sicherman, Caroline Clifford, Lynn Gordon, and Patricia Palmieri were not yet in print. Ernest Boyer and Allan Nevins, in their important studies of American higher education, hardly mentioned women and women's advent on the educational scene in the nineteenth century.[2] *A Dangerous Experiment* plowed new ground. Its furrows were sometimes shallow because no one had been there before, and I shall sometimes dispute its findings. But *A Dangerous Experiment* has been widely cited, has influenced much later work, and I am sure has sent many questors after women's history delving into new troves of archives and artifacts.

A generation has passed. The history of nineteenth-century women has not only been explored but analyzed, cogitated on, and theorized about. Most important, it has been made part of America's past. *A Dangerous Experiment* was a catalytic contribution to that process.

Meanwhile, the full story of women's experience at the University of Michigan as both students and faculty has not been told, certainly not in the light of the explosion women's history has undergone during the last generation. Women's experience at the University of Michigan was partly commensurate with women's experience at other state universities and partly different. Both women's admission and their acceptance was easier in the "new" western universities like Minnesota, Iowa, or Wisconsin. The University of Michigan's tradition of setting its standards and practices by those of the Ivy League East was hard to overcome. But Michigan was the first of the older universities to accept women. Its acceptance was limited, as we shall see, especially when women became a critical mass on campus, by the end of the 1890s, but nonetheless women were there—a breakthrough for women into the new academia.

Dorothy McGuigan was a friend of mine. As members of a generation of women that had come of age before World War II, we shared a bond. It would have been good if she had been able to update her work herself. She died of cancer in 1982, a disease we shared but I survived.

But there are also advantages in having someone else finish the job. Dorothy was a creative writer and had been a journalist. I am a historian who has taught and published in American history for several decades, and I bring a slightly different perspective to the study of women at Michigan. My biography of Alice Freeman Palmer, an 1876 Michigan graduate, has put me in intimate touch with a small segment of Michigan women. My long connection with the Bentley Historical Library, both as a member of its staff and as a frequent researcher in its collections, has also influenced my approach. Although I have lived in Ann Arbor since 1948, I am not a Michigander. I grew up and was educated in the different and more egalitarian atmosphere of Minnesota.

Dorothy McGuigan did her work well, but it is time to embellish and add to her story and to provide the perspective of the new scholarship. *A Dangerous Experiment* needs to be revisited.

NOTES

1. "A dangerous experiment" was the phrase used by the University of Michigan's Board of Regents to describe coeducation: "By many it is regarded as a doubtful experiment, by some as a very dangerous experiment . . . certain to be ruinous to the young ladies who should avail themselves of it . . . and disastrous to the institution which should carry it out." See *Proceedings of the Board of Regents of the University of Michigan* (hereafter *Regents' Proceedings*), 1837–64, 796.

2. Ernest Boyer, *College: The Undergraduate Experience in America* (New York: Harper Bros., 1987); and Allan Nevins, *The State Universities and Democracy* (Urbana: University of Illinois Press, 1962).

Introduction

Kathryn Kish Sklar and Lynn Y. Weiner

Almost 130 years ago, during the winter semester of 1870, a young woman named Madelon Stockwell entered a classroom full of young men and initiated the long history of women at the University of Michigan. In this splendid book, Ruth Bordin unearths the tale of this remarkable experiment in coeducation by looking at the changing lives of students, faculty, and staff. In doing so, she relies on the traditional historian's archival information, such as official records, newspaper reports, and statistical data. At the same time, her narrative of specific events in Ann Arbor reflects larger trends in the history of women and education in the United States.

Our own experiences at the University of Michigan occurred during an era of especially great transition at the university—the tumultuous years between 1965 and 1973. Thinking that readers would be interested in learning more about that significant period, and also that some personal narrative and oral history might add a useful dimension to Ruth Bordin's account of women at Michigan, we recount some highlights in this introduction, drawing on our memories (reinforced by stories in the *Michigan Daily*) as well as our perspectives as historians. We hope in this way that Bordin's history might stimulate readers' memories of their own pasts.

We represent two generations of women whose lives were forever changed by the rich opportunities and traditions at the University of Michigan. The institution nurtured our growth. Its warm and open environment helped us devise career paths that might not have been accessible elsewhere. Our lives have been deeply shaped by the university's responsiveness to our needs. This essay takes these fundamentally positive aspects of our experiences at Michigan for granted and, in an effort to understand the changes that altered our lives as well as the university, emphasizes our encounters there with the forces of social change. Kitty shares her children's belief that Ann Arbor was an ideal environment in which to grow up. Lynn's son is currently a Michigan undergraduate. Our affection for the university takes many forms, one of which is our respect for its capacity to change.

Our friendship began in January 1971 in the first women's history course at Michigan, taught by Kitty and taken by Lynn. It ripened during Lynn's

senior year when, as a history major, she wrote an honors thesis on Emma Goldman that Kitty supervised. After graduation Lynn completed a Ph.D. in American studies with a dissertation in women's history, and we became colleagues in that new and exciting field.

Kitty's world as a graduate student between 1965 and 1969 frequently overlapped with Lynn's as an undergraduate between 1968 and 1972. We were both part of the same processes of change that were altering all aspects of university life, especially those pertaining to women. Looking back from the perspective of thirty years, three aspects of change seem especially apparent: its rapidity, its multiplicity, and the importance of individual risk taking in challenging the status quo. This brief introduction offers glimpses of the changes we experienced in student life, in the curriculum, and as faculty.

The political and social context of those years was everything, of course. The civil rights and antiwar movements of the 1960s had offered courageous examples of people who stood up to authority while insisting on change. Kitty had the example of her then-husband, Robert Sklar, an untenured assistant professor in the history department. In 1966 he helped students resist the U.S. Attorney General's intimidating practice of issuing a list of allegedly Communist-front organizations that should be banned from campuses. When protesting students needed a faculty sponsor so they could found a new local chapter of a proscribed organization, the W. E. B. Du Bois Club, Robert Sklar agreed to serve and recruited others as faculty cosponsors; the university then sent all of the faculty names to the House Unamerican Activities Committee.

Both Kitty and Lynn were active participants in the antiwar movement and the Black Action Movement. Almost everyone wore buttons, declaring their political affiliations, their positions on the issues of the moment, and the demands they were making on the future. Hair grew longer, clothes became more colorful, and authorities felt more embattled.

Like so many of her peers, Lynn participated in strikes, teach-ins, and rallies focused on issues of the antiwar, student, and Black action movements. As many scholars have suggested, participation by women in social movements like these has historically often led to a recognition of gender discrimination, a questioning of gender boundaries, and an exploration of new arenas of struggle in the realm of women's rights.

Changes pertaining to women and gender came easier in this context. For example, the social lives of women at the University of Michigan, as at universities around the country, had long been constrained by the in loco parentis rules described by Bordin as beginning at the turn of the twentieth century. The university acted as a surrogate parent by monitoring the social activ-

ities of young women residing in dormitories, maintaining curfews, hiring house mothers, and restricting male visitors. By 1946 women had a 10:30 P.M. curfew; by 1958, freshmen had to be home by 11:00 P.M., and upper-class women by midnight. Dress regulations in the dormitories required women to wear skirts or dresses when visiting certain lounges or cafeterias. In the early 1960s student complaints about these dress codes escalated.[1]

When Lynn first encountered the dorm regulations at Stockwell Hall in 1968, the paternalistic regulations were rapidly becoming anachronistic, partly because of transformations in social mores but also because women were outraged that, as library hours lengthened, men had the late hours to themselves. Although housemothers still attempted to maintain curfews, women easily and gleefully dodged the rules, as their predecessors had doubtlessly done for decades before. By 1968 women students could avoid curfews with written parental permission. The next year the rules were abolished. Students today have never seen the odd social phenomena caused by such rules: the clusters of couples trying to find a last minute of privacy in front of the dorms in the minutes before curfew, or the bizarre "panty raids" consisting of hundreds of male students thundering toward dorms that housed restricted women.

Finally, there were the changing geopolitics of dorm housing. The once all-male South and West Quads and the Union were nearest to central campus, while the once all-female Stockwell and Mosher-Jordan Halls, as well as the League, were more distantly located. That landscape changed as many dorms and facilities became coed, initially in separate wings of the dorms and, then by today, hall by hall or even room by room.

In the fall of 1968 a female *Michigan Daily* sportswriter successfully challenged the rule of "no women, children or dogs allowed in the press box" by citing the Fourteenth Amendment and promising to remain "inconspicuous." On 20 September 1969, another barrier fell as *Daily* photographer Sara Krulwich, now with the *New York Times*, became the first woman photographer allowed on the football field. Michigan graduate and then United Press International photographer Andy Sacks brought Sara on the field with him. Security guards with walkie-talkies converged and threatened to physically remove her, so she got other photographers ready to photograph her forced removal. "It was terrifying," she remembers. "I said something lame like, 'this is the way they treat the Blacks in the South, and I can shoot pictures as well as any of them [pointing to the other photographers].'" She held her ground, and began to shoot pictures, "shaking, and with tears in her eyes," according to an observer at the time. A few days later, Sara Krulwich received a letter from Will Perry, director of sports information at the university. He had been

informed, he said, that Sara was "a regular photo gal" and that "I guess we are breaking all kinds of tradition around here." As long as she agreed to "act professionally," she was now welcome on the field.[2]

In the early 1970s students' grassroots readiness to act combined with hard work by organizers to effect changes in university policy. For example, students organized teach-ins on such women's issues as day care and abortion rights. These usually attracted standing-room-only audiences. A lecture on sexism and racism by Gloria Steinem and welfare rights advocate Margaret Sloan drew an audience of over fifteen hundred to the Power Center. Soon thereafter the university established an office of women's advocacy.

"Sisterhood" was powerful, but "women" was too sweeping a social category for those within it to agree on one set of needs and goals. In 1970 a teach-in celebrating the centennial of women at the university brought together women across the political spectrum, including Michigan congresswoman Martha Griffiths, President Robben Fleming's assistant Barbara Newell, and radical feminist Robin Morgan, as well as other scholars, activists, and politicians. Catcalls and cheers from the audience of six hundred interrupted the introductions as the audience was urged by Morgan to join the speakers on stage to break down the "anti-woman" and "elitist" structure of the program. A tumultuous session followed with lively discussion of the Equal Rights Amendment, radical lesbianism, and the nature of women's liberation.[3]

An all-male bastion, the University of Michigan Marching Band, accepted women for the first time in 1971. Resisting the integration of women into this music program, band director George Cavender said that marching band was "more violent physical activity than would be proper for a lady." He added that, "It would be too hard. We couldn't excuse a woman from rehearsals if she had 'female problems.' I certainly don't excuse any of my boys from practice."[4] In their assault on tradition the women musicians seemed to keep up with their high-stepping male counterparts just fine. Soon afterward the famous all-male cheerleading squads in the Michigan stadium were gender-integrated as well, although at first only by allowing "pom-pom girls" to join the boys on the field.

Those entrenched in the institution were not the only ones resisting the new order. The *Michigan Daily* itself mirrored the tensions resulting from shifting gender roles, with articles both promoting and denigrating feminist activities. For example, when Lynn, then a *Daily* reporter, wrote a column objecting to a sportswriter's metaphor comparing a football to a woman, the sports staff responded with a "joke" column about a ludicrous feminist journalist named Louella, who destroyed the paper.[5] The *Daily*'s tradition of male editors-in-chief, broken previously only in wartime, finally toppled in 1972

with the appointment of Sara Fitzgerald, now a journalist and writer in Washington, DC.

These changes developed against a backdrop of university resistance to government affirmative action mandates. During the same year, 1970, that the centennial of women at Michigan was celebrated in such a tumultuous way, another group of women filed a complaint against the university for sex discrimination. Bordin traces the background of this complaint, lodged with the Department of Health, Education and Welfare (HEW) by a group known as FOCUS on Equal Employment for Women. By the early 1970s there had been little improvement in the hiring and promotion of women on the faculty. After disputing the government on details of an anti-discrimination plan, university administrators, faced with a blockage of government contracts until they were in affirmative action compliance, agreed to reduce sex bias in employment by achieving "salary equity for males and females in the same job classification" and giving priority to women seeking promotion in non-academic positions. As was pointed out at the time, neither measure addressed the serious lack of equity for women in faculty ranks.

In 1971 President Robben Fleming still argued that because women "wanted both a family and working life" they could not handle the time commitment needed to excel in academics. The University Commission for Women disagreed with this stance as well as with Fleming's argument that the "deep and historical pattern" of sex discrimination was not for the university to reverse. The commission instead stated in the same year that "there is a dawning awareness at the university that women are a force to be reckoned with in the years to come."[6]

Michigan was probably as male-dominated as any elite Ivy League university in the late 1960s, but by 1972 in Ann Arbor, as elsewhere, those privileges were under assault. For example, in mid-May 1972, the Ad Hoc Committee Concerned that President Fleming Does Not Meet With Women stationed themselves outside Fleming's office for a week, recording and observing all his visitors. They found that only 13 percent of the president's visitors were women, that they came with groups in which a majority were men, that they did not address women's issues, and that none of the women saw Fleming without an appointment or without first checking with the secretary, practices that many of the male visitors did not observe.[7]

Changes in the lives of graduate students came more slowly and were often less visible than those affecting undergraduates. Before 1969, the Department of History had almost no women graduate students, apart from teachers seeking MAT degrees, and only one faculty member, Sylvia Thrupp, a distinguished Canadian scholar of early medieval Europe. In the ceremony to

award Ph.D.'s in 1969, President Robben Fleming asked the "wives" of the degree candidates to stand and warmly acknowledged their tireless support of "putting hubby through." This underscored the oddity of the few women who were robed to receive Ph.D.'s.

One of the most remarkable and revealing features of those years was a consciousness-raising group that in the winter of 1970–71 brought together faculty, faculty wives, graduate students, and at least one undergraduate. Many were on their way to becoming well-known scholars in their chosen fields: Zelda Gamson, Rayna Rapp, Gayle Rubin, Kitty Sklar, Adrienne Harris, Marilyn Young. Like the tens of thousands of American women who later joined such groups in the early 1970s, we learned about the collective pattern of our lives by reading feminist texts and through the Chinese method of "speaking bitterness" about our individual experience. In the spring of 1970 we decided that the group had served its purpose and, with a parting gesture of solidarity, staged the "First Annual Ann Arbor Women's Film Festival."

The courage that carried us forward in those days was often more contingent than planned—a fortuitous intersection of everyday life and the special circumstances of the time. Kitty decided to study women's history when, after graduating from Harvard in 1965 with a near-toxic dose of the history of American men, she resolved to pursue a Ph.D. only if she could study women. Women seemed more interesting, and since almost entirely unstudied, presented ample opportunity for original work. As the mother of two children born during her undergraduate years and as a faculty wife, she was curious about the logic of gender within history. She realized that a woman who studied women was unlikely to be taken seriously by the historical profession, but lacking any evidence that she would have access to the profession anyway, thought she had little to lose. Equipped with a fellowship that amply rewarded any program she entered, she studied nineteenth-century American women as agents of historical change. In the summer of 1968 she completed the research for her dissertation by driving her children and their baby-sitter from archive to archive in a nonair-conditioned car.

Kitty remembers that she ended up teaching at the University of Michigan not because she thought she deserved a job there when she completed her Ph.D. in 1969, or because she thought others would share her interest in the history of women. Far from it. Instead, she could not cope with the demands of teaching at Eastern Michigan University in Ypsilanti, the former teacher-training school where many Michigan faculty wives with Ph.D.'s had sought employment. At the height of protests against the Vietnam War in the fall of 1969, she naively carried her conscience to work and declared that all students in her U.S. history courses would receive a grade of "A" because she

was not willing to cooperate with the process by which students could be drafted if their grades put them on probation. She should have taken it as a warning sign when some of her colleagues began to snub her in the hall. Having known only elite institutions where middle-class students had rights, she innocently assumed that working-class EMU students also had rights. When her grading practice brought her to the attention of student journalists who were seeking a way to challenge the university's right to censor their paper, she agreed to support their decision to print antiwar views that violated the censorship rules. Within a week these students were expelled and drafted. Deeply shaken, and thinking she could not survive at such an authoritarian institution, she explored the possibility of teaching at Michigan's Residential College. There, under the benign rule of Dean James Robertson, she began teaching in January 1970. From the protected perspective of East Quad and through seven tumultuous semesters she witnessed and abetted the growth of feminism on campus.

Sometime around the spring of 1970 it became possible to think of women as serious subjects of academic study, and Kitty's class in American women's history, first begun in January 1971, became a venue for the creation of new knowledge about women. Lynn remembers the class as "transformative" because it showed that history included the stuff of everyday life. Guest speakers in the course included a pair of English midwives who discussed the historical significance of their work. That semester, as well, Duke University professor Anne Scott visited Ann Arbor to talk about the importance of the new field of women's history and called on women to "dare to exercise powers outside the defined limits."[8] Now, a quarter of a century later, when the field of women's history has developed into one of the most dynamic and prolific areas of historical study, the process of putting together a syllabus is a challenging one because there is so much to choose from. Then, when we knew relatively little, we relied on Eleanor Flexner's Century of Struggle: The Woman's Rights Movement in the United States (1959), classic works like Charlotte Perkins Gilman's Women and Economics (1898) and Thorstein Veblen's Theory of the Leisure Class (1899), and autobiographies like Emma Goldman's Living My Life (1931). For minority women we drew on contemporary writings like Toni Cade's The Black Woman: An Anthology (1970). Kitty's courses in women's history created a strong student constituency for women's history, and the history department responded by creating a tenure line in the department for the field. In the department's wisdom, however, they chose someone else to fill the position, and Kitty moved on, accepting a tenured appointment at UCLA.

One notable success of the women's movement on campus in the early

1970s was the creation of a women's studies program. This fostered crucial new space on campus for the generation and distribution of knowledge about women. A remarkable committee that included senior faculty, junior faculty, graduate and undergraduate students came together to design the program and successfully advocate its establishment to Dean Frank Rhodes. Lydia Kleiner, a work-study student, convinced Student Services to hire her in the summer of 1972 to investigate creating a program. She met with Kitty Sklar and together they contacted everyone who was active in feminist politics or feminist intellectual work on campus. Kitty's class in women's history had shown that feminist questions could be combined with scholarly methods to produce new knowledge about women. We believed that women could be an effective category of scholarly analysis in every discipline. The committee's success depended on its ability to attract senior faculty to its ranks. This was accomplished when Libby Douvan and Norma Diamond joined us. Success also hinged on our ability to hold together our diverse ranks, which embraced lesbian activists, young mothers who worried about meetings that stretched beyond the limits of their child-care resources, and socialists who doubted the utility of gender as a category of analysis. Kitty remembers going to the window during one particularly contentious meeting to hide irrepressible tears of frustration. Miraculously, however, committee members agreed on a design for the program, carried their proposal to Dean Frank Rhodes (later president of Cornell), who had the foresight to approve the plan, and launched a new course, "Introduction to Women's Studies," in the fall of 1972.[9]

This was the beginning of the university curriculum's transformation by new courses in women's studies and the creation of new fields of knowledge pertaining to gender. In many ways, the struggles of the 1970s finally brought to fruition the efforts, begun in the late nineteenth century, to have women faculty teach students something other than "physical culture," an effort led by Detroit women like Catharine Kellogg who unsuccessfully attempted to endow a chair for women faculty in 1899. Bordin also shows how in analogous ways the pioneering studies of the first women graduates Amanda Gage and Madelon Stockwell, who received their degrees in 1872, were followed by the tens of thousands of women graduates over the course of the next century.

At the end of the twentieth century, the climate for women at Michigan is no longer precarious. More women students are enrolled, more teaching assistants hired, more women faculty are in the classrooms. And after years when, as Bordin shows us, the loftiest university appointment for women was that of the dean of women, great strides have been made in university administration. In 1977 Joan Stark was named dean of the College of Education, the

first woman to lead a college other than the School of Nursing. In 1989 political scientist Edie Goldenberg became dean of the College of Literature, Science and the Arts, and in 1997 psychologist Nancy Cantor was named provost and executive vice president for academic affairs.

But the books are not yet closed on the "dangerous experiment" in coeducation at the University of Michigan. Ruth Bordin demonstrates that as late as 1996 fewer than a third of all tenured or tenure-line faculty in fourteen of the seventeen colleges of the university were women. Bordin clearly shows us that those who fostered change in the 1970s were not the first generation to alter the institution by demanding access to it. Nor, her book suggests, will they be the last. Continuity with the past is a strong resource for women troublemakers. This book provides a firm foundation for an enriched future.

Kathryn Kish Sklar is Distinguished Professor of History at the State University of New York, Binghamton; Lynn Y. Weiner is Professor of History and Associate Dean of the College of Arts and Sciences, Roosevelt University, Chicago.

NOTES

1. Milt Freudenheim, "Cinderellas," *Michigan Daily*, 26 January 1946; and Jane McCarthy, "New Midnight Closing Hours set for Upper-class Women," *Michigan Daily*, 4 December 1958; both in Susan Holtzer, ed., *Special to the Daily* (Ann Arbor, MI: Caddo Gap Press, 1990), 183.

2. Sara Krulwich, e-mail correspondence with K. K. Sklar, 15 October 1998. Robin Wright, "Broad-Side," *Michigan Daily*, 15 October 1969; in Holtzer, *Special to the Daily*, 89.

3. Lynn Weiner, "Women Disrupt 'U' Teach-In," *Michigan Daily*, 13 October 1970.

4. Pat Bauer, "'U' Band Marches On—Minus Women," *Michigan Daily*, 17 September 1971; in Holtzer, *Special to the Daily*, 188.

5. Lynn Weiner, "Good Humor: Laughs Sold at Others' Expense," *Michigan Daily*, 14 November 1971.

6. Sara Fitzgerald, "Fleming Meets Unit on 'U' Sex Discrimination," *Michigan Daily*, 9 December 1971; and Virginia Nordin, "Defending Women's Commission," *Michigan Daily*, 9 December 1971.

7. Jan Benedetti, "AHCCTPFDNMW?" *Michigan Daily*, 24 May 1972; in Holtzer, *Special to the Daily*, 187.

8. Debbie Thal, "Scott Says Historians Ignore Women's Role," *Michigan Daily*, 23 February 1971.

9. Gayle S. Rubin with Karen Miller, "Revisioning Ann Arbor's Radical Past: An Interview with Gayle S. Rubin," *Michigan Feminist Studies*, no. 12 (1997–98): 91–108. For an update on the Women's Studies Program, see Abigail Stewart, Anne Herrmann, and Sidonie Smith, "The Joint Doctoral Program at the University of Michigan," *Feminist Studies* 24, no. 2 (summer 1998): 356–65.

A Chronology of Women at the University of Michigan

1817 The University of Michigan was founded.

1837 The original statute establishing the University of Michigan was written, stating that "the university shall be open to all persons who possess the requisite literary and moral qualifications."

1841 University degrees were first granted to women in the United States.

1848 The Seneca Falls Convention on the rights of women was held.

1858 University of Michigan president Henry Tappan stoutly opposed the applications of Sarah Burger, Harriet Patton, and Augusta Chapin for admission to the University of Michigan.

1859 Nearly 1,500 Michigan citizens signed and presented to the Board of Regents a petition for the admission of women to the university.

1862 The Morrill Act was enacted, funding state land grant universities.

1867 The State Legislature adopted a joint resolution favoring the right of women to attend the University of Michigan, declaring that "the high objects for which the University of Michigan was organized will never be fully attained until women are admitted to all its rights and privileges."

1870 The Board of Regents passed a resolution allowing women to attend the university, and Madelon Stockwell became the first woman to enroll.

1876 The Quadratic Club, the first all-women's society, was founded.

1880 Mary Henrietta Graham, believed to be the first African American woman at Michigan, graduated with a Ph.B.

1885 Sophia Bethena Jones, the first African American woman to graduate with a medical degree, was admitted to the Medical Department.

1886 Barbour Gymnasium opened, providing the first on-campus space for women students' exclusive use.

1890 Ida Gray (Dent. 1890) became the first African American woman to graduate in Dentistry from the University of Michigan and the first black woman in the United States to earn a D.D.S. degree.

The Michigan League was established as a counterpart to the exclusively male Michigan Union. The League combined a small women's

club called the Alethian Society with the larger Fruit and Flower Mission.

Five sororities with fifty-five total members were established.

1891 Women alumnae proposed that they be allowed to raise funds to pay the salaries of women faculty elected by the regents. The University Senate refused the arrangement.

1894 The Women's League, a growing booster organization, proposed taxing each male student twenty-five cents to raise money to buy land for women's playing fields. They did not prevail.

1896 Eliza Mosher, one of Michigan's first women Medical School graduates in 1875, returned as the university's first dean of women, a position created to oversee the health and behavior of female students.

1899 Catharine Kellogg and a group of women from Detroit offered to make a substantial gift to the university for the endowment of a chair to be occupied by a woman, not to teach physical culture or gym, but a course in what would today be women's studies. The matter was tabled by the regents.

1900 President Angell called the increase in the number of women obtaining college educations "one of the most striking educational facts of our time." By 1900 women constituted the majority of graduates in the Literature Department.

1902 The university established the doctrine of in loco parentis, regulating women's living arrangements, social calendars, dress codes, and modes of behavior. Myra Beach Jordan, the new dean of women, set up a series of rooming houses, after which women's dormitories followed.

 After the newly-formed junior faculty research club refused to admit women, the Women's Research Club was inaugurated.

1905 A women's athletic association was organized, creating women's baseball, hockey, and basketball teams.

1909 The first Jewish sorority, Alpha Epsilon Phi, was established.

1910 Women outnumbered men, 22 to 13, respectively, among the students being initiated into the Phi Beta Kappa honor society.

1915 Two all-women dormitories, Helen Newberry Hall and Martha Cook Hall, were first opened to students.

1917 Regent Levi Barbour established a fellowship program at the university for Asian women seeking professional degrees in the United States.

 Fourteen alumnae clubs formed the Alumnae Council of the University of Michigan Alumni Association.

1920 Elizabeth Crosby came to the University of Michigan to teach in the Department of Anatomy. She became the highest-ranking woman faculty member at the Medical School. In 1946 she was chosen the first woman to give the university's prestigious Henry Russell Distinguished Lecture.

The Nineteenth Amendment gave American women the vote; women voted for the first time in a national election. Helping to win the vote for women were several University of Michigan alumnae, including Lucy Maynard Salmon (1876) and Octavia Bates (1877).

1921 The Faculty Women's Club was organized; it included both faculty members' wives and the few women on the teaching staff.

1929 The construction of the Women's League building was completed.

Esther Marsh Cram became the first woman elected to the Board of Regents.

1930 The first state financed dormitory for women, Mosher-Jordan Hall, opened.

1944 The regents placed the first limit on the number of women who could be admitted to the university, making enrollment dependent upon the availability of housing.

1945 The Society of Women Engineers was organized.

Women held all of the editorial positions at the *Michiganensian* and served as presidents of the senior classes in the College of LSA and in the Law School.

Women served for the first time as "waiters and busboys" in the dining rooms of "that sacrosanct male bastion, the Michigan Union." They were still compelled, however, to enter the Union through the side door.

1946 The all-male Student Council was replaced by the Student Government Council, a co-ed student legislature where women won 7 out of 50 seats.

1949 The joint faculty and student Committee on Student Affairs decided not to recognize any organization that prohibited memberships based on race, religion, or color.

1954 Women were finally allowed to enter through the front door of the Michigan Union.

1955 The first woman academic dean, Rhoda Redigg, was appointed in the School of Nursing.

Elizabeth Crosby became the first woman admitted to the Faculty Research Club since its founding in 1900.

1957　After standing vacant thirty-three years, the position of Alice Freeman Palmer Professor of History chair was awarded to Caroline Robbins, its first recipient. In 1924 George Palmer had donated $35,000 to establish the chair, "the holder of which shall always be a woman."

1961　Senior women with good standing were allowed to move off-campus and coeducational dormitories began to appear in greater numbers.

1962　Louise Cain, the former president of the League of Women Voters in Michigan, proposed the Center for the Continuing Education of Women (CCEW). In 1964 CCEW opened its doors with a three-fold mission of service, research, and advocacy.

1964　The Michigan Union and the Women's League merged administratively, largely bringing an end to gender-segregated social facilities.

Title VII of the Civil Rights Act was enacted, barring unemployment discrimination on the basis of sex.

1965　Executive Order 11246 was issued, requiring federal agencies and contractors to take affirmative action in overcoming employment discrimination.

1968　Barbara Newell, the first woman to serve as an executive officer at the university, was appointed acting vice president of student affairs.

1970　Women filed a comprehensive sex discrimination complaint against the university. The federal government investigated, found that the university had failed to develop an adequate affirmative action plan for women, and temporarily withheld federal research funds.

The Board of Regents officially abolished the curfew requirement for women living in university residence halls.

The Women's Advocate Office was established in Student Services; Claire Jeanette was appointed first advocate.

1971　In response to the federal government's finding of sex discrimination, President Robben Fleming established the Commission for Women (CFW) with Barbara Newell as its first chair. The commission successfully pressed for changes in university policies and practices.

The Human Sexuality Office was created as part of the Office of Student Affairs, and Cynthia Gair was appointed as the first lesbian advocate.

1972　The Office of Affirmative Action was founded, with Nellie Varner as its first director.

Seven women were admitted to the previously all-male University of Michigan Marching Band.

Congress enacted Title IX; in response, President Fleming created a committee to study women's intercollegiate athletics.

1973 The Executive Committee of the College of LSA approved the proposal for a Women's Studies Program, and the next fall five courses were offered. Margaret Lourie was appointed the first director.

The Athletic Department, under pressure, inaugurated a women's varsity athletics program.

1974 Carolyn Davis was appointed as associate vice president of academic affairs and became the first woman to hold a permanent position in the University of Michigan's senior administration.

1975 Women's studies was approved as an undergraduate major.

1976 Title IX of the Education Amendments went into effect, covering educational programs and activities receiving federal financial assistance (enacted 1972).

1977 Joan Stark was appointed dean of the School of Education, becoming the first female dean to lead any college or school at Michigan, except the School of Nursing.

1978 Amid protests, Barbour Gym was demolished.

1979 The Women of Color Task Force was formed to address staff concerns and to provide opportunities for professional development.

1980 The first annual "Take Back the Night" rally was held.

The university adopted specific guidelines to protect all university employees and students from sexual harassment.

CCEW's Women in Science and Engineering (WISE) program was established and Barbara Sloat named director.

1984 Graduate courses in women's studies were added with the creation of the graduate certificate program.

1985 Linda Wilson was appointed vice president for research. This was the first time a woman had been appointed as an executive officer in the university, except in an interim capacity.

1986 Following an anti-rape sit-in, the university created the Sexual Assault Prevention and Awareness Program (SAPAC), with Julie Steiner as its first coordinator.

1988 Blenda Wilson was appointed chancellor of the Dearborn campus. She was the first African American woman to hold a position as an executive officer at the university.

The "Women's Agenda for the 1990s" was submitted to the president of the university. It called for attention to mentoring, workload balance, hiring and salary equity, and the need for special efforts to address race and sex discrimination experienced by women of color.

1989 CCEW changed its name from the Center for the Continuing Education of Women to the Center for the Education of Women (CEW).

The President's Advisory Commission on Women's Issues (PACWI) was created by President James Duderstadt; Carol Hollenshead was named chair.

Edie Goldenberg was appointed dean of the College of Literature, Science and the Arts.

1990 The percentage of tenured and tenure-track women on the faculty continued to lag. In the 1980s it grew only 1 percent, from 17 to 18 percent of the faculty.

The Family Care Resources Program was established and Leslie De Pietro appointed as its first director.

1992 The Michigan Initiative for Women's Health (MIWH) was founded to foster research and education on women's health issues.

1993 The Board of Regents adopted a policy prohibiting discrimination based on sexual orientation.

1994 President James Duderstadt announced the Michigan Agenda for Women, a plan to make Michigan "the leader among American universities in promoting and achieving the success of women as faculty, students, and staff."

The Institute for Research on Women and Gender was founded and Abigail Stewart named director.

The Women's Studies Program established an interdepartmental doctoral degree program in cooperation with the English and psychology departments.

CEW and the Women's Studies Program launched the Women of Color in the Academy project designed to highlight contributions of women of color and to build a faculty network.

1997 Graduate school dean Nancy Cantor was appointed to the position of provost and executive vice president for academic affairs.

1998 At the recommendation of President Lee Bollinger, the regents appointed three women to positions as executive officers, bringing the total to five. For the first time an equal number of women and men held leadership positions.

Chapter 1

Pursuing the Cause

Soon after the University of Michigan's winter term began in 1870, Professor Martin L. D'Ooge informed his students that on the next Monday "a young lady will join this class. I will seat her as you are, alphabetically. I expect you all to be gentlemen."[1] The young woman was Madelon Stockwell of Kalamazoo, long a scholar of the classics, who did so well on her entrance examinations that she was admitted to the university with advanced standing and was able to graduate with the class of 1872, a class that had begun its studies as an all-male body in 1868. The men seated next to Stockwell did behave as gentlemen, and Professor D'Ooge's alphabetical seating proved to be felicitous. Stockwell married the man in the adjoining seat, Charles King Turner, when he graduated from the Law Department in 1873.

Although some professors and students had not been overjoyed to see Michigan become coeducational, the new departure, the "dangerous experiment," went remarkably well. Interim President Henry Simmons Frieze (1869–71) was sympathetic, as were Professors D'Ooge and Moses Coit Tyler of the faculty. Tyler expressed his sentiments on women and education when he wrote in Stockwell's autograph book that June, "But who is this so arrogant as to determine what may be the sphere of another? . . . [I]t is whatsoever worthy horizon in life any personality can make for itself."[2] The next fall Madelon Stockwell was joined by thirty-three other women, two in law, eighteen in medicine, and thirteen in what was then the Department of Science, Literature and the Arts. In 1875 over one hundred women were enrolled.[3] Coeducation at the University of Michigan was under way.

When Michigan opened its doors to women in 1870, women had had limited access to higher education for several decades.[4] Oberlin College had been coeducational since it commenced instruction in 1833. Almost all the Protestant denominational colleges that sprouted throughout the Old Northwest in the mid-decades of the nineteenth century, as well as the new state universities like Wisconsin, Iowa, and Minnesota, accepted women undergraduates. Normal schools, which focused on training teachers, were univer-

sally coeducational, as was the Michigan Normal School in Ypsilanti, next door to Ann Arbor. Coeducation was least evident on the eastern seaboard, perhaps slowed by the presence there of established women's colleges. Vassar, the first major eastern women's college, began teaching courses in 1865. Yet even in the East coeducation had found a foothold, chiefly at Swarthmore (1864) in Pennsylvania and at Bates (1863) in Maine. In 1872 ninety-seven colleges accepted women students.[5] These opportunities for women in higher education, however, did not preclude the fact that in 1869 most of the older and more distinguished American universities barred females. The great eastern colleges and universities were closed to women. The University of Michigan's dangerous experiment was in that sense an innovative first.

The last half of the nineteenth century, particularly the Civil War period, experienced one of the great explosions in higher education in the United States. In 1860 just over 1 percent of the white males of college age was enrolled in institutions of higher learning. By 1900 this percentage had more than doubled, to 2.4 percent. Actual enrollment figures are much more impressive. In 1860, 30,000 students were attending college. By 1900 this figure had become 250,000, 40 percent of them women.[6]

As Barbara Solomon has pointed out, women's access to advanced education, be it in the academy, college, or professional school, has been granted only when it was in the larger society's interest to do so.[7] A number of factors contributed to this explosion of women into higher education. First, the growth by mid-century of a public school system, not yet free but publicly subsidized, had vastly increased the need for teachers. Beginning during the Revolutionary period with the idea of "Republican Motherhood," which endowed domesticity itself with political meaning, education and the women's sphere were linked. The Republican Mother was charged with a patriotic duty to educate her sons in moral and virtuous citizenship. This both required some degree of education for women and legitimized women's role as teachers.[8] By 1870 three out of five teachers in the United States were women.[9] Not only were women considered better fitted than men for teaching, a nurturing profession, but also important was that women could be paid less. Education was a local function. To the extent that schools were tax supported, funding came from local government, and, consequently, those taxed for public education demanded that no more be spent than was absolutely necessary. The gradual growth of educational opportunities for women stemmed partly from the expanding need for cheap teachers in the growing public school system. It was legitimized first by the concept of the Republican

Mother and later transformed by the doctrine of spheres into women's responsibility for home and children.

A second factor was the impact of the Civil War. By 1870 one of every eight women over ten years of age was employed, mostly in menial service and factory jobs.[10] The Sanitary Commission, a civilian organization that provided humanitarian services for the armed forces, had trained a whole generation of middle-class women in volunteer activism. The Freedmen's Bureau, created to help the newly emancipated slaves, gave women a new and challenging niche in the teaching profession during the Reconstruction. But perhaps most important in terms of women's wider entry into higher education was the abolitionists' decision after the Civil War to subordinate demands for women's suffrage and to concentrate their efforts on the enfranchisement of black males. This accommodation caused a split in the suffrage movement. Many leaders accepted this compromise, while radicals like Elizabeth Cady Stanton and Susan B. Anthony did not. Nevertheless, the compromisers began to look for other means of women's empowerment. For many activist women the temperance movement emerged as a replacement for the antislavery movement and as a substitute for a women's suffrage campaign, which few men endorsed. The temperance movement was also important as a vehicle through which women could address and hopefully cure social ills.[11] Higher education for women became another crusade behind which the leaders of the old antislavery movement could throw their support.[12]

Third, the ferment and expansion in higher education as a whole benefited women. Society not only made far greater provision for training teachers, especially through the new normal schools with their shorter course of training and in which women made up 57 percent of the enrollment in 1874, but also generally democratized higher education.[13] By mid-century the new midwestern and western states were establishing publicly supported universities with low or no fees that were open to all, including women. While the Morrill Act of 1862 did not specifically mention women, it encouraged the democratization of higher education by allotting public lands to the states to promote "the liberal and practical education of the industrial classes in the several pursuits and professions of life."[14] By stressing agriculture and the practical arts, the act enlarged the breadth and appeal of higher education. Farmers and their families began to demand the right for women to attend publicly supported institutions along with the men. Most land grant institutions enrolled women from the start.[15]

Publicly supported colleges and universities, however, found the pressure

to admit women most unrelenting. Iowa accepted women when it opened in 1855. Wisconsin admitted its first woman in 1863. Kansas, Indiana, and Minnesota followed in 1869. City College of New York, the first municipally supported institution of higher learning, was closed to women when it began instruction in 1847, but the taxpayers forced the provisions of equivalent female facilities, and in 1870 Hunter College was founded. Ladies' courses, Ladies' Colleges, and Normal Departments were an early and typical accommodation to the demand for coeducation in the western colleges and state universities. Wisconsin, Grinnell, Northwestern, and Missouri all took that path, although this compromise was relatively short-lived. In 1863, for example, Wisconsin, had a normal department open to women, and other educational opportunities developed at that university during the Civil War. In 1867, however, Wisconsin abolished coeducation and established, not without protest, a separate female college; yet by 1872, because of opposition to segregation, women again were allowed to attend regular classes if they wished. After John Bascom's inauguration as Wisconsin's president in 1874, the cause of women's education in public universities had a well-placed friend, and women students' place at the University of Wisconsin was never again in serious jeopardy.[16]

Michigan was not immune to this mid-century change. The original charter of the University of Michigan provided for a "female department," but no money was ever appropriated to establish it. When the public pressure to support women's higher education accelerated in the post-Civil War period, the State of Michigan had already provided for a separate Morrill Act institution in East Lansing and a flourishing Normal School in Ypsilanti, a teacher's college that both educated women students and was partially staffed by women faculty. Most of Michigan's private Protestant denominational colleges, including Albion, Alma, and Hillsdale Colleges, were coeducational.[17] To some extent this relieved the pressure on the university to admit women, but, as the flagship state educational facility, Michigan could not escape the issue of coeducation.

As Dorothy McGuigan pointed out a generation ago, "the first salvo of the battle over coeducation at the University of Michigan was fired in May of 1855, when the liberal-minded State Teachers Association held their annual meeting in Ann Arbor."[18] One of its lively debates concerned the admission of women to the university, and on the last day of the session a resolution was adopted affirming that coeducation of the sexes was both "practically expedient" and "in accordance with true philosophy."[19] Perhaps the convention's concern with the question was inspired, at least in part, by the fact that the

University of Iowa admitted women that year. No woman sought admission to Michigan, however, until 1858, and the regents of the university faced the question for the first time at their June meeting. Sarah Burger and Harriet Patton, both of Ann Arbor, and Augusta Chapin, of Lansing, formally applied for admission. President Henry P. Tappan (1852–63) stoutly opposed their acceptance and contended that the faculty was wholeheartedly behind him. Michigan governor Kinsley Bingham favored the women's admission, as did two of the three regents who were appointed to a committee to review the situation and prepare a report. Although the debate was lively, a decision was postponed until September, and the committee continued its investigation of the merits and problems of coeducation. The regents ultimately refused admission to the women.[20] Agitation in favor of coeducation continued sporadically until the end of the Civil War.

As the war drew to a close, Lucinda Hinsdale Stone and her husband, James Andrus Stone, emerged as formidable advocates of higher education for women, an idea that by then was gaining public support in many parts of the country. Lucinda Stone had been principal of the Kalamazoo Preparatory School, part of a network of "branches" that Michigan's organic act of 1837, which provided a public education system for the state, placed under the governance of the regents of the University. When in 1841 the regents decided that the branches were absorbing too much of the infant university's income from the sale of public lands, they discontinued their support, and the branch school at Kalamazoo became Kalamazoo College.[21] Lucinda Stone continued as principal of the College's Ladies Department.[22] Madelon Stockwell was one of Stone's students; Stockwell later graduated from Albion College. James Stone also became active in lobbying the state legislature for coeducation, and Regent George Willard, an Episcopal clergyman and later professor of Latin at Kalamazoo College, became an ardent advocate of coeducation. If earlier most of the university faculty was largely opposed to the admission of women, as President Tappan had claimed in 1858, James Boise, then a professor of Greek at Michigan, publicly championed the idea; responding to the growing national and local ferment on the questions, other faculty members soon came to support Boise's position. Alexander Winchell, for example, rethought his position in a considered essay he wrote in 1866.[23] Some new faculty members were also sympathetic. Martin D'Ooge, who replaced Boise in classics in 1868, and Moses Coit Tyler, who became professor of rhetoric and English literature in 1867, were among them. Slowly but surely the atmosphere was changing at Michigan, as it was everywhere else. In 1867 the state legislature adopted a joint resolution calling for the admission of women to the univer-

sity.[24] No unit of public instruction could much longer prevent women from enjoying its privileges.[25]

Actually, women had informally attended classes at the University of Michigan as early as 1866. Alice Boise, whose father, James, was professor of Greek, joined his students that year, participating in classes without seeking formal enrollment, which would certainly have been refused had she requested it. Erastus O. Haven (1863–69), who had replaced Tappan as president of the university, was not opposed to the higher education of women, as Tappan had been, but he was not an advocate of fully integrated coeducation. He believed in establishing a separate Ladies College, affiliated with and parallel to the university. He implemented such an initiative five years later while serving as president of Northwestern University; similar plans were used at a number of eastern universities, including Radcliffe at Harvard, Pembroke at Brown, and Barnard at Columbia.[26] At Michigan President Haven's plan was opposed principally on the grounds that creating an affiliated college for women would be prohibitively expensive.

Meanwhile, the coeducation crusaders in the Kalamazoo area had not given up. James Stone used his newspaper to champion the cause, and George Willard kept the issue before the Board of Regents. The Michigan legislature passed another pro-coeducation resolution. In January of 1870, with two new members on the board, the regents finally bowed to the public will. The University of Michigan was open on the same terms to its daughters as to its sons. The Stones and Willard had won. Lucinda Stone counseled her former student, Madelon Stockwell, to apply at once for admission.

When in 1870 Michigan, the largest and among the oldest public universities, opened all its divisions to women on the same terms as men, it marked a major breakthrough for the coeducation movement nationwide. Cornell soon followed, as did the University of California. Total accommodation and acceptance came first in those universities west of the eastern seaboard, which were eager to build their academic reputations through aggressive institutional reforms. In contrast Radcliffe College, originally known as the Harvard Annex, remained a curious stepdaughter that Harvard declined to accept as its own for nearly a century.

Chapter 2

"A Most Hopeful Experiment"

When women students officially joined the University of Michigan community in 1870, American academia was taking its first steps toward revolutionary changes that transformed higher education before the century was out.[1] Noah Porter, president of Yale University, commented in his inaugural address in 1871 that "never, perhaps, did this subject [of higher education] occupy the thoughts of so many persons and occupy them so earnestly."[2] Michigan was ahead of many other major institutions in the transformation.

In one respect President Tappan, fresh from travels and study in Germany, had led the way when he brought the European university ideal to Ann Arbor in the 1850s. There it gained a precarious foothold, perhaps for the first time, on American soil. The ways of the American college had long been identified with religious piety. Innovation and the new science were associated with unsettling religious implications and were suspect. Tappan was not afraid to bring to Michigan's faculty those scholars who challenged orthodox religious dogma, like Andrew Dickson White, or questors after science, like Francis Brunnow, both of whom had experience in European universities. At Michigan White introduced the lecture system, another German innovation, as well as the first courses in European history, this at a time when Greek, Latin, and mathematics formed the core of the curriculum and compulsory courses in philosophy and religion were traditionally taught by the president.[3] Nonetheless, Michigan retained many of the characteristics of the old pre-Tappan college, with its strict regulation of student life including compulsory chapel, a rigid curriculum in the Literature Department composed largely of classical languages and literature, philosophy, and mathematics, and a heavy emphasis on rote learning by the recitation system.

By 1870, however, most of these parochialisms had been seriously challenged at Michigan. The original concept of higher education as general preparation for life rather than specific preparation for the professions had long been abandoned. Professional training in medicine, law, and engineering were already fully provided for at Michigan, and dentistry and pharmacy

were added in 1875 and 1876. In 1856, because of space and budget constraints, the university had abandoned its management of student housing on campus. Students lived and ate where they pleased, freeing student life from the paternal regulation so entrenched at the eastern colleges. Compulsory chapel persisted, however, until 1872.

The curriculum, too, was relatively easily reshaped at Michigan. Harvard's president, Charles Eliot, introduced the elective system of course offerings there in 1870.[4] Michigan began experimenting with elective courses at about the same time, while Yale, for example, did not introduce electives until 1884.[5] Michigan was also ahead in introducing science into the curriculum. Other major universities allowed some science courses but only within new science schools, which had limited influence upon undergraduates. The Sheffield School at New Haven and Lawrence College at Cambridge, for example, were designed to limit the impact of the new science curricula on undergraduates.[6] This pattern was not followed at Michigan, where science courses flourished as part of the Department of Literature, Science and the Arts (LSA).

Michigan had long since abandoned religious conformity as a necessary qualification for faculty appointment. In fact young George Palmer, already on the faculty at Harvard, tried in 1870 to secure a Michigan faculty appointment, which President Henry Simmons Frieze (1869–71, 1877, 1880–82) offered but eventually withdrew. Palmer was about to marry a Swedenborgian, and he believed her unorthodox religious background would be more acceptable at Michigan than at Harvard.[7] As late as 1878, Alexander Winchell, previously a professor at Michigan, was dismissed from Vanderbilt because of his acceptance of Darwinism. Princeton University no longer demanded that faculty belong to a particular denomination but did demand orthodox theism. Rochester, Wesleyan, Amherst, and Brown, among other institutions, had religious qualifications for faculty members.[8] Michigan did not.

Although University of Michigan president James Burrill Angell (1871–1909) had ministerial training, he had not been ordained, and he always identified himself with the new generation of secular university presidents: Eliot at Harvard, Daniel Coit Gilman at the University of California and later Johns Hopkins, and Andrew Dickson White at Cornell. The university was seen by these men not as a bulwark to orthodox theology but as a means to promote a better society. The university would act as a counterforce to both materialistic values and narrow sectarianism. They believed that university-educated men would be independent in politics and religion and that this independence would be nourished by history, literature, philosophy, politics,

and science as the center of the curriculum. All these disciplines were concerned with man and the natural world.[9]

Scholarship was pursued for its own sake at Michigan, and this notion of what the university was all about seemed to have permeated the student body. In assessing Michigan's influence on her development, Lucy Maynard Salmon, who graduated with Michigan's class of 1876 and who later became a professor at Vassar College, placed first the consciousness that the faculty was pursuing and advancing knowledge. At Michigan she had been taught by example that intellectual production was necessary.[10] Salmon also commented on the lack of rules and the freedom allowed the students. There were no grades, no formal prizes, nor formal ranking of students. The university assumed each student was doing his or her best work.[11]

When women students arrived on the University of Michigan campus, it had twelve hundred students, over half in its professional schools, then called "departments." Its budget was over $100,000. It was the largest university in the United States, and its students came from all over the country. A great many of the lawyers practicing in the northwestern states had been educated in its Law School.[12] The women who were admitted in the 1870s came not only from Michigan but also from New York, Ohio, Wisconsin, and even from the Sandwich Islands (now Hawaii). Over half the students were from outside the state of Michigan. Not only was the faculty innovative and involved in the new scholarship in religion and science, but the student body was eclectic and, for the Midwest, quite cosmopolitan. During the 1872–73 academic year students from five foreign countries and thirty states were represented at Michigan.[13]

President Angell, who had been recruited to Michigan from New England in 1871, found in Michigan an institution "shaped under broader and more generous views of university life than most of the eastern colleges."[14] Angell in turn attracted new faculty, seven in the fall of 1872 alone.[15] The university was strengthened in many ways during Angell's presidency. He deliberately buttressed Michigan's already strong commitment to the basic sciences, introduced the seminar method of teaching, greatly augmented the library and had its holdings catalogued, and enlarged the university's collections of botanical, zoological, and geological specimens.[16]

Angell gave his full support to the university's new commitment to coeducation. Women students found a secure place in all departments, including medicine and law. No woman was to graduate in engineering until 1895, but women were not formally excluded. Faculty opposition to women on the campus seems to have disappeared promptly. In his 1870–71 report to the regents Angell wrote: "no difficulty or disadvantage has been met with. No

one connected with the University . . . not even those members of the faculty who were at first opposed or distrustful, any longer express any apprehension in regard to its effect [the admission of women], either upon our internal condition or our reputation abroad." He added that in fact the policy change had vastly improved the university's relationship with the legislature and the people of the state.[17]

As for male students, no one can know exactly what they thought. During the campus debate on the admission of women the *Chronicle*, a student newspaper that reflected the views of its male editors, favored the higher education of women but was somewhat ambivalent about admitting women into the existing departments and courses of study at Michigan. The paper insisted that the university not fall into the trap of Ladies Courses, which could easily evolve into a special boarding school with second-class standards. The paper argued that the legislature was remiss in not providing funds to alleviate the already severe overcrowding of university facilities before reaching a decision to admit women.[18] Most male students accepted women as peers, and in 1871 the *Chronicle* reported that "ladies both on and since admission to the University have met with the profoundest respect."[19] Martha Arnold Boughton (Lit. 1880) commented that the women in her class "were always treated with the utmost courtesy and consideration."[20] Women were also well treated at Cornell University when they first arrived there. M. Carey Thomas, who attended Cornell and later became president of Bryn Mawr College, reported that "the gentlemen treat the ladies with greatest deference and respect. They will even wait in the hall to open a door for you." When she walked into her analytical geometry class, the men stopped laughing and talking and took off their hats.[21]

The records of the class of 1872, which had been all-male when it was admitted but became the first class to graduate women, contain no mention of any trauma from the "innovation," as President Angell called it.[22] In fact male class members instructed the class secretary "to express in writing to the faculty that Miss [Amanda] Gage be allowed to graduate with us." She did, receiving a bachelor of science degree in 1872.[23] For decades after graduation, members of the class regularly exchanged news in round-robin letters. The two women in the class, Madelon Stockwell Turner and Amanda Gage Scoot, submitted their reminiscences and contributions along with those of the men. Both women married Michigan men from the class of 1873. While neither engaged in professional careers, both were very active in civic and benevolent organizations. Stockwell recalled later that "the young men of my class were, without exception, very kind to me."[24]

All this paints a rosy picture of women's welcome at Michigan. But the forces that opposed women's education nationally were not quiescent. Thomas Wentworth Higginson as late as 1881 wrote, "why is it that, whenever anything is done for women in the way of education, it is called 'an experiment,'—something that is to be considered, strongly opposed, grudgingly yielded and dubiously watched,—while if the same thing is done for men, its desireableness is assumed as a matter of course?"[25] As Barbara Solomon has pointed out, the academic ability of women was obvious by 1870.[26] No longer could anyone contend that women could not learn as well as men, and President Angell in his first report to the regents stressed that "the young women have addressed their work with great zeal," and they do "not evince less variety of aptitude or less power of grappling even with higher mathematics than we find in the young men."[27] Yet Darwinian theory, rapidly gaining adherents as part of the new science, appeared to provide a rationale for opposition to higher education for women. Darwinian theorists suggested that traditional limits on women's sphere were biologically determined, casting the weight of apparent scientific proof behind restrictions on women's roles.[28] Medical men were quick to translate this notion into the dictum that for women to study and learn jeopardized the healthy functioning of their female organs. Opposition to the higher education of women was soon based upon both "scientific certainty" and moral principles underpinning the welfare of society at large. Women's energies were needed to bear children and should not be dissipated in study. Edward H. Clarke, once a member of the Harvard Medical School faculty, became the foremost proponent of this position, which he explained in a book entitled *Sex and Education; Or, a Fair Chance for the Girls*. The book was published in 1873 and soon became a popular best-seller.[29]

President Angell, reporting to the regents on women students' academic prowess, also advised that the women's academic work did not seem "to put a dangerous strain on their physical powers, and their absence by reason of sickness does not proportionally exceed that of the men."[30] Clarke's thesis held little sway within the university. The *Chronicle*'s only reference to Clarke came years later when it described him as "the once famous, but almost forgotten Dr. Clarke."[31] There is no evidence that women students paid his ideas any heed. Although they frequently referred to what they were reading, none of their surviving letters or diaries mention Clarke or his book. Michigan student Olive San Louie Anderson had certainly read *Sex and Education* before 1878, when she published her novel *An American Girl and Her Four Years in a Boy's College*, but other women students do not seem to have been affected by Clarke's ideas.[32]

Nonetheless, many other Ann Arbor residents were familiar with Edward

Clarke's writings. While personally helpful to many women students in his flock, George Duffield, minister of an Ann Arbor Presbyterian church, opposed further expansion of women's education or political rights. He used Clarke's arguments in expressing his views from the pulpit and in the press. Lucy Salmon, then a student in the Literature Department, took him to task in a public letter, declaring "we have no account given us that a woman's soul was made unlike that of a man, no different way of salvation prescribed for a woman. . . . If little children study together . . . if a man and woman were destined to pass their life together, who shall draw the dividing line and say that for these four years of college life they shall be separated."[33] President Angell regularly reiterated that study had no adverse effects on women's health.[34] Julia Ward Howe took on the task of rebutting Clarke on the national level.[35] She surveyed all universities and colleges enrolling women, including Michigan, where her informants assured her "that there is not a single instance of sickness which has come from over-study, or from any cause connected with the routine of college life."[36] Instead, it was the unanimous testimony of the Michigan women "studying law, and medicine, and science, and the arts, in the classrooms and lecture room, and library, and laboratory, that their health was never better."[37]

Despite these controversies, women students often formed warm and personal relationships with nonuniversity residents in Ann Arbor. Lucy Salmon and Alice Freeman, who have left the fullest accounts of their college years in the 1870s, had no trouble finding sympathetic landladies who welcomed them into their homes. The churches were eager to find room for women students in their congregations and often sought their assistance in Sunday School work. Some male students may at first have been skeptically curious about the women in their classes, but soon the men courted the "university girls" openly, eager to make them their wives as well as student colleagues. Many faculty members obviously enjoyed having these bright women students in their classes and hoped that their presence would act as a restraint on the often obstreperous behavior of the male students, which it did for awhile. Chapel became almost civilized.

In many ways the 1870s was a golden decade for women students at Michigan. Exotic, competent, attractive, bright, and not yet too numerous to be a threat to male hegemony, women found a degree of acceptance that in later years proved almost impossible to duplicate.[38] Olive San Louie Anderson's 1878 fictional portrayal of a relatively hostile environment for women at Michigan has been interpreted as representative of women students' experiences in coeducational institutions in the 1870s, but no extant contemporary

student documents describe the scenes she presented in *An American Girl and Her Four Years in a Boy's College.*[39] Contemporary accounts do not corroborate Anderson's story. When *An American Girl* appeared, the *Chronicle* published a letter by one of the first Michigan alumnae protesting that "on the whole, the book . . . is a little volume that the university girls who have read it look upon as a dishonor to the University, and one through which they have been deeply wronged."[40] The *Chronicle*'s editors thought the portraits of the faculty were amusing, but "so far as available sources of information are to be trusted, the first [female student] was a woman who respected herself in every way, and therefore was treated with entire courtesy."[41]

Anderson's fictional presentation of women's treatment at Michigan was reinforced much later by an article in the student magazine *Inlander,* which in 1896 told of Lucy Salmon and a friend walking the streets of Ann Arbor for three days trying to find a landlady who would accept them and conveying the impression that Lucy Salmon looked back bitterly on her student days.[42] Salmon wrote a furious letter to President Angell protesting the article's misstatement of fact and reasserting that, indeed, she had loved her student days.[43]

Material from other sources tends to confirm that women students were treated well in the early years of coeducation. Although M. Carey Thomas later described her years at Cornell in the 1870s as unpleasant at best, in letters she wrote at the time her studies began, in 1875, she described the male students as interested and sympathetic. Thomas professed to be a "complete convert to 'Co-ed.'"[44] What lack of acceptance there was of women students appears to have come not from the academic community but from other young women not attending the universities.[45] Perhaps they resented the attention the newcomers received.

How did Michigan's pioneer women students experience college life? Except that they had no women role models on the faculty, their experience was not very different from that of their male peers. Unless their families lived in Ann Arbor, and few did, they arrived by train at the little town on the Huron River, sometimes accompanied by a family member and sometimes not, after a journey that often took more than twenty-four hours. Some, like Alice Freeman, had made prior arrangements with an Ann Arbor landlord or landlady for board and room. Others found a place in the several rooming establishments near campus. Almost all had roommates, for economy if for no other reason, and they usually boarded at the same household where they roomed. Occasionally, a group of students, both male and female, followed a practice long used by men of forming an "eating club," hiring a cook, and dividing the

expenses. Lucy Salmon was part of such an arrangement, while Alice Free-
man and Lucy Andrews were not.

All incoming students took entrance examinations unless they held
diplomas from Michigan high schools accredited by the university. Some,
like Lucy Salmon, were assigned "conditions" as a consequence of their per-
formance on the entrance examinations and decided to spend a year or two
at Ann Arbor High School getting themselves properly prepared in classical
languages and mathematics and acquiring the diploma that ensured their
entrance to the university without further examination. Others, like Alice
Freeman, risked making up the conditions while carrying the usual fresh-
man load.

Classes were large and classrooms crowded, especially before University
Hall opened in 1873. The classics curriculum in which most Literature
Department students were enrolled required first-year students to take Latin,
Greek, and mathematics and to complete one written exercise each week.
Botany was added in the second semester.[46] The emphasis on mathematics
and classics continued the first semester of the sophomore year, but then the
curriculum broadened. Rhetoric and English literature were added, and his-
tory could be substituted for mathematics. In the junior year physics and
chemistry were each taught for a semester, history remained an option, and
French and speech were available. All courses were elective in the senior year.
Political economy, Italian, philosophy, and American literature were all
added to the curriculum in the 1870s.

The medical and law schools, which women also attended, had briefer
terms and more rigid requirements. At President Angell's urging the med-
ical course was increased in 1877 from two terms of six months each to two
nine-month terms. The Law Department, however, continued to offer a
course of two six-month terms until 1882.[47] By 1880 women were also trained
in dentistry, that department having been established in 1875. One of the
early dentistry students was Alma Fullgruff, who later practiced in Berlin,
Germany.[48] All members of these faculties were also engaged in private
practice, and several lived outside Ann Arbor, commuting by train to the
university during the term.

The Medical Department faculty originally opposed coeducation and
insisted that the "only practical method for obtaining the objective sought is
be a complete course of separate instruction" for women students; it was sug-
gested that the faculty would be willing to instruct women's courses for five
hundred dollars extra compensation per course.[49] All the regents except
George Willard, the staunch supporter of women's rights from Kalamazoo,

voted in favor of the medical faculty's plan.[50] When eighteen women enrolled in the Medical Department in the fall of 1871, they were placed in segregated classes. But the medical faculty soon found this arrangement inefficient, and the regents were not eager for the extra expense. Segregated classes were abandoned after only one year, although women students in medical classes continued to be seated separately, and separate anatomy laboratories for women students were maintained until 1908.[51] Women medical students tended to identify with other women students on campus and were much more campus oriented than their male colleagues. They often joined campus organizations like the Student Christian Association and the Lecture Association.

In the 1870s women participated freely in most campus organizations. Fraternities were closed to women, of course, but fraternities did not yet dominate the Michigan campus. There were no fraternity houses until 1879, and only seven fraternities, all small, existed in 1870. The Junior Dance, known as the "J-Hop," was the most important social occasion of the college year; although it later came firmly under fraternity control, in the 1870s the J-Hop was still an all-campus event.[52] Women students did not participate in the occasionally violent "rushes" that characterized many student organizations. Lucy Salmon, attending her first chapel service as a Michigan student, reported witnessing the first rush of the year: "banisters were broken down, the floor was completely covered with hats, buttons, neckties, etc." The faculty members observing this scene urged the women students to confront the men, in hopes that their presence would stop the melee; it did. Salmon later commented that male students "are not nearly as bad as they used to be before the girls came [to Michigan]."[53]

Perhaps women students did help civilize the campus, but the dominant organized activities on campus in the 1870s were the relatively staid Student Christian Association, the Lecture Association, student publications, and class organizations. Women students played major roles in each of these groups. Women wrote for the *Chronicle* and the *Oracle*, the student newspapers. They played a very active part in the Student Christian Association, which met on a coeducational basis once a week in the largest lecture hall as well as in separate class meetings. Salmon commented that the sophomores in the spring of 1874 met after their astronomy class for half an hour, "informally" talking over the troubles or worries of the members.[54] Two women were among the eight officers of the association in 1875. Although women were not among the managers of the Student Lecture Association in the 1870s, they attended its events, which featured both women and men as speakers and panelists. Mary Livermore, a prominent suffragist, appeared as a speaker in the 1870s, as did E. L.

Goodkin, editor of the *Nation*.[55] Women consistently served as class officers in the 1870s, even in the Medical and Law Departments. Alice Freeman was an officer in Literary Adelphi, one of the two flourishing literary societies. Octavia Bates, later a prominent philanthropist and suffragist in Detroit, was an officer in the law students' Webster Society, as well as being vice president of the Law Department's junior class. Women students were always among the commencement speakers.[56] Women also founded their own society, the Quadratic Club, "for mutual acquaintance and improvement in science, literature and the arts."[57] The "Q.C.," as it was called, had its organizing meeting in Lucy Salmon's room.[58] Its sixteen members met once each week, responding to roll call with a quotation from an author such as Whittier, Ruskin, or Macaulay and proceeding to discuss "some high-minded question to sharpen our ideas," such as dress reform or the advisability of protective tariffs.[59] Lucy Salmon saw the club as ameliorating destructive interclass rivalry because all classes were represented. Also its members came from all over the United States. The method for selecting club members is not quite clear. Obviously, not every woman student could or did join, although the club democratically invited all "university girls" to literary exercises and a social in 1876.[60]

One of the ways in which the careers of women students differed from that of men was that women were much more likely to graduate. For example, in the class of 1876 the attrition rate for males was about 50 percent. All the women who entered the university with the group received degrees, except for two, who died before their studies were completed.[61] But this does not necessarily mean that women's college residency was uninterrupted.

Many students took some responsibility for their own support. Both men and women frequently left the campus for a semester to teach, and many had already taught briefly and saved some money before entering Michigan. Two women whose families suffered financial losses in the Panic of 1873 are good examples. Alice Freeman left school in her junior year to serve as principal of a secondary school in Illinois. As a senior Lucy Salmon became the manager of a male student boarding club, thereby acquiring free board.[62] Eight out of twenty women in the class of 1876 left the campus for some period during their college course in order to teach.[63] A good many of their male classmates made similar accommodations. Tutoring and coaching other students was another source of income for some students. Although in the 1870s Michigan's fees were very low, about $10 per year, it cost about $350 per year to attend the university . Thus, it could cost almost $1,400 to acquire a bachelor's degree, a considerable sum for a middle-class family of the time.[64]

By the end of the 1870s, 159 women had been awarded degrees from the

University of Michigan; 55 of them were in the Literature Department, 10 in law, 8 in pharmacy, 9 in homeopathic medicine, and 77 in the Medical Department. Six Literature Department graduates had taken a second degree, and 17 had completed the course in less than four years. This represented a formidable body of intelligent, trained women, most of whom soon found themselves integrated into the working world. For Literature Department women who did not marry immediately upon graduation, this usually meant teaching, either in the secondary schools or the new eastern women's colleges or state normal schools. A number of Michigan women taught at private academies or in public high schools. Because of the connections that stemmed from President Angell's accreditation work with the schools, he served as a very important employment agent for both undergraduates needing to earn money to continue at Michigan and for male and female graduates. In a study Lucy Salmon did in May 1879, 42 of the 55 women graduates of the Literature Department had been teaching at least part of the time since leaving Michigan.[65] Graduates Mary Marston, Lucy Chapin, and Katharine Coman went directly to Wellesley College to teach classics and history. May Sheldon, Alice Freeman, Lucy Andrews, Arlisle Young, and Lucy Salmon all taught briefly in secondary or normal schools before joining the faculties of women's colleges. Physician Eliza Mosher, an 1875 graduate of the Medical Department, was named the first superintendent of Massachusetts' new Sherburne Prison for Women. Most of the women physicians went into practice, as did the law graduates.

Women graduates regularly found jobs for one another. They maintained close ties with one another, with the Michigan faculty, and with their male classmates through frequent correspondence and social visits. The Michigan connection continued to function throughout their lives. Wellesley students, led by their Michigan-trained professors, journeyed to nearby Sherburne Prison to put on special holiday programs for its inmates. President Angell was a commencement speaker at Wellesley College and served on its Board of Visitors. His former students from Michigan still cherished his advice. Professor Martin D'Ooge, who taught many women students Greek and classics, served on the Board of Managers of the American School of Classic Studies at Athens, one of the great nineteenth-century consortia devoted to further academic knowledge. As president of Wellesley College, Alice Freeman Palmer, who had studied under D'Ooge at Michigan, led Wellesley into membership in the American School, making Wellesley the first women's college to participate.

This networking, mutual help, and recognition of expertise and opportu-

nities provide evidence of the degree of acceptance experienced by women students at Michigan in the 1870s: faculty, students, and administrators were all part of the "Michigan connection." Indeed, there were no hard and fast barriers between the sexes for students at Michigan, either in their student days or in their later professional lives. The only exception was the very small fraternities, whose influence was limited. Women felt as empowered as their male colleagues. They were unafraid and uncowed. They could do the work, command respect, and look forward to substantial professional accomplishments, which many of them realized. In the 1890s when these women were early middle-aged and replete with honors, a campus publication the *Castalian*, which usually honored prominent faculty with biographical sketches and portraits, published a series of sketches on the women students of the 1870s, including Alice Freeman, Eliza Mosher, and Octavia Bates. The articles paid tribute to the women's lasting influence on the university.

Women joined the University of Michigan community in every capacity except one; they did not become part of the senior faculty. As the number of women undergraduates and professional degree candidates grew in the 1870s, however, they did find instructional and other jobs at Michigan. In 1877 Kate Crane, Ph.D., became an accountant in the clinical laboratory, and M. L. Farrand was hired as the only assistant to the university librarian.[66] Although many newly graduated women were employed at Michigan, they were excluded from the most important positions—those on the university faculty. This pattern would continue for nearly a century.

Chapter 3

Change and Redefinition

Throughout the 1880s women's roles in the University of Michigan community seemed not to change appreciably. Women continued to be active in all campus organizations except fraternities, men's musical societies, and athletic clubs. They not only attended classes with their male confreres in all departments, except engineering, but they also served as class officers, joined the literary societies, and wrote for student publications. Nor did their numbers change much proportionately. Women remained approximately a third of the Literature Department's graduates, as they had been in the late 1870s. They were accepted as peers and equals in the Michigan community and "treated with the utmost courtesy and consideration."[1] Ora Thompson Ross (Lit. 1880) later recalled how she cherished "the free and uncensored existence led by women students in those days."[2]

By 1900, however, substantial change had taken place. Not only had overall university enrollment increased markedly, but women constituted 47 percent of the Literature Department enrollment and outnumbered men in the graduating class. At the same time, women's numbers had dropped significantly in medicine, and women had almost disappeared from the Law Department. The law faculty's attitude toward women is exemplified in a lonely woman student's comment that "during my years at Michigan, the Law School offered no encouragement to women students . . . This was not the case with men students."[3] Women were conspicuous only by their absence from engineering, in which they never gained a real foothold. Even the engineering mathematics classes in the Literature Department were unwelcoming to women. Elsie Hadley White (Lit. 1890) wrote: "Ruth Gentry and I were the only girls in a large class of engineers. We had front seats and left the room first. I never did see the faces of those young men in class."[4] Yet a lone woman, Marian Sarah Parker, graduated in engineering in 1895 and practiced in New York City until 1906. She served her firm by designing the steel framework for a number of turn-of-the-century projects, including the Flat Iron Building and the Waldorf Astoria Hotel in New York.[5]

Concomitantly, women were rapidly organizing their own separate society. By 1900 there were two communities at the University of Michigan, one composed of women, the other of men, and, while the two continued to meet in some classrooms (mainly in the Literature Department), their extracurricular lives were almost completely divided. This separatism increased rather than diminished during the next two decades.

This phenomenon was not unique to Michigan but took place also at the University of Chicago, Stanford University, and the University of California.[6] At first glance much of the initiative for segregation seems to have come from the women. On coeducational campuses they began to demand separate organization, special housing, and women's buildings. But these demands were in many ways reactive, because in the 1890s women were slowly but surely being excluded by men from campus activities and sometimes from the campus itself.

As the numbers of women increased on coeducational campuses at the end of the century, male bastions of power panicked. By 1900, 40 percent of college students were women, who flocked to the liberal arts, while men in large numbers ceased to major in the humanities.[7] The sea of female faces in languages, literature, and classics courses alarmed male professors and administrators. They also found threatening the number of women whose scholastic performance was superior. Women outnumbered men among the students being initiated to the Phi Beta Kappa honor society at the University of Chicago, and in 1910 at Michigan twenty-two women but only thirteen men were inducted.[8] One contemporary student of higher education at the turn of the century commented that "in coeducational institutions . . . Phi Beta Kappa is apt to be monopolized by the more diligent sex and goes by the name of 'the woman's club.'"[9] William Rainey Harper, president of the University of Chicago, feared that his new university was being feminized, and with the backing of much of his senior faculty he proposed that women students be separated from men in the classrooms for the first two undergraduate years. Stanford University, with the blessing of Jane Stanford, imposed a quota on the number of women to be admitted. Although women had been on campus since 1872, Wesleyan College banned them altogether in 1908. Tufts University, Rochester, and Western Reserve University put women students in separate coordinate colleges.[10] Michigan was hardly immune. Separatism was a device the male establishment could use to control what they saw as the inundation of campuses by women and the subsequent feminization of universities.

Largely because of President Angell's enlightened leadership and his deep commitment to the higher education of women, Michigan's response to the increasing number of women students was measured and moderate. In

1893, when the number of women in the Literature Department increased in one year from 33 to 37 percent, Angell warned that in a generation college-trained women could outnumber men. But he added that he felt this would be socially beneficial and reminded the university community that "women have uplifted" the level of secondary education, particularly west of the eastern seaboard. Nonetheless, he suggested that henceforth "boys" needed to be stimulated more than "girls" to participate in higher education.[11]

In 1900 Angell used a goodly proportion of his annual report to assess the results of three decades of women's admission to Michigan. No doubt he was attempting to allay some of the fears arising from Michigan's coeducation "experiment." He called the increase in the number of women getting college training "one of the most striking educational facts of our time." He saw the motivations of women students changing: a generation earlier almost all women students were preparing for a professional career, he said, but now a considerable number studied merely for the sake of acquiring culture that would "enrich and adorn their lives." Was Angell trying to soothe the fears of the all-male Board of Regents by gently suggesting that women were no longer a threat? In fact, women themselves began to see studying at the university as a social asset rather than primarily as professional training. One alumna saw it as "an excellent marriage bureau, bringing together two people of similar education, tastes, and friends."[12] Angell implied that women were not the competitors of the male student; they simply wanted the "polish" of a university education that would enable them to gracefully serve on volunteer committees and improve the dinner parties that aided their husband's careers. Angell also mused almost nostalgically, however, at the accomplishments of Michigan women graduates over the past thirty years. He saw the 394 women who had graduated from the Medical Department as successful in the practice of medicine, including "a few in surgery." They had been accepted in the medical societies and had made large contributions to foreign medical missions and to institutional medicine in women's prisons, reformatories, and schools. Michigan women had also done well in the practice of dentistry. Although they had not been accepted as practicing pharmacists except in institutional settings such as hospitals, many had offered their services to manufacturing chemists. In law the numbers of women students had always been small, and very few had made their careers in court practice. Some female law graduates had become teachers of history or political science, but President Angell feared that women would never find the practice of law congenial or remunerative. The vast majority of trained women had, of course, become teachers, and Angell remarked on the very credible record of Michigan graduates in

this area, of which he was obviously proud.[13] In 1903 President Angell noted that the debate on coeducation had been reopened nationally, with some universities again experimenting with separate instruction for women, but he added that he saw no need to reconsider the question of the admission of women to the University of Michigan. [14] Still, fears about women students' success were sufficient to provide some of the impetus to create an increasingly segregated university community at Michigan.

Male students, perhaps more than faculty or administrators, were determined to control campus activities, and this was a new development. Earlier men had been welcoming to women. Now they seemed to need to keep them out of student affairs. Why this change? As the enrollment of women increased, male fraternities also grew in number and strength. By 1895 there were twenty-one fraternities at Michigan, three of which were new chapters that appeared between 1891 and 1895. In 1879 there had been only seven chapters, with no residential houses and tiny membership rosters. By 1890 large fraternity houses dotted the outskirts of the campus; Psi Upsilon had forty-seven members, and Alpha Delta Phi had twenty-seven. The fraternity bloc continued to grow. By 1920 there were thirty-two social fraternities at Michigan, most of them residential.[15]

From 1852 to 1936 the University of Michigan had no men's dormitories. Men who did not live in fraternities were housed in rooms rented by private landlords scattered throughout the east side of Ann Arbor. In contrast, fraternity members not only lived in residential chapter houses, but all fraternity men joined together in publishing the *Palladium*, a glossy yearbook, as well as in sponsoring the J-Hop and other social activities. In fact, fraternities took over the J-Hop in 1886. They had a residential base and the organizational strength to dominate campus extracurricular life. There were five sororities in 1890 with fifty-five members, and in 1915, when the first women's dormitory opened, there were fourteen sororities, thirteen of them with houses. By the time that sororities grew strong, however, fraternities already controlled most organized campus activities. The growth of Greek societies greatly weakened the literary societies to which both women and men had belonged and which had experienced great popularity after women arrived on the Michigan campus in the 1870s.[16] By the turn of the century at Cornell and Wesleyan fraternities were even stronger than at Michigan. At Wesleyan 90 percent of the male students belonged to Greek societies, and at Cornell they completely ran the campus and did not permit their members to speak to "coeds." Women students were not even allowed to attend class meetings.[17] The effects at

Michigan were not so severe, but undoubtedly the fraternities' increasing strength and power threatened women's position on campus.

Another factor that contributed to separatism was the increasing conservatism and growing professionalism of higher education by the turn of the century. Curricula were rapidly being solidified, faculty rank and qualification carefully defined. Scholarly research increasingly replaced other goals as the aim of the university faculty. Although resisted by President Angell, the first hints of academic bureaucracy were appearing. Presidential and departmental authority increased as the size of the faculty grew. By 1900 the doctorate was emerging as the crucial credential for young scholars, while many older faculty based their scholarly qualification on much less formal criteria. The professionalization of academia was almost complete.[18] While the 1870s had been a time of experiment and flexibility in higher education, the turn of the century saw increasing rigidity in admission and graduation requirements, curricula, and professional qualifications.

At Michigan, for example, the medical course in 1870 consisted of two six-month terms. In 1891 medicine became a four-year course, with classes lasting a full nine months and many of the medical faculty devoting most of their time to teaching and research rather than to private practice. The Hygienic Laboratory, forerunner of both the Department of Epidemiology and the School of Public Health and headed by Victor Vaughn, who also headed the Medical School, conducted pioneer research work in the control of contagious diseases. The university was being professionalized.

In the nineteenth century women in medicine clearly understood they were entering a service profession. They may have yearned to be scientists, but first of all they had to meet practical needs. In 1923 Susan Anderson (Med. 1897) wrote to her alma mater that she was still in debt for her education, practicing in Frazer County, Colorado, for people who were very poor. Her income was four hundred dollars per year.[19] The case has been made that increasing professionalization within the universities and the growing emphasis on science and research in medical education specifically jeopardized women's positions as medical students. [20] In fact, President Angell and Dean Vaughn both expected enrollment of women to drop abruptly in 1891 when the medical course was lengthened, but this did not happen immediately.[21] In 1893 fourteen of forty-seven graduates of the Medical Department, or nearly 30 percent, were women. By 1905, however, there were only two women in the medical school graduating class of sixty-one students.

Another factor encouraging gender separatism was a strong sense of

community among the women themselves. Lynn Gordon has argued convincingly that the turn-of-the-century separatism, in part a response to the increasing exclusion of women from men's campus activities, was also a positive statement by women themselves about gender distinctness.[22] Educated, middle-class women were building separate communities throughout the country, in the rapidly growing women's club movement, the settlement houses, and on the campuses. Michigan was no exception. These new female communities encompassed a strong belief in a special mission for educated women, and women were increasingly active in establishing their own on-campus communities, with organizations and activities that paralleled many of those dominated by male students. At Michigan the men's Board in Control of Athletics had its counterpart in the Women's Athletic Association, the all-male Senior Banquet in the All-Women Freshman Spread, and the men's Waterman Gymnasium in the women's Barbour Gymnasium. At the same time, both men and women increasingly emphasized organized extracurricular activities because they saw them "as preparation for professional, business and civic leadership" after college.[23] By 1900 addressing civic and social responsibilities through voluntary associations was an acceptable avenue for applying women's talents in the public sphere, and Michigan women were active in developing their own organizations to promote civic virtue and social improvements.[24]

Although less important at the University of Michigan than nationwide, the growth of certain feminized professions was also a factor encouraging separatism. At the turn of the century college and university programs in sanitary science burgeoned, later evolving into domestic science and eventually home economics. The students and the faculty of these new departments were predominantly female. But from the beginning the State of Michigan considered this type of training the responsibility of Michigan State College, rather than that of the University of Michigan. At Cornell, where a quota on the admission of women had been established, courses in "home economics" were excluded from the quota system and developed autonomously after 1900, removing many women from the mainstream of the university but giving them unrestricted use of a separate space.[25] At the University of California at Berkeley domestic science courses appeared in 1912 and helped to foster a separate women's community.[26]

Several new professions dominated by women—social work, library science, and professional nursing—began to appear. Training for the rapidly growing field of librarianship, heavily female early in the century, came late to

the University of Michigan. A few courses were offered in the summer session until the Department of Library Science was organized, in 1926.[27] Social work training, which was pioneered by an independent professional school later attached to the University of Chicago, only appeared on the Ann Arbor campus in 1921, and a separate school of social work was not organized until 1951.[28] Nursing was the exception to Michigan's slow response to training in the feminized professions. In 1891 the regents authorized the medical faculty to establish a training school for nurses in connection with University Hospital, and in June of 1894 the school graduated its first class of ten, all women. Its students continued to be exclusively women until 1970. But overall, training for the feminized professions was either late in its arrival to the Michigan campus or, in the case of home economics, did not appear at all.

Meanwhile, the professional schools separated themselves more completely from the Literature Department and raised their standards. Law became a three-year course in 1896. Engineering formed an independent unit in 1895, which meant that engineering students no longer took science and mathematics courses with liberal arts students. While the number of women increased proportionately in the liberal arts, they almost disappeared from the professional programs, except nursing, which were the fastest-growing units of the university. Because their huge enrollments were largely male, women were never the numerical threat to the professional schools that they were at the University of Chicago, for example.

Perhaps an exception to this growing separatism occurred in graduate education. Women pursued graduate degrees almost as soon as they appeared on campus. Inez Blanche Slocum received a master of arts degree upon examination in 1874.[29] Lucy Andrews and Alice Freeman both did graduate work in the 1870s, although neither completed graduate degrees.[30] Lucy Salmon, another member of the class of 1876, returned to campus in 1882 after several years of teaching and earned an M.A. degree in history.[31] The university's first advanced public health degree in hygiene was awarded to Edna Day in 1897.[32] Women continued to maintain their place in graduate studies at the University of Michigan throughout this period of growing separatism.

By 1900, 144 women had earned graduate degrees from the University of Michigan. In 1897, 13 women received master's degrees, and Mary Gilmore Williams (Lit. 1895) received a Ph.D. degree in Latin. Nine of the master's degree candidates specialized in the humanities, mostly in Latin and history, but 1 woman received a master's degree in bacteriology, and 2 women were among the 4 master of science candidates.[33] In the first years of the new cen-

tury women continued to receive large numbers of master's degrees. In 1903 the M.A. degree was conferred upon 14 women and 16 men, but no women received the M.S. degree, although 2 received Ph.D. degrees.[34] In the last quarter of the nineteenth century the master's degree usually qualified men and women for teaching in some form of higher education, and a large proportion of graduate students, including many women, went on to teaching careers at both the high school and college levels.

The development of students' extracurricular activities in this changing environment illustrates the growth of separatism. The division of the University of Michigan campus into two separate gender-based societies was not accomplished so much by the segregation of existing clubs and structures as by the creation in this period of new institutions. The Student Christian Association (SCA) had never previously excluded women or divided them into separate sections. In 1885, with 730 professing Christians on campus, over 300 paid dues to the organization. The SCA had subsidiary organizations in all departments, each with its own weekly prayer meeting. In fact the SCA had so many meetings every week that it used not only its own rooms but also the rooms of the literary societies. Yet by the 1890s men were already abandoning the SCA. According to Alice Hamilton, who graduated from Michigan's medical school in 1893, "a man loses caste as soon as he goes into it [the SCA]."[35] Ironically, by the time the SCA's own building, Newberry Hall, was completed in 1891, its central importance in the religious life of students had been challenged by newer gender-segregated organizations, such as the Young Men's and Young Women's Christian Associations. In 1916 the university YMCA erected its own building, Lane Hall, three blocks north of Newberry Hall on State Street.[36] This development was not universally welcomed: as one alumna lamented, "I am very sorry to know that SCA has been split into the YMCA and the YWCA, as the SCA was so potent in the good old days."[37]

Before 1906, when the first student council was formed, such student government as existed was encompassed in each department's classes. Every class elected officers whose chief tasks involved the supervision of social and athletic events, with the senior classes in the various departments taking a large share of responsibility for graduation ceremonies and festivities. In the early 1880s women students served as class officers as frequently as men, given their representation in the student body. As late as 1885, eight women were elected class officers in the Literature Department, two in medicine, one in law, and two in dentistry.[38] Women still appear on the roster of class officers in 1910 but in no greater numbers than they had in 1885, despite the proportional increase in women students in the Literature Department. Only three among thirteen

officers of the senior literature class were women. Although women consti-
tuted 43 percent of the students, all the student committee chairs were men.
Women still appeared on some of the committees, but the most important
ones, like the executive committee, were all male.[39] The senior medical stu-
dents, with only two women in the class, made one of them the class poet and
the other the class prophet. Neither office conveyed much political power,
but at least women were recognized as part of the class.[40] The dentistry stu-
dents elected the only woman in their class as its secretary. By 1910 there were
no women in the graduating classes of law, pharmacy, and engineering.[41]
More significant was the fact that class organizations were no longer the chief
vehicle through which student activities were organized and individual stu-
dents made their impact on the university community. The new campus-wide
Student Council was male, as was the new center of much university social
activity, the Michigan Union building; the Women's League, which was the
focus of many women students' social activities, was still without a permanent
campus home.

In the autumn of 1889 women students established their first separate orga-
nization after the short-lived Quadratic Club of the 1870s. Calling themselves
the "Fruit and Flower Mission," a small group of women defined the task of
doing volunteer work in the university's hospitals. Open to all women students,
the mission operated under an executive committee that met on Saturday
mornings. On Sundays members visited the hospitals to read to and talk with
patients and to distribute small gifts of fresh flowers and fruit. Occasionally, the
club was able to give patients small amounts of financial assistance.[42] By the
1890s women had both been forced and had chosen to take a separate route.

A good example of how women's exclusion from male activities and the
need for a women's community encouraged gender segregation at the Uni-
versity of Michigan arose in the realm of athletics. Sports had been informal
(although sometimes intercollegiate) and largely unorganized at Michigan for
decades. But by the 1880s an Athletic Association and its board of directors
were in charge, setting schedules, supervising training, and raising money to
pay the expenses of the teams.[43] By 1895 the Athletic Association had become
an official body composed of five members of the University Senate (senior
faculty) and four students chosen by the Student Athletic Association. This
group also set standards of scholarship and academic achievement for com-
petitors.[44] The first primitive gymnasium located behind the south wing of
University Hall opened in February 1886, but it was unclear whether women
students would be allowed to use it. The *Chronicle* reported that some groups
opposed women's use of the gym but declared that it supported access for

women. A number of women students sought access to the facility, and finally two hours each day, 8:00 to 9:00 A.M. and 1:30 to 2:30 P.M., were "set aside for ladies"; women students quickly organized an executive committee to make and enforce rules for the gym during these periods.[45]

Waterman Gymnasium, the university's first facility built specifically for athletics, was completed and opened for use in October 1894. At the time Joshua Waterman made this gift to the university he told the Detroit chapter of the Collegiate Alumnae Association that he intended its benefits for both men and women students.[46] When the gymnasium was completed women students were allowed to use it during the morning and men in the afternoons and evenings. President Angell proudly told the Board of Regents that no classes were scheduled after 4:00 P.M. so that faculty and students could exercise.[47] He failed to report that women's access to Waterman Gym was scheduled at the same time as many morning classes. Yet the president did emphasize the need for a separate women's athletics building. Generous gifts from Regents Levi Barbour and Charles Hebard provided much of the necessary funding, and construction on a women's facility, named for Levi Barbour, was approved in 1895.[48] While effectively excluded from the first athletic facility, women students were to be given a facility of their own. Much the same pattern can be seen in the case of Ferry Field, which Dexter M. Ferry said he donated to the university for the use of both sexes but which male students monopolized to the exclusion of women. The Women's League, a growing booster organization with considerable alumnae support by 1908, proposed taxing each male student a quarter to raise money to buy land for women's playing fields.[49] With contributions from women alumnae and others, the university eventually acquired Palmer Field for use by women's athletic groups.

Completed in 1896, the Barbour Gymnasium provided women students with an on-campus space for their exclusive use for the first time. The democratic co-use of such facilities as the university possessed, which had marked the 1870s and 1880s, was at an end. Barbour Gym was much more than an athletic facility. It was to be the focus of women's activities on campus for over thirty years. Dorothy McGuigan wrote that in autumn upper-class women of the Women's League, after meeting at the Barbour Gym, sallied forth from its doors to the Ann Arbor train depot to meet incoming first-year women students and to help them find their way to boarding houses and around the campus. In the parlors of Barbour Gym male students could be entertained, and over the coal stove in the building's basement cocoa and fudge could be made; McGuigan adds, "there was a splendid auditorium on the second floor,

and in a day when Ann Arbor rooming houses provided a bowl and a pitcher for washing facilities, the women's building boasted not only a dozen gleaming porcelain tubs, but a beautiful little white tile swimming pool. The whole building, its red brick set with cathedral windows and turrets, its interior lined with varnished golden oak, was a gem of McKinley baroque."[50] Barbour Gym was also the place where women students from the various schools and departments could meet one another. Fannie Dunn Quain (Med. 1898) remembered "the happy times when we forgot work and played with the girls of the Literary Department at the gymnasium, vaulting, jumping, and running races on the track."[51]

Women students and alumnae used the Barbour Gymnasium facility to reinforce and enhance their own separate community at Michigan. The Women's League met in the auditorium. All-female dances were frequently held there. The Women's Athletic Association was organized to utilize the gym's facilities and was open to all women students who paid dues of fifty cents per year. Soon women organized baseball, hockey, and basketball teams with regular schedules.[52] Women embraced with enthusiasm the separatism that had been at least partially forced upon them.

One result of the new separatism at the University of Michigan was the enhanced social role of the wives of Michigan faculty members. At the University of Chicago and other campuses on which women faculty played a greater role in the formation of a women's community, faculty's wives were less crucial. Michigan women had almost no female role models on the faculty and none among the senior faculty. At first they seem not to have missed them. The women students of the 1870s identified with male faculty and with their fellow students, and there is no evidence that they looked to the wives of their professors as arbiters of their lives. As students, Alice Freeman, Lucy Salmon, and Eliza Mosher had responded to the male power structure rather than to the shadow world of faculty wives and daughters. They recalled Professor D'Ooge and President Angell as proffering them invitations to academic study and providing social opportunities. There must, of course, have been some interaction between professors' wives and campus women during this period. Charles Kendall Adams's wife certainly supervised the preparation of the Christmas dinner to which he invited his student, Alice Freeman, in 1874.[53] But women students in the 1870s and early 1880s rarely talked or wrote about faculty members' wives or their interactions with them, nor did they enlist these women's help in any way. Their focus was on their professors, who were the instruments of their success and with whom they identified.

This lack of attention to faculty's wives changed almost over night in the

1890s. They began to figure prominently in press notices and student publications, identified of course by their husbands' names. They served as sponsors, patronesses, and helpers of the new women's community, including the Women's League, the Women's Athletic Association, the sororities, and even class events, which had become quite segregated by this time. Faculty's wives became an integral part of the women's campus community in the 1890s, although it was not until 1921 that the Faculty Women's Club was organized; it included both faculty members' wives and the few women on the University of Michigan teaching staff.[54] This pattern persisted until World War II.[55] For example, when the Michigan League was organized in 1890, faculty's wives were called upon to play significant roles. The initial organizational meeting of the league included faculty's wives and women students. The wife of the university president, Sarah Caswell Angell, presided at the League's first general session, and membership was open to "faculty ladies," the wives and daughters of Michigan faculty members, as well as women students. Its first "social" was held in the homes of Mrs. Martin D'Ooge and Mrs. Bradley Martin Thompson, and faculty's wives regularly set aside "afternoons" for student callers. In fact, when Juliette Sessions (Arts 1893) was president of the League and Susan B. Anthony visited Ann Arbor to see an old friend, Sessions took advantage of Anthony's visit to ask her to address women students at Michigan. She was firmly rebuked by the faculty's wives for not consulting them in advance and for doing a political thing, which appeared to commit the League to the cause of women's rights.[56] It also became fashionable for faculty members' wives to attend the classes of professors who were popular with women students.[57] Edith Ellen Petee (Lit. 1905) recalled "the remarkable spirit of the faculty ladies who year after year made welcome the new crop of timid girls who came to Ann Arbor. They called on us and invited us to their homes, and in every way showed the tireless spirit that gave Ann Arbor its homelike atmosphere."[58] More than one university woman of that period mentioned Sarah Angell as having a lasting influence in her life.

Faculty members' wives became so important to women students largely because there were few women faculty and no senior women professors to serve as role models. The greatest number of women faculty in higher education was earlier in 1879–80, when they constituted over a third of all academic personnel, a share that had dropped to 22 percent by 1962.[59] In the nineteenth and early twentieth centuries women with scholarly ambitions and a real mission to do research or teach had to content themselves with positions in the women's colleges, small coeducational (often church-related) colleges, or teachers' colleges. Women also received token acceptance as faculty in the

new land-grant universities of the Midwest, including Minnesota, Iowa, and Wisconsin, where their professional duties were largely confined to the new feminized professions.

Although Ezra Cornell had declared in 1874 that there would be no obstacles to hiring women faculty at Cornell University and that "merit as a teacher will be the test," women were employed there only on the faculty of the school of home economics. No woman joined the tenure track in Cornell's College of Arts and Sciences until 1947, and there were no women professors there until 1960.[60] Lucy Salmon was offered a position in history at Wisconsin in 1892, but she chose to remain at Vassar.[61] In 1895 the University of California at Berkeley had one woman fellow. California acquired no female full-time faculty until Jessica Peixotto was appointed instructor of economics, in 1904.[62] Louisa Reed Stowell became an assistant in microscopical botany at Michigan in 1877 and continued to serve in that capacity for over a decade.[63] By 1885, in addition to Stowell, one woman worked as a clinical assistant in dentistry, and another was the dispensing clerk in the chemical laboratory.[64] Alice Hunt was hired as an assistant in drawing by 1890, a position she was to hold for over twenty-five years, and Vida Latham was an assistant in pathology. But there were forty-six full professors at that time and not a woman among them.[65] One bright female Literature Department student reported, "at the Senior Reception Professor Hudson said, 'If you were only a man I'd ask you to come back as my assistant in history next year.'"[66] Women students appreciated the few opportunities they had to work with women mentors. Fanny Read Cook (Lit. 1890) described later how much she had admired Mrs. Stowell, who taught her microscopical botany.[67]

In the early 1890s women were consistently employed as assistants in the medical school and in the sciences, especially botany, then considered "the ladies' science." Pay for these faculty assistants ranged from one to three hundred dollars.[68] Women were more successful in the sciences, in which busy professors wanted inexpensive assistance with demonstrations, laboratory work, and clinical teaching, than in the humanities, in which most of the instruction was by lecture. In history or Latin scholarly production and research was done by the individual scholar and not in a laboratory, where technical assistance and scholarly cooperation were the rule.

Because of the university's failure to appoint women to full-time academic positions, faculty organizations remained exclusively male. In 1900 the Research Club was founded to provide an opportunity for faculty to share professional work and interests. No women were on its rolls until 1955. In 1902 a junior faculty research club was formed; women assistants petitioned for

membership but were refused. A month later they formed the Women's Research Club with Lydia De Witt, instructor in histology, as president. Within a few months it had a membership of eleven.[69]

By 1892 agitation was building, particularly among women alumnae, to have women represented on the University of Michigan's regular faculty. In October 1891 women alumnae asked to be allowed to raise funds that would be used to pay the salaries of women faculty elected by the regents. The University Senate, composed of all the full professors, resolved not to consent to any such arrangement. Some funds were raised, but without regental approval the women did not release the funds.[70] President Angell continued to explore the question of women faculty, and there is no evidence that he was unsympathetic. In January 1892 he wrote to the presidents of a number of midwestern universities and the women's colleges asking for their reaction to the appointment of women as faculty. The reply of James H. Ganfield, chancellor of the University of Nebraska, was typical. Ganfield said he had "never found the slightest inconvenience whatever arising from having professors of both sexes," including having men subordinate to women.[71] Nothing was done, however, probably because of the opposition of regents and current faculty, and the University of Michigan continued to train women but not to hire them. Nonetheless, women, especially alumnae, continued to agitate and raise money. Mrs. T. W. Palmer of Detroit gave ten thousand dollars toward an endowed chair.[72] Others gave smaller sums. The question of having women on the Michigan faculty was also a lively issue among students. During the winter of 1895–96 the *Castalian*, a student newspaper, conducted a symposium on the question of women faculty. All seven of the college presidents asked to contribute supported the appointment of women. Henry Wade Rogers of Northwestern University reported that his institution had a woman as chair of romance languages. President Angell said he favored appointing women, as did alumni representatives.[73]

By this time Angell was actively seeking a woman professor for a new university position, that of dean of women. He first attempted to lure Alice Freeman Palmer back to her alma mater, offering both her and her husband, the Harvard philosopher George Herbert Palmer, faculty appointments at Michigan. George Palmer rejected this offer as resolutely as he had earlier rejected a similar one from the new University of Chicago.[74] Angell's next choice was Katharine Coman (Lit. 1880), then professor of political economy at Wellesley College. Coman replied to Angell's offer acerbically, "if the Regents . . . wish to propose a chaperone for students, and propose to dignify that office by allowing the woman who holds it to do a little University teaching," she was

Madelon Stockwell, the first woman admitted to the university, in 1870, was "the target of curious stares, of pointed fingers, and whispered remarks." *(UM Photographs Vertical File, BHL.)*

In the 1880s Ann Arbor's private boardinghouses, such as the Misses Gray's, accommodated both men and women. *(H. J. Crosby Collection, BHL.)*

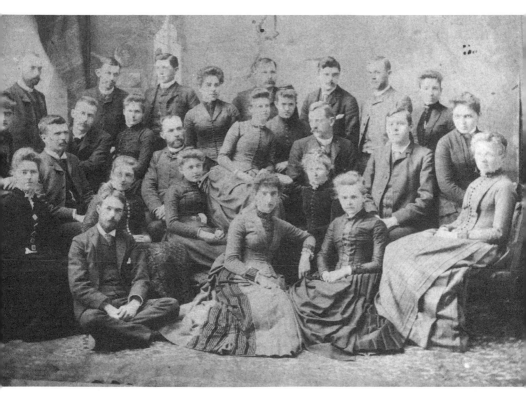

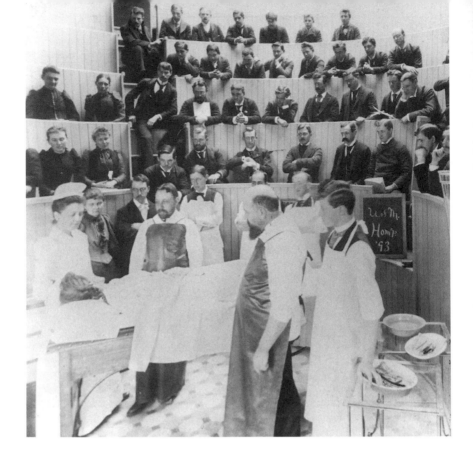

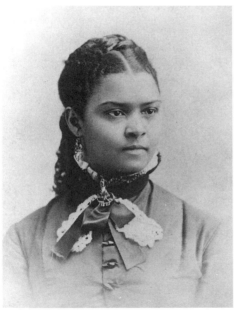

In the late 1870s Michigan's Medical Department abandoned plans for a separate women's curriculum, but gender segregation remained in some facilities as did seating in coed classes. *(Alumni Association Records, BHL.)*

Mary H. Graham, believed to be the first African American woman admitted to the university, completed a Ph.B. in 1880. *(UM Student Portraits Collection, Box 4, BHL.)*

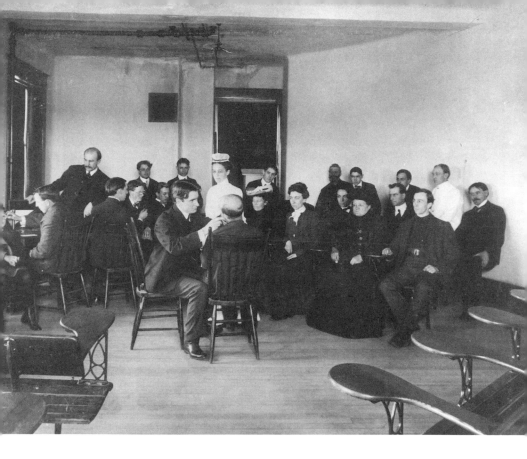

Between 1870 and 1900 the
Medical Department graduated
nearly four hundred women,
including many with specialized
skills, such as surgery and
opthalmology. *(UM Photographs
Vertical File, BHL.)*

Alice Hamilton, pioneer in
environmental and industrial
medicine, graduated in 1893. In
1919, when hired by Harvard
University, she commented, "Yes, I
am the first woman on the Harvard
faculty. I'm not the first woman
who should have been appointed."
(BHL.)

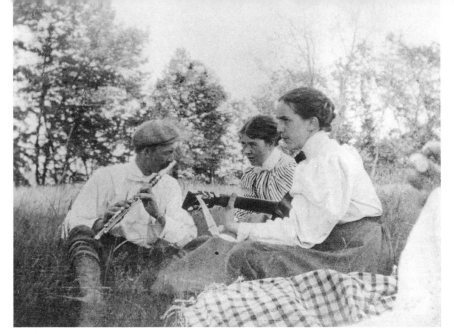

Coursework and university activities occasionally gave way to informal campus picnics; long after graduating from Michigan one alumna recalled "the glorious places around Ann Arbor to picnic and enjoy the great out-of-doors." *(UM Photographs Vertical File, BHL.)*

Collegiate Sorosis members outside the Sorosis house in 1908. By the early 1900s women students' social lives increasingly centered on separate societies, clubs, and boardinghouses. *(D'Ooge Scrapbook, BHL.)*

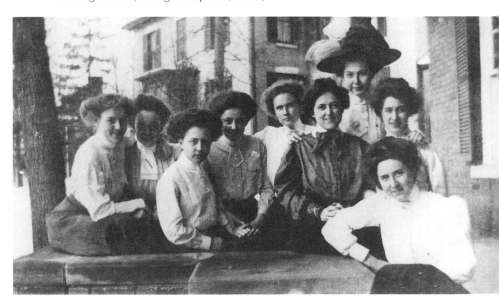

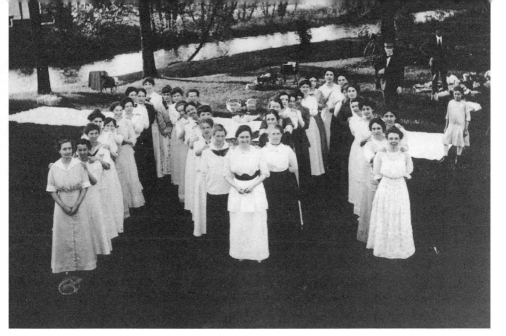

The "Michigan Dames," a group of faculty, graduate students, and wives established in 1914–15, showed their support for Michigan during an afternoon outing. (*UM Photographs Vertical File, BHL.*)

Nursing students from Michigan's homeopathic hospital tend a "victory garden" on the hospital's lawn during World War I. (*M. V. Mann Collection, BHL.*)

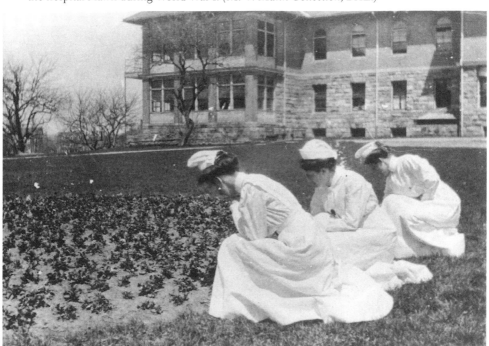

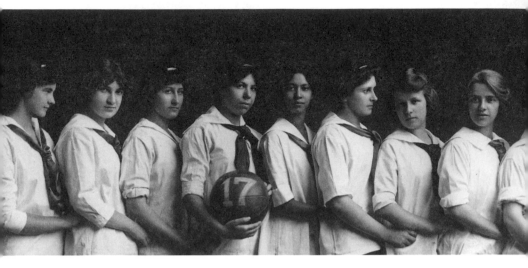

The construction of the Barbour Gymnasium in 1896 enabled women students to take physical education courses and to play sports, including basketball. *(UM Photographs Vertical File, BHL.)*

By the 1920s more than a quarter of all Michigan graduates were women. Then, as now, women were more likely to graduate than their male peers. *(Alumni Association Records, Box 137, BHL.)*

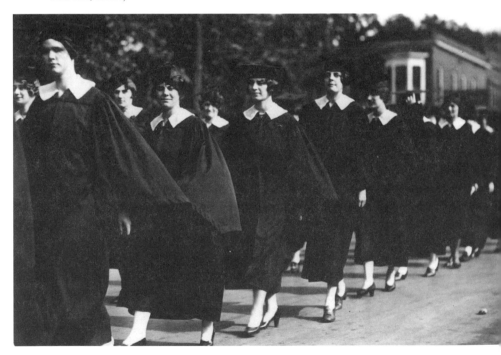

"Most beautiful of all traditional Michigan ceremonies, [Lantern Night] was staged with pomp and ceremony. . . . The Freshman Pageant this year was titled 'The Cycle of the Seasons' . . . which told the story of Persephone's visit to the underworld." *(Alumni Association Records, BHL.)*

Raising money for a women's social center on the Michigan campus was the principal activity of alumnae in the 1920s; proceeds from sales at this shop in Grand Rapids helped support the construction of the Michigan League. *(Alumni Association Records, BHL.)*

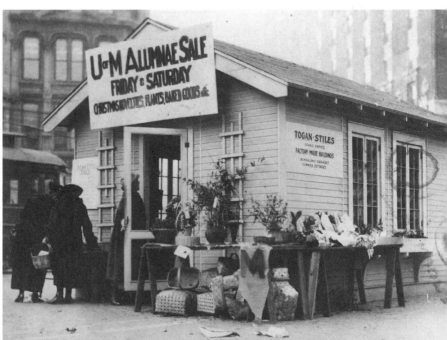

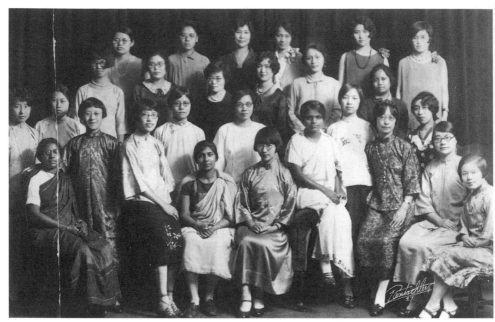

A group of "Barbour Scholars," 1927. An endowment from Regent Levi Barbour brought women students from various Asian countries to campus. *(Alumni Association Records, BHL.)*

One woman graduate, when asked about memories of Ann Arbor, recalled "the Huron River in spring, when it was almost crowded with canoes." *(Alumni Association Records, BHL.)*

not interested. If, however, the regents had truly recognized the fitness of appointing women to Michigan's faculty, she might come, if she were one of several women who were given proper authority and rank.[75] Angell's reply has not survived.[76] Coman formally refused Angell's reply in July 1895.[77]

Angell then turned to another Michigan graduate, Eliza Mosher (Med. 1875). Mosher was a respected Brooklyn practitioner who had taught briefly at Wellesley and Vassar and had served the State of Massachusetts as superintendent of a women's prison. Mosher hesitated. She had serious doubts about accepting the faculty position. Early women graduates of Michigan were far from certain that women students needed a special guiding hand, nor did they wish to take a chair that was clearly designed for a woman. They expected to be equals in an equal society, and Mosher wanted a professorship in the University's Medical Department. Victor Vaughn, the head of the department, demurred. Vaughn and Mosher had been classmates at Michigan, and he surely knew her. During her second year as a student she had been appointed assistant demonstrator in anatomy under the aegis of Alonzo Palmer and taught everyone in the class. In Vaughn's autobiography neither Mosher nor any other women (including his wife) are mentioned, although Vaughn did hire several women in junior positions during his tenure.[78] Perhaps he knew Mosher too well. She was strong-minded, confident, and accustomed to being in charge.

On 30 October 1895 President Angell made Mosher the best offer he could obtain for her: the position of dean of women with the rank of full professor in the Literature Department, with opportunities to lecture on hygiene to students of both sexes. Vaughn would permit her to lecture to women medical students, a concession that certainly humiliated Mosher. Angell also sent her the plans for the new Barbour Gymnasium and asked for her comments and suggestions.[79] Mosher was still uncertain of the course she would take, but the plans for the women's building intrigued her. At least she would have her own castle from which to reign, albeit over a smaller territory than she wished. Katharine Coman wrote Angell that she approved of his choice but wished they would not call her dean of women, but, rather, "vice-dean," because the first title "seems to me to emphasize the distinction between men and women students which it hitherto had been the wholesome policy of the University to ignore."[80] Coman's views demonstrate that the first generation of women students at Michigan would never become reconciled to the new gender separatism on campus. Mosher herself fired a last salvo. She wrote Angell early in 1896 that she had been elected vice president at the annual meeting of the Brooklyn Pathological Society, the first woman in a major eastern city to be so

honored. She added, "this statement might count for something perhaps with *Doctors* of your state."[81]

Mosher accepted the University of Michigan's offer in 1896 and worked hard during her six years as dean of women. She organized a three-year gymnasium course and hired women trained in the new area of physical culture to teach it. She personally conducted a general physical examination of each woman student. She took her professorship in hygiene seriously and eventually offered a three-year program in the field. One semester was devoted to personal preventive health, and the rest of the course explored what was then known as "sanitary science," a forerunner of public health and social work. At the end of Mosher's first year at Michigan acting president Harry Burns Hutchins characterized her courses as "elective but well attended."[82]

Mosher's appointment led to intensified agitation for hiring more women faculty members. A crucial test of the university's resolve emerged in 1899, when the matter of an endowed chair for a woman came before the Board of Regents. Catharine A. Kellogg of Detroit, along with other Detroit women, offered to make a substantial gift to the university toward the endowment of a chair to be occupied by a woman of ability "with high ideas respecting the character and aims of her sex," not to teach physical culture or gym but to offer a course in what would now be called women's studies.[83] The matter was tabled. By the turn of the century, however, in addition to Eliza Mosher, there were twelve women teaching at Michigan, most of them in the sciences and all of them with either the rank of instructor or assistant and the inevitable low pay.[84] For example, in 1903 two women assistants in zoology were appointed at salaries of one hundred and one hundred and fifty dollars, respectively; Lydia M. De Witt became an instructor in histology at six hundred dollars per year.[85] But by 1915 the dozen women of 1900 had shrunk to only three: the director of women's physical education, a woman physician in the Health Service, and Myra Jordan, Dr. Mosher's successor as dean of women. None had advanced degrees.[86] The cause of faculty status for women had in fact lost ground.

By 1900 Michigan had conferred 144 advanced academic degrees on women, in addition to the professional degrees granted to women in the professional departments. Many of the academic degree recipients had distinguished careers at other universities and colleges, including at women's colleges. But the University of Michigan found it impossible to accept women faculty at anything but the most junior level, and even that partial acceptance deteriorated year by year after the turn of the century. Still, President Angell was sympathetic to the idea of women faculty. The women in his own family had shown him what women could do. His wife's cousin, Mary Caswell, was

a professor at Wellesley. His own cousin, Caroline Hazard, was president of Wellesley at the turn of the century. Angell had heartily accepted women students on campus in the 1870s, and he bragged about women graduates' accomplishments in his 1900 report to the Board of Regents. He queried his colleagues at other institutions about women faculty. But his own faculty would not give way. They found their male prerogatives challenged by this new generation of women whom they themselves had helped to educate. They feared so much and so unnecessarily that women would take their jobs and their academic laurels that they could not accept them as faculty colleagues. The regents, except for Levi Barbour, were no better, and Barbour fostered separatism with his scholarships for women, his women's building, and eventually his dormitory. It was a sad time for women at the University of Michigan, and unfortunately, except for older women like Katharine Coman and Lucy Salmon, the women students themselves seem not to have known it. They rejoiced too much in their newfound women's community.

Women faculty faced greater discrimination at Michigan than at other coeducational state universities. The absence of the so-called feminized professions (library science, social work, and home economics) on campus undoubtedly contributed to this situation. The lack of women faculty on the Michigan campus persisted into the Progressive Era, shaping the collegiate experience in Ann Arbor and making it different from that at Berkeley, Minnesota, Wisconsin, or the women's colleges.[87]

Another development on male and coeducational campuses at the turn of the century was the doctrine of "in loco parentis."[88] Michigan followed the pattern that was emerging nationwide. Cornell University instituted compulsory dormitory living for women in 1884, but men were still unsupervised and lived where they pleased. The result was that at Cornell qualified women students were admitted on the basis of the availability of supervised beds, men on the basis of classroom space.[89] Women were housed in dormitories at the University of Chicago from the time the university opened in 1892, but since only 20 percent lived on campus, the rest commuting from their nearby homes, a women's building was more important than dormitories in supervising women students' college life. Ida Noyes Hall, after several partial and temporary makeshifts, opened in 1915 and provided clubrooms, gymnasium, pool, and lunchroom facilities.[90]

One could date the supervision of women students at Michigan from Eliza Mosher's arrival as dean of women in 1896. In many ways, however, in loco parentis antedates Mosher's appointment to the faculty and was generated by women students themselves, inspired in part by one early alumna of

the university who strongly believed in the advantages of a women's community. The Michigan Women's League had its origins in the spring of 1890, when, at a Collegiate Alumnae Association meeting on campus, Alice Freeman Palmer spoke about the need for women to organize. Her address resulted in the formation of a small club of independent women called the Alethian Society, which, the following year, along with the Fruit and Flower Mission, became the Michigan League. The League, working with the Student Christian Association, met and welcomed new women to campus. Experienced students accompanied the new arrival to church and put on welcoming teas. The League also participated in raising money for a women's building.[91] In describing the origins of the League, the *Castalian* observed that "this movement meets a want felt in many a college, even where the names of women appear among the faculty," an assertion borne out by the experience at other institutions, notably Illinois, Wisconsin, Iowa, and Albion College, which followed the lead of Michigan women in establishing their own "women's leagues."[92] Although women students tried to set standards for housing in private homes and boarding houses, there was no official supervision of housing even after Dean Mosher's arrival. Emma Ackerman (Lit. 1900) remembered living in the "mixed" rooming houses of the era and rebuking the young man in the next room for coming to her door in his bathrobe to ask a question.[93] By 1900, though they still shared rooming houses, women students were disciplined for entertaining men in their rooms.[94]

Eliza Mosher resigned as dean of women in 1902, ostensibly because she had been diagnosed with breast cancer, and she felt it improper to continue working with young "girls." Yet she had never much liked her job. Although she made the most of her teaching in the Literature Department, she knew that she belonged in medicine either as a teacher or practitioner.[95] At the time of her resignation President Angell appears to have had some doubts about the wisdom of continuing a quasi-faculty post like dean of women. He corresponded with his counterpart at the University of Wisconsin, who replied that he was afraid that if women were given a "guardian" more and more women students would enroll "who have more the temper of the girls' school than of the university."[96] But both presidents concluded that public opinion demanded the supervision of women students and that deans of women were therefore necessary. Mosher had in many ways been a transitional figure. She herself had come from the era of unsupervised equality. She guarded women's health and promoted physical fitness, but she had little interest in social supervision or in the women's campus community. Michigan women students handled those aspects of campus life themselves, with the assistance

of alumnae and faculty members' wives. Mosher recommended an academician to President Angell as her replacement, Maud Keller, "a scholarly woman" about to receive a doctorate from Columbia University.[97]

Angell, however, chose the in loco parentis path. Myra Beach Jordan (Lit. 1893), who was chosen to succeed Mosher, had no advanced degrees and made no pretense of wanting to teach. No dean of women until Deborah Bacon, in the 1950s, was again to hold academic rank at the University of Michigan. Jordan was the true founder of official university supervision of women's housing. She set up the system of rooming houses for women, known as League Houses, that were inspected, supervised, and approved through her office. The first university dormitory for women was the gift in 1915 of Helen Newberry, who had previously given Newberry Hall to the SCA. The Martha Cook dormitory, a gift to Michigan from William W. Cook in memory of his mother, opened the same year with 125 upper-class women in residence.[98] By 1920, in addition to Newberry and Martha Cook, four small dormitories in converted houses had been provided, and the Betsey Barbour dormitory opened that year. About 350 women lived in sororities, but the great majority lived in League Houses. Although no new women's dormitories appeared until 1930, when Mosher-Jordan Hall opened, women's lives were closely supervised from 1903, and the university's right and duty to act as a substitute parent was clearly acknowledged.

Ironically, given the increasingly circumscribed role of women on campus, the first major bequest to the University of Michigan was made by a woman. Elizabeth Bates, an upstate New York physician who was not a Michigan graduate, left her entire estate of $130,000 to endow a chair in the Department of Medicine and Surgery for the diseases of women and children. The only restriction on the bequest was that the university continue to admit women to its medical programs and give them the same advantages as it gave to men. The regents authorized the medical committee to find "the proper man" for such a professorship and eventually chose to divide the funds between two male physicians already on the medical faculty.[99] The regents and the medical faculty have been accused of misusing the bequest because, it has been argued, Bates intended the chair she endowed to be occupied by a woman. This is in error. Bates's will says nothing about the gender of the new chair's occupant, only that women medical students be admitted and treated equally.[100] It is true that at the time the bequest was accepted Eliza Mosher's appointment to the Bates chair would have been highly appropriate, and there is no doubt that the Medical School circumvented Bates's intention to enlarge the facilities for the medical education of women. Instead, the money was

used as the sole support for the Department of Obstetrics and Gynecology, and, by effectively establishing a ceiling for its funds, the bequest thwarted that department's expansion rather than facilitating it.[101] Yet by 1910 money from other women donors had funded six fellowships and made partial provision for two endowed chairs.

It was also during the Progressive Era that African American and Asian women made their way to the University of Michigan. Sophia Bethena Jones (Med. 1885) was the first African American woman to graduate with a medical degree. Jones not only practiced medicine for many years but also founded nurses' training at Spelman College and was resident physician at Wilberforce University.[102] Ida Gray (Dent. 1890) was the first African American woman to graduate in dentistry from the University of Michigan and also the first in the United States with a doctor of dental science (DDS) degree. She practiced in Chicago for many years.[103] The class of 1896 included two African American women, one of whom was Emily Harper Williams (Lit. 1896), who taught for many years at Hampton Institute and Tuskeegee as well as in the schools of Washington, DC. She credited her commitment to a career in education to Mrs. Gayley-Brown, her landlady during her first two years in Ann Arbor. Years later Williams wrote, "I have given my service as a teacher so that I could be helping as she would have wished me."[104] Williams's memories of her Ann Arbor days were full of fun and frolic. She described coasting after supper down Corkscrew Hill and a Halloween oyster roast on the heights overlooking the Huron River: "we were a jolly party of girls and all went well until supper was over and we started home. It seemed so late." But the women's landlady gave them no trouble, and Williams commented that their pranks were innocent enough.[105] Among women students at Michigan, racial integration and acceptance seem to have functioned in the 1890s. Segregation and prejudice came later.

Two Chinese women, adopted daughters of missionary Gertrude Howe (Med. 1872), who spent much of her life in China, arrived on Michigan's campus in the 1890s to study medicine. Since the Chinese Exclusion Act was then in force, President Angell had to use his considerable diplomatic skills and connections to get the young women into the United States. They returned to China when their training was completed and worked as medical missionaries for many years. Tomo Inouye (Med. 1901) came to the university from Japan and after her graduation returned to serve her country. Regent Levi Barbour took an interest in Michigan's Asian students and frequently extended to them the hospitality of his home. In 1912, while on an around-the-world trip, Barbour visited Michigan women medical graduates overseas and was deeply

impressed by the impact they had in their own countries. As a result Barbour established the Scholarships for Oriental Women at the university in 1917; the program has assisted several generations of Asian women to receive professional education at Michigan.[106]

By 1920 women's role at Michigan was well set in the patterns it was to follow until the second feminist revolution in the late 1960s and 1970s. Women were permitted as students in all Michigan's colleges and departments and presumably attended on an equal basis with men, but they were heavily concentrated in the College of Literature, Science and the Arts (LSA).[107] They had almost disappeared from the professional schools, except for nursing, which along with education were the only feminized professions at the University of Michigan at that time. Women continued to be conspicuous by their absence from the faculty and from the growing roster of university administrative posts. The organizational life of the university's students, including athletics, student government, living quarters, and social and philanthropic organizations, were almost completely segregated by gender. Women and men students met only in classes, and then chiefly in the College of LSA, and in the dating game.

Chapter 4

Women, War, and Crisis

No women were present in 1861 when the University of Michigan faced its first national crisis, the Civil War. Forty years later the Spanish-American War came and went so swiftly that ordinary campus life hardly skipped a beat. What ramifications war had on campus resembled a musical comedy more than a serious encounter. Isabel Ballou (Lit. 1899) described the student soldiers' awkward attempts at drill as "excruciatingly funny, with sticks for guns and makeshift uniforms."[1] World War I was a different matter. The campus was in upheaval, faculty and students were trying out new roles, and women students were not exempt. World War II had even more profound implications.

Women's role on campuses in times of national crisis and the reactions to them have changed over time. Great external crises such as wars have inevitably left marks on university campuses, but how these changes have affected university women has ranged from the superficial to the fundamental.

The turn-of-the-century revolution in the definition of women's roles, with its attendant gender separation, was essentially complete by 1917. With the onset of U.S. military involvement in World War I, the gender-segregated American campus was temporarily transformed into a military training facility and a research and development resource bank. The disruption was almost total. At first campuses emptied of men, as faculty and students volunteered for military service, then filled again as officer training programs flourished in academic enclaves and the scientific and technical resources of universities were mobilized for the war effort. The major impact of this change fell on the male community. Other than increasing and accelerating nurses' training programs and providing short paramedical courses for Red Cross workers, few women directly felt the impact of the campus conversion to a military machine on their academic lives. Nationally, however, there was some buckling of the rigid proscriptions on women's movement onto the senior faculty and into male-dominated professions like engineering. At Michigan this occurred only marginally.

Problems specific to the University of Michigan and related to its home in Ann Arbor also proved to be important. World War I placed enormous social strains on the Ann Arbor community because of its large German-born population. In many neighborhoods only German was spoken, and there was a widely read and popular German-language press. Ann Arbor's Germans were universally loyal to their adopted country. But, in the hysterical ethno-phobia and anglomania that accompanied the war, ethnic tensions ran high. German businesses lost trade. German-speaking children were persecuted by their classmates, and the more assimilated German Americans tried to further enmesh themselves in the predominant English-speaking culture. Ann Arbor's sense of community was sorely strained. The university was also affected, even during the period of American neutrality. Soon after the war in Europe broke out, in 1914, a young French instructor honeymooning in Paris joined the French army, and his colleague in the German department hurried across the Atlantic to join a regiment in the kaiser's army. Pacifist sentiment and commitment to neutrality also had strong support on campus. The student-run oratorical association featured antiwar speakers like William Jennings Bryan, Rabbi Stephen Wise, and Norman Angell.[2]

The largest Michigan contribution to the worldwide peace movement was made by a recent alumna, Rebecca Shelley (Lit. 1910). As a student, Shelley had met Jane Addams when Addams came to Ann Arbor to speak; Addams was ultimately refused permission to address the students. Shelley and Addams met again when Shelley was teaching in Freeport, Illinois. Shelley joined Addams on the famous "peace ship" sponsored by Henry Ford, which sailed for Europe in 1915 in the hope of negotiating for peace. In fact, Shelley was responsible for the meeting of Ford and Rosika Schwimmer, the famous Hungarian feminist and pacifist who had the idea for the peace ship. Shelley was the youngest delegate to the International Congress of Women, which met in The Hague that same year. She was an official University of Michigan delegate appointed by the dean of women, Myra Jordan. Although the women from the belligerent nations who crossed battle lines to attend the Congress joined with other delegates in calling for an end to the slaughter, the delegation that the Congress sent to European capitals to influence rulers and ministers proved unsuccessful. Shelley, however, continued her crusade for peace, meeting with President Woodrow Wilson in 1916 as part of a committee she had organized to pressure him to preserve U.S. neutrality. Shelley remained a strong advocate of peace throughout her life, demonstrating against the Vietnam War and picketing the Pentagon in 1970.[3]

During World War I student and faculty devotion to neutrality and peace

met a pro-Allied superpatriotism under the aegis of the National Security League, organized by senior university faculty and led by Law School dean Henry Bates, history chairman Claude Van Tyne, and geologist William H. Hobbs.[4] Once the United States entered the war these hawkish, anti–civil libertarian positions went unchallenged. All pacifism and criticism of the war was viewed as pro-German activism that aided the enemy.

In October 1918, when the war was almost over, formal charges against Carl E. Eggert, the assistant professor of German who fought for Germany, were presented to the Board of Regents. He was suspended from the faculty but was paid his salary until the end of the term.[5] When Eggert asked for reinstatement after the war, his request was denied. Other faculty in the German department were also dismissed. Almost over night enrollment in the German department dropped from 1,300, the largest foreign language department in the university, to 150, making dismissal of faculty fiscally desirable as well.[6] To their credit, however, the regents refused to terminate all teaching of the German language. A communication to the regents from the national headquarters of the National Security League in February 1918, asking for a general inquiry into the "loyalty" of the Michigan faculty, was promptly tabled.[7]

Women had been eager students of German and active in the German language social clubs, which, unlike the French clubs, were gender segregated early in the century. Because women students had their own institutions in the German department, their attachments to the department were strong. Grace Bacon (Ph.D. 1910), later a professor at Mount Holyoke College, credited her experience with Michigan's German department, and especially her studies with Professor Ewald Boucke, with changing her life and providing her with her ideals.[8] The wartime hysteria that equated everything German with the hated "Hun" severely challenged this attachment to German culture. Muriel Babcock (A.M. 1918) later recalled that, when Walter Damrosch conducted the New York Philharmonic Orchestra in University Hall, only Polish, French, and American composers' works were performed. German composers were excluded.[9]

Despite U.S. General Leonard Wood's admonitions in late April 1917 that students should stay in school and not enlist until military needs were known, enrollment at the University of Michigan the following fall saw a decrease of 1,509 students, fully one-seventh of its student body. As soon as war was declared, over 300 men joined the armed forces, and the regents generously allowed many eager volunteers credit for the fall semester and graduation with their classes. Eventually, 12,601 Michigan men, including alumni, saw active service. One-third of them were officers, not surprising considering the edu-

cational qualifications of Michigan alumni. By 1918 the percentage of women in the College of Literature, Science and the Arts, which had been decreasing, rose again to one-third.[10] One hundred and sixty-six members of the faculty served in the military.[11]

As early as 1916, 25 percent of the clerical workers at the University of Michigan, many of them women, resigned to work for better wages in war factories.[12] Eight nurses from the hospital training school joined the armed forces before the year was out, and many were engaged by the Red Cross. Alice Evans, director of physical education for women, left the university to join the U.S. Surgeon General's office to do reconstructive work.[13] Although three ambulance units were recruited from among Michigan men, no women served with them.[14] A small break in gender patterns occurred in the College of Engineering. A number of women enrolled in two-month nondegree courses designed to train gunsmiths, machinists, blacksmiths, and mechanics at the technical rather than the professional level.[15] The new short courses to prepare women in nursing and first aid, food conservation, and motor mechanics emphasized women's potential in gender-specific ways.

During World War I women students' roles on campus were probably best described as cheerleading and service. The cheerleading was certainly compatible with traditional female roles. Student after student recalled the long parades honoring the men sent to Camp Custer, an important military training facility in western Michigan: "everyone plodded or raced enthusiastically through the dreary autumn streets to send 'the boys' off with all good cheer."[16] Some remembered "the stirring war meetings . . . the leaving of the Naval men from our own classes, and the many precious hours spent in the Angell House preparing dressings for the Red Cross."[17] President Angell had died in 1916, and since President Harry Hutchins (1909–20) always preferred his own home on Monroe Street to the university's official presidential residence on South University Street, Angell House, as it was then called, lay vacant. War saw it put to use as a center for female service activities. In its gracious rooms women students and faculty member's wives met to roll bandages and prepare dressings to be sent to the front. Another woman student wrote that "their work was a link to keep us in touch with our boys 'Over There' who were giving all for the good of humanity and we hoped toward an everlasting peace."[18]

Women students helped to supply eating facilities for the few civilian men left on campus who could not board at army or navy messes. When, in February 1918, Newberry Hall was closed because of a coal shortage, the tearoom run by the YWCA and staffed by women students was moved to the basement of Barbour Gymnasium, where it continued to function throughout

the war.[19] When the influenza epidemic hit Ann Arbor, in October 1918, military units on campus were especially vulnerable because of improvised and overcrowded housing and sanitary facilities. With nursing services in short supply, women students, faculty's wives, and townswomen filled the gap.[20] Nurturant service was generally expected of women, and that expectation was earnestly and enthusiastically fulfilled by campus women, but their use as replacements for men called to war service was very limited. Of thirty-seven junior faculty and teaching assistantships vacated by men who went into war service, only four were filled by women. These positions were in zoology, analytical chemistry, and geology, and a woman also became a reader in the Department of Education.[21] Overall, women on campus contributed to the war effort through inspirational support and volunteer part-time service. Eight hundred women students registered for some kind of war service.[22]

Yet some women left the campus to make direct contributions to the war effort. Although no figures are available for women, as they are for men, anecdotal evidence of women's activities is substantial. May Louise Carson (Lit. 1921) was an assistant manager of the shell department in a munitions factory during her summer vacation in 1918.[23] Catherine B. Heller (Arch. 1923) built seaplane wings as a carpenter first-class for over two years. Caroline Walker, a student in the Literature Department (1915–17), served as a machine gun instructor in the marines. Although she was married and had children, Fannie Dunn Quain (Med. 1898) supervised the equipping of a 250-bed hospital in 1917 and continued to be active in the field of public health all her life. Lady Willie Forbus (Law 1918) spent the summer of 1918 as legal advisor to the draft board and executive secretary of the Military Training Camps Association. As a student at the University of Michigan, Ruth Emery worked from July to December 1918 as a censor, translating French, Italian, Spanish, and Portuguese letters.[24]

At the time of the Armistice there were sixty-nine women students and alumnae working in Washington, DC; for example, Nora Deardoff (Lit. 1908) served on the staff of the national headquarters of the American Red Cross.[25] Many others were in war-related service in France. Several Michigan women were decorated by the French government, and some stayed on in Europe doing refugee work or teaching for months and years after the war. The gender roles of University of Michigan women on the campus were barely touched by the war experience, but in the wider world women found many nontraditional and war-related jobs to fill.

After World War I most of the gender patterns established at the turn of the century were still firmly in place. The pictures of student organizations in

the yearbook, the *Michiganensian*, present a visual study of gender segregation. The literary societies were all segregated. The senior staffs of student publications were all male, except for a "woman's page" editor or two. Only a few clubs were open to both sexes: the denominational religious clubs, foreign language groups, and foreign student organizations. Musical organizations were single-gender clubs, as were most dramatics groups; the comedy club was the only coeducational theatrical group. The YMCA and the YWCA were, of course, gender segregated. The student-run paper, the *Michigan Daily*, was not only staffed by men but obviously expected a largely male readership: most of its advertisements were for men's clothing or movies, concerts, and plays, entertainment for which men would usually make the arrangements. The new intramural building with its swimming pool was closed to women. Enrollment at the university passed ten thousand students for the first time, and two new presidents, Marion LeRoy Burton (1920–25) and Clarence Cook Little (1925–29), brought many changes to the campus, including a greatly enlarged physical plant, administrative reorganization, increasing emphasis on research, and expanding auxiliary services. But Burton and Little left the gender roles and segregation of the early twentieth century intact.

President Burton's wife, Nina Leona Moses Burton, formally organized the Faculty Women's Club in 1921, structuring most activities by faculty members' wives to meet social and self-help goals rather than to perform services for women students or faculty. The Faculty Women's Club did operate a children's nursery in its headquarters on Ingalls Street for several years, but it was essentially a drop-in center for the convenience of its members rather than a service enterprise.[26]

President Little saw himself as being concerned with the whole student experience, and a University College, which was opposed by faculty members and never implemented, a "Freshman Week," the introduction of vocational guidance services, and a greatly expanded Health Service were among his innovative programs.[27] But he also perpetuated gender segregation. The new building for the Women's League, the Men's Intramural Building, and a women's athletic field with its own building were all constructed during his administration. Yet he made no friends among Michigan's state legislators and conservative regents by publicly endorsing what might well be considered a women's issue, namely birth control.[28] His tenure as president was short-lived.

By 1921, when the comprehensive alumni directory was published, other than those who taught women's physical education or who served as deans of women, only four women appeared on the roster of Michigan's regular fac-

ulty, all as instructors in the Medical School. This pattern was to change very slowly in the time between the two world wars.

One woman who joined the tenure track in the medical school was Elizabeth Crosby, a distinguished neuroanatomist. Trained at the University of Chicago, where she received a doctoral degree in 1915, Crosby joined the Michigan faculty as an instructor in 1920. She taught anatomy and worked with G. Carl Huber in his laboratory. She served as an instructor for six years and was not promoted to assistant professor until 1926. She received tenure as an associate professor in 1928 and became the highest-ranking woman in the Medical School.[29] Huber died in 1934, yet, despite Crosby's close association with him and his work and her growing international reputation, she was not appointed to succeed him.[30] Soon after Huber's death she wrote to the dean of the Medical School, Albert C. Furstenberg, that "a woman in my position, as second ranking member of the anatomy department, might under all circumstances, prove an embarrassment" to the Medical School, and she offered to return to the rank of instructor or to resign. She feared she would no longer be used as a major professor and principal investigator but as an ordinary teaching assistant.[31] Furstenberg's immediate reaction is not known, but the following year she was promoted to full professor. Crosby was a dedicated and gifted scientist, sure of her professional competence, but she was a self-effacing woman. Her proffered resignation could indicate deep resentment that she was not chosen to succeed Huber, with whom she had worked so closely. Crosby always insisted, however, that the University of Michigan had treated her fairly and well. In an interview she gave when she was nearly ninety years of age, and replete with honors, she confessed that her unquestioning acceptance of her treatment at Michigan was no longer "popular," a polite reference to the reemerging feminist movement. She added that she had never expected anything, so what she received was more than satisfying.[32]

On the surface the Medical School was more accepting of women instructors than other university faculties. Women appeared on its roster as instructors, and, after the University Health Service was organized in 1917, many of its physicians were women. At least part of this acceptance of women was self-serving. Inexpensive and accessible services were essential to keep laboratory instruction flowing smoothly without placing undue burdens on senior male faculty. Elizabeth Crosby's experience illuminates the difficulties faced by women faculty within the medical school and in the broader university community. Still, in 1946 Crosby was chosen to give the university's prestigious Henry Russell Distinguished Lecture, a first for any woman at Michi-

gan.[33] Yet the all-male Research Club, established in 1900, did not offer Crosby membership until 1955.[34] She was one of a group of three women admitted at that time, the other two being Helen Peak, professor of psychology, and Louise Cuyler, professor of music.

Martha Guernsey Colby was the first woman after Eliza Mosher to receive a tenured faculty position in the College of LSA. She began her career as an assistant in psychology, then part of the philosophy department, and in 1921 she was promoted from instructor to assistant professor.[35] Colby received tenure at the time of her promotion to associate professor in 1936, the same year that Elizabeth Crosby became a full professor; at the same time Hazel Losh joined the tenure-track faculty in another nontraditional field for women, astronomy.[36] Margaret Elliott Tracy received a doctoral degree in economics from Radcliffe College in 1924 and was appointed as an assistant professor in Michigan's Business School in 1936.[37] Interestingly, both Elliott and Colby married senior professors after they joined the faculty. Although nepotism rules were in effect in most midwestern state universities, Michigan seems not to have followed such a policy in this period. Both women continued on the Michigan faculty and received tenure after their marriages.

When library science appeared on campus in 1926, a woman was appointed associate professor in that discipline and retired at the same rank twelve years later.[38] Two women instructors had been teaching library science courses since 1920.[39] Public health was another area in which women early acquired an academic toehold. When the Division of Hygiene and Public Health was organized at Michigan in 1921, a woman was appointed director of public health nursing, and in 1923 Margaret Bell was appointed associate professor of physical education for women and physician in the Health Service.[40] In 1929, when the School of Music became part of the university, a number of women became members of the university faculty. And by the late 1930s women were appointed to the faculty of social work, which was part of the Rackham Institute based in Detroit. Women were also to be found in the Speech Clinic on the Ann Arbor campus.[41] In brief, women found a place in the new professions that often had been organized by women and which were increasingly accepted as feminized fields of teaching and study.

Meanwhile, money earmarked to endow two chairs for women was accumulating in university trust funds. In 1924 Alice Freeman Palmer's husband, George Palmer, gave $35,000 to establish a chair in history to be known as the Alice Freeman Palmer Professorship, "the holder of which shall always be a woman . . . appointed on the same grounds as a man would be," with the same

privileges, duties, and salary as a male professor.[42] A year later the regents attempted to convince Palmer to let them appoint a man to the chair. He expressed "extreme unwillingness."[43] The regents noted at their next monthly meeting that the fund had almost reached $35,000, at which point the deed of the gift specified that the professorship must be established.[44] Nothing was done, however, until 1957–58, when Caroline Robbins, the first Alice Freeman Palmer Professor of History, was finally appointed.[45]

The value of the Catharine Kellogg endowment, which had been accumulating interest since 1899, surpassed $35,000 in 1926 and, according to the terms of the gift, should have been used to endow a new chair. The regents excused themselves from this obligation by pointing out that this sum was now insufficient to endow a chair. They asked for and received permission from Kellogg's heirs to let the fund continue to accumulate until its value reached $100,000.[46]

Around the fringes of university policy gender-based taboos were breaking down but very slowly. For the most part the regents were not sympathetic to women as anything other than students, and the university's senior faculty, particularly in the Department of Literature, Science and the Arts, hoped to keep their establishment an exclusively male club.

This pervasive negative attitude toward women in the faculty ranks did not go unnoticed by women students. Florence Lavinia Abbott replied to a questionnaire from President Little's office that "the University of Michigan is behind other state university's [sic] of this section, for example the Universities of Wisconsin and Illinois, in one respect. Although the University of Michigan has a large number of women students, it recognizes neither their needs nor the teaching ability of women, in appointing so few women to the faculty."[47] Another alumna explained that she would never send her children to Michigan because "there is an attitude of men (students and faculty) towards women that is just not right . . . my daughter's [sic] at Dana Hall preparing for Wellesley."[48]

At the end of the 1920s, however, a woman was included for the first time on the university's Board of Regents. In November 1929 Esther Marsh Cram (Lit. 1895) was appointed by Michigan's governor to the board, and later she was elected and reelected to full terms. Cram was a schoolteacher who had taught in Detroit and Flint; she emerged as a devoted regent who took her duties very seriously.[49] Cram's service established the precedent of including a woman on the board, and, except for a few months following Cram's retirement in 1943 because of ill health, there has been at least one woman on the board ever since.

Gender separation was not the only kind of segregation practiced in the 1920s. While Florence Baker White (Lit. 1909) recalled "taking a Negro girl to the Freshman Spread" in 1905,[50] and African American and European-American women shared social activities at the turn of the century, by the 1920s the few African American women on campus lived in segregated rooming houses or in the homes of African American families in Ann Arbor. The color line was drawn at all campus dances and other social events. African Americans were banned from the university's swimming pools and gymnasia.[51] Racism flourished among the faculty, students, and administrators.

In 1928 the office of the dean of women decided to do something about what it saw as unsatisfactory living conditions for minority women students. A League House on Hill Street near the railroad tracks was approved that summer "for colored girls." Local African Americans demanded better conditions and the administration arranged for a university-owned house at the corner of Glen and Arbor Streets to be furnished, and a black woman was hired as a matron.[52] This caused an even greater protest by other local and student groups who objected to such segregation. The house could not be filled, and the project was abandoned.[53] In 1931, however, another segregated League House was opened at 1102 East Ann Street, and it continued to be used for several years. Also in 1931 African American women students applied for admission to Mosher-Jordan, the new women's dormitory. Two were accepted. One did not come, but the other did, and the dean of women saw the event as a success, crediting the young woman with making "a very good adjustment."[54] The actual experiences of this woman have not been recorded, but the principle of integrated campus housing had been established. The first interracial women's cooperative was organized in 1940 by a group of Methodist students interested in supporting "a more liberal attitude" toward race and religion. The house had financial problems and was not a success.[55]

The change in university housing policy was in part a result of increasing protest on campus by the Negro-Caucasian Club, which had been founded in 1926 by twenty-six black and white, male and female, students. Its officers included students of both races. In 1928 it made its first formal protest to John Effinger, dean of the College of Literature, Science and the Arts (LSA), asking for equal access to social and recreational facilities at the university regardless of race. The club was not warmly received. According to one participant, the dean thought they were out of their minds to expect equal access.[56] That same year several African Americans entered the Law School, including one woman who had earlier become one of the youngest Michigan graduates, at the age of seventeen. By the end of the first year all of these students had left the university, despite their earlier brilliant academic records.[57]

As African American women struggled, Asian women were quietly accepted into the university. But by 1917 many Asian women students at Michigan, most of whom received scholarships under the terms of the gift to the university from Regent Levi Barbour, had difficulty finding satisfactory housing. Most Ann Arbor landlords did not want Asians in their homes, and the university was reluctant to commit limited dormitory space to what it saw as a potentially explosive experiment in integration. When the first Asian women moved into the Betsey Barbour dormitory in 1921, however, the "experiment" was considered a great success, and by 1931 Barbour Scholars were required to live in dormitories during their first year at Michigan.[58]

While Jewish women seem not to have been explicitly excluded from campus housing and social activities, no doubt they were not always welcome. The first Jewish sorority, Alpha Epsilon Phi, was founded in 1909, and it was joined by Phi Sigma Sigma in 1921. These clubs provided Jewish women students with social and cultural support.[59] While they had been largely invisible in the 1920s, by 1940 Jewish students were more prominent on campus. Hillel's activities were regularly reported in the *Daily*. Hillel and the Jewish sororities' and fraternities' activities were duly recorded in the *Michiganensian*. There were a few male Jewish professors on campus and probably a secretary or two, but during the 1930s Jewish students knew there was no place for them at the University of Michigan among the faculty. The few token slots had been taken long since and more were unlikely to open soon.

The principle of in loco parentis flourished in the period between the two world wars and affected all women, regardless of their race or ethnicity. Although the dean of women's separate responsibilities for women students continued, a dean of students was created in 1921 to administer living and social affairs for all students.[60] As President Burton pointed out, Michigan had more women students on its campus than any of the eastern women's colleges, and the university took its custodial responsibilities with great seriousness.[61] During the 1923–24 academic year the dean of women, Jean Hamilton, gave a series of compulsory lectures during the first six weeks of the term for all incoming women students, fourteen hours in all, to give them "a better start." There is no evidence that women felt this was a waste of time, although it must have been an onerous burden in their busy schedules. Hamilton also encouraged nonsorority women students to take more leadership of women's activities on campus, and in 1925 an "independent" was elected president of the Women's League.[62]

Housing for women students remained a perennial problem. The university had taken full responsibility for supervising women's housing early in the twentieth century, and it continued to oversee the location and suitability of

living quarters for women students. In 1921 over eighteen hundred women were registered as students, and dormitory capacity was very limited. The three small women's dormitories could accommodate slightly more than three hundred students, another three hundred lived in sorority houses, and four hundred lived either at home, in rooming houses, or with friends. Nearly eight hundred women students lived in the one hundred League Houses. Standards for these university-approved residences included a maximum of fifteen persons using one bath.[63]

By the mid-1920s the university was considering a permanent solution to the housing problem. Although the existing dormitories had all been financed by private gifts, in 1926 a subcommittee of the Board of Regents, including the president, was created to study the possibility of state financing for university dormitories. The regents decided to ask the State of Michigan to provide an appropriate site and half the construction costs for a large new women's dormitory.[64] The new building, Mosher-Jordan Hall, opened in the fall of 1930 and caused a reduction in the number of League Houses by more than two-thirds. The owner-managers of the rooming houses on which the university had depended for housing its women students for nearly three quarters of a . century were deeply shaken. A major Ann Arbor industry was rendered virtually obsolete, just as the growing Great Depression had a catastrophic effect on student enrollment. The next year dormitories, sororities, and the remaining League Houses were all in acute financial distress.[65] By the fall of 1934 the number of women students in League Houses was down to one hundred. Over seven hundred women students were then housed in the university's dormitories.[66]

An era had ended. Suddenly the dormitory had become the standard campus home of Michigan women students. Until the exodus into private, off-campus apartments in the 1970s, the university dormitory remained the dominant mode for providing living space for women students.

The largest achievement of women at the university in the interwar period was the fund-raising for and construction of the new, luxurious women's building, the Michigan League. In February 1921 Mrs. William D. Henderson, secretary of the Alumnae Council, asked regental permission to launch a campaign to raise one million dollars to build a women's building on a site to be provided by the Board of Regents.[67] For five years Michigan women students and alumnae worked toward this goal, and in his presidential report of 1927 President Little announced "with gratification and some masculine amazement the completion of the fund for the Michigan League Building." By June the Alumnae Council had received one million dollars in

pledges, in addition to the expenses of the campaign itself, and a half-million dollars in cash and securities. Women students on campus had themselves raised $60,000 in cash and $50,000 in pledges. Not only was there money for construction and furnishings, but an additional quarter-million dollars was set aside for an endowment.[68]

The new building opened in May 1929. Men were allowed to use the front door and the restaurants, and there was one coeducational lounge, but the laundry, kitchenettes, library, and the resting rooms with cots were reserved exclusively for women.[69] Campus women took justifiable pride in the new building, but for some reason it was not as heavily used as had been intended or as had the Barbour Gymnasium. In 1932 new management was installed, students were hired as service staff, a social director was engaged to live in the building, and a dormitory was created on the fifth floor to house women students employed at League facilities.[70] The new plan of operation proved successful, and a wide range of women's activities was centered in the League until the Student Activities Building was erected in 1957.

Meanwhile, the Great Depression was having profound effects on the university. Enrollment fell by 10 percent. Faculty salaries were cut from 8 to 20 percent on a sliding scale favoring those with the lowest wages.[71] The city of Ann Arbor, although less distressed than most of southeastern Michigan, was also hit hard. Retail trade, long dependent on free-spending students, declined by 50 percent. Unemployment rose to almost 20 percent.[72] Fraternities and sororities were especially hard hit by the depression: twenty-one out of forty-nine Greek societies found themselves in difficult financial circumstances, and seven fraternities were forced to close. To some extent the closing of Greek houses did unsettle the student power structure, which before had been firmly in the hands of the fraternities and their female auxiliaries. But most campus spheres were only marginally affected. Economic dislocations and political ferment abounded, and women students were affected by and participated in these changes, but student leadership stayed in the hands of male students. The tradition of separate gender communities that had reigned for a quarter of a century continued with few changes. The depression, like the halcyon days of the 1920s that preceded it, seemed to have little effect on campus gender roles.

By the mid-1930s subtle changes began to take place. The Student Christian Association again became coeducational, and its name was changed to the Student Religious Association. A woman was elected president of the senior class in the Music School, and women and men appear together in most informal photographs of campus activities. The ads in the *Michigan*

Daily were directed as frequently at women as at men. Women joined in the concert bands and were allowed to participate in the card section at home football games. In 1937 there were three women in the Law School's senior class, whereas they had been almost nonexistent in the 1920s, and a number of women were present among the graduates in architecture. While most of these women took their degrees in design, some were in architecture proper. By 1935 the *Daily* had a larger women's staff, including a business manager for women. The two staffs were still technically separate, however, with women allowed to report only on women's activities, primarily fashion and social events. Except for the traditional Union Opera and Junior Girls' Class Play, gender segregation in drama activities was abandoned.[73] Some relaxation of the old taboos was beginning to occur.

New Deal reforms that reshaped American society also had an impact on the Michigan campus. The federal government's Public Works Administration was responsible for the construction of a number of new buildings, among them Stockwell Hall, named for Michigan's first woman student.[74] Scholarships and student loans were increased substantially, and a textbook lending library was established.[75] The National Youth Administration (NYA) created jobs that supported increasing numbers of students. In 1935, for example, the NYA employed eighteen hundred students. In 1936–37, 75 percent of the men and 25 percent of the women students on campus were either partially or fully supported. The records do not indicate whether this difference in sex ratio represented a belief by administrators that in crisis it was more important to subsidize the education of males.[76]

Another outcome of the depression was the development of cooperative housing. The first cooperative housing for men had been organized in 1932. In 1937 a group of women students rented a furnished house, shared the housework and cooking, and by working eight hours per week managed to reduce board and room expenses to $5.50 per week, about half the charges at university dormitories. A second women's "co-op" was organized the next year.[77]

As the 1930s progressed pacifism and neutrality again became consuming campus issues. Students complained about the presence of the Reserve Officers Training Corps on campus, but since ROTC was voluntary at Michigan their protests were not very effective. Several new, more radical student organizations such as the National Students League found a measure of support at Michigan, and a chapter was organized on campus in 1933. The next year the League against War and Militarism received university recognition, and in 1935 the frankly socialist Student League for Industrial Democracy was organized.[78] But neutrality, rather than fundamental change in the capitalist

economy, was always more attractive to Michigan students, who tended to reflect the political mainstream. Gerald P. Nye, a United States senator investigating the role of munitions makers in World War I and crusading for strict neutrality laws, came to campus to speak at the Michigan Union in October 1934. Roger Baldwin of the American Civil Liberties Union spoke the same week.[79] During the spring of 1940 the *Michigan Daily* contained such stories as "Is a Pacifist Position Tenable?" Norman Thomas spoke on campus in opposition to United States involvement in the new European war.

Most students, male and female, were too busy trying to meet their tuition, books, housing, and living expenses to participate in political activities. The depression and its aftermath were the paramount practical realities in their lives. Although new ideas were important to some articulate student activists, Michigan undergraduates played a small role in the general student ferment that swept many large American campuses in the late 1930s. Michigan's was a basically conservative student body reflecting in many ways the conservatism of the state and of the university faculty, the administration, and the Board of Regents. Michigan students did not lead the way in campus activism in the 1930s as they would in the Vietnam War era.

In November 1939, during the so-called phony war in Europe, Michigan pioneered the polling tradition it would later perfect through the Institute for Survey Research (ISR), by conducting a student poll. The question was: should the United States intervene in the war against Hitler if England and France appear to be losing? The results showed 77 percent of the men and 63 percent of the women students saying no.[80] Why were women students somewhat more willing to endorse U.S. involvement in the war than male students? Was it because women were less likely to have to put their own lives at risk, or was it because they better understood the evil cancer Hitler was imposing on Europe and threatened to impose on the entire free world?

As war became a virtual certainty, university president Alexander Ruthven (1929–51) anticipated its onset with real dread. He had been on campus in 1917–18 and had seen at first hand the havoc caused by the invasion of army training groups and the almost complete disruption of university programs and goals to meet dubious short-term needs. He hoped he could control events by planning the best use of the university community, and to a large extent he was successful.[81] He discouraged U.S. Navy Admiral Nimitz when he proposed the establishment of a naval ROTC unit on the Michigan campus and the granting of Michigan credit for a midshipman's cruise. But the University of Michigan calendar was accelerated to three terms, permitting graduation in two years and eight months of study, and new programs

were initiated, including the Judge Advocate General's School, which also trained a few Women's Army Corps recruits and made use of the otherwise almost empty Law School. Enrollment decreased sharply, falling 17 percent by 1942, but the academic regimen was maintained intact. Over the course of the war Michigan's enrollment fell from twelve thousand to seven thousand students. The presence on campus of four hundred men in various military training programs helped to replace those male students who volunteered or were drafted for military service. Two hundred faculty members took leave. In all thirty-two thousand alumni and students served in World War II, and five hundred of them died.[82]

The coming of the war changed women's position in American society, if only temporarily, much more so than had World War I. The U.S. War Labor Board ruled that working women were to receive pay commensurate with that of men in similar jobs. While 29 percent of U.S. jobs had been open to women before the war, after 1941, 55 percent of jobs were open. Industrial plants learned that women were able to cut out the aluminum patterns for aircraft parts as well as they could cut out a dress and that women could operate a drill press as well as they could a juice extractor.[83] "Rosie the Riveter" became a common and generally accepted element of American civilian life. Women continued to serve as nurses, but they also had their own units in the armed services. The Women's Army Corps (WACs) was organized in 1942, and the Women Accepted for Volunteer Emergency Services (WAVES) was established in 1943. Women also served in the Coast Guard and in the Marines. The Women's Air Force Service Pilots (WASPs) made use of women's piloting skills to conduct test flights of new aircraft and to move large numbers of new planes to bases.[84] Campus women shared in this expansion of women's roles. As F. Clever Bald wrote in his 1946 essay on the University of Michigan at war, "the shortage of men gave women new opportunities and responsibilities."[85] In fact, those responsibilities were not so much new as a partial return to the position of equality Michigan women students had enjoyed in the 1870s and 1880s.

During the war women became editors of the *Michigan Daily;* women even invaded the roster of sports reporters. An editor of the *Michiganensian* predicted that "in another year even a 4F [a man physically disqualified from military service] will be a phenomenon on a *Daily* staff of dictatorial women."[86] By 1945 all the editors of the *Michiganensian* were women, as were the presidents of the senior classes in the College of LSA and in the Law School. Two women enrolled in chemical engineering courses, and one was

Registering for classes at Michigan in the 1930s was a complex, exhausting, and sometimes daunting process. *(Alumni Association Records, BHL.)*

Between the 1920s and 1960s women dominated undergraduate enrollments in the fields of music, nursing, the humanities, and the arts. *(Alumni Association Records, BHL.)*

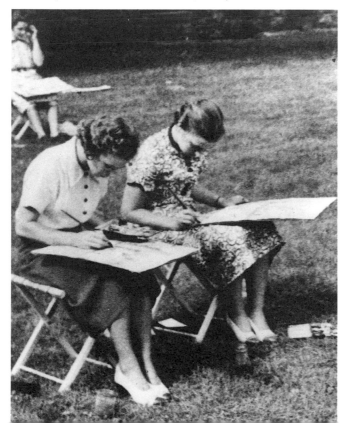

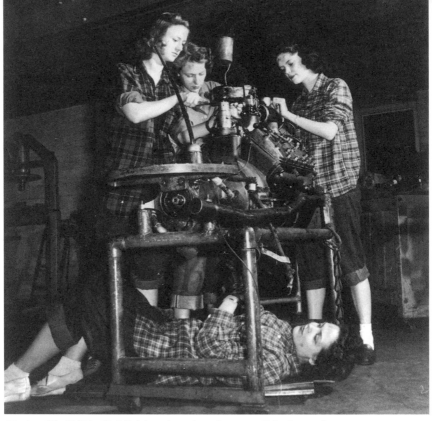

During World War II, Michigan functioned as part of the home front; women students did volunteer work, sold war bonds, joined the women's branches of the armed services, and learned new skills, including motor mechanics and machine repair. *(UM Photographs Vertical File, BHL.)*

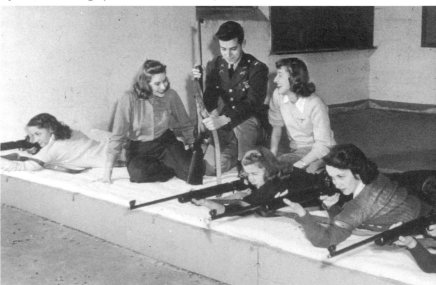

World War II gave rise to new mores in women's clothing, social relations, and entertainment, and Michigan women students reflected the new mood. *(Alumni Association Records, Box 138, BHL.)*

Also on the home front, women practiced "preparedness" in the rifle range. *(BHL.)*

In the early postwar period, women students began to choose the expanding scientific and engineering fields; this woman is conducting research in aeronautical engineering and aerodynamics. *(Alumni Association Records, BHL.)*

Professor Elizabeth Crosby, 1949. Crosby was the first woman faculty member in the Medical School and, in 1956, the first woman recipient of the distinguished Faculty Achievement Award. She was awarded the National Medal of Science by President Carter in 1980. *(E. Crosby Collection, Box 6, BHL.)*

A gymnast displays her vaulting skills in the 1950s. Eliza Mosher, the first dean of women, was successful in organizing a three-year gymnasium course for women. Her legacy of physical education for women survived until the 1960s. *(Alumni Association Records, Box 138, BHL.)*

Elizabeth Douvan (center), one of the first women researchers at the Institute for Social Research, in 1956, directed a study for the Girl Scouts of America. In 1994 Douvan delivered the prestigious Henry Russell Distinguished Lecture, only the second woman in the university's history to be so honored. *(News and Information Services, BHL.)*

Women's acceptance into the field of engineering came slowly. These women, pictured in 1959, were the first coeds to study naval architecture. *(Alumni Association Records, Box 138, BHL.)*

Participation in intramural athletics helped students to grow in physical and social confidence and brought together women from varying fields of academic study. *(News and Information Services, BHL.)*

Women student researchers at the University Hospital in the early 1960s utilized early computer technology in analyzing the incidence of cancer. *(Alumni Association Records, BHL.)*

This "Twist" contest during homecoming weekend illustrates both changing social relations during the early 1960s and Michigan students' continuing enthusiasm for homecoming events. *(UM Photographs Vertical File, BHL.)*

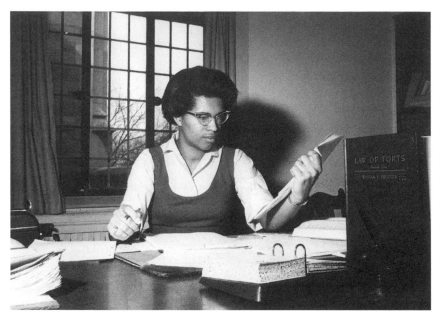

Student Amadyda Kearse had few women colleagues in the Law School in 1962. By 1976–77, however, nearly a quarter of Law School students were women. *(BHL.)*

Women students at Michigan worked for a variety of social and charity causes, as this 1967 photo of a volunteer collecting a donation demonstrates. *(News and Information Services, BHL.)*

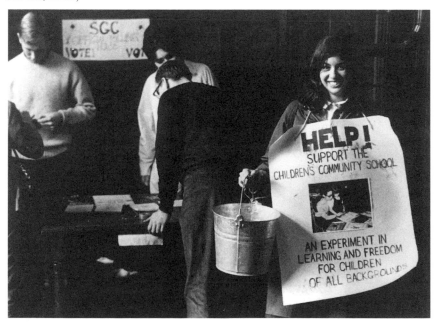

admitted to an engineering honorary society. Two Michigan women were also elected to membership in the American Society of Mechanical Engineers, and women served on the staff of the *Technic*, the College of Engineering's primary publication. Women organized a student group known as the Society of Women Engineers.[87]

A "Women's War Council" coordinated the array of women students' war-related activities at the University of Michigan, including Red Cross work, hospital service, maintenance assistance to the university's Buildings and Grounds department, entertainment of servicemen and trainees, and war stamp and bond sales.[88] Red Cross classes were organized in the Women's League building, using it to capacity. Because its space and services were utilized for war work, the League's schedule of private parties and banquets was curtailed. The "Soph Cabaret," the Junior Girls' Play, and the Freshman Project were abandoned, and volunteer war work substituted.[89] Women students assisted at the Red Cross blood bank, served as hostesses at the United States Service Organizations (USO), and acted through a childcare committee as proxy parents for children whose fathers were in service and whose mothers were working in war plants.[90] By 1945 the senior women's defense stamp drive had been extended to all university employees and to the men's dormitories. Sophomore women volunteers assisted overworked nurses at University Hospital, bathing babies and feeding patients. First aid classes were conducted in dormitories and sorority houses.[91]

Women students took over much of the routine maintenance work on the University of Michigan campus. Groups of women students, calling themselves "modern Cinderellas," assisted the below-strength buildings and grounds crews to keep the campus free of waste paper, leaves, snow, and ice.[92] Women served for the first time as "waiters and busboys" in the dining rooms of that sacrosanct male bastion, the Michigan Union.[93] They were still compelled, however, to enter the Union through the side door.

The university embarked upon several noncredit training programs in civilian protection, open to both men and women, including police work, blackout protection, air raid warden training, emergency medical services, first aid, decontamination, and fire control.[94] A number of women with University of Michigan bachelor's degrees and some last-semester seniors were trained in the College of Engineering as aides for positions in the Army Map Service and at government arsenals. Twelve groups of fifty women attended a ten-week course to prepare them for work at the Willow Run Bomber Plant in Ypsilanti.[95] A "Postwar Council," intended to generate interest in planning for the peace, was founded the day after the attack on Pearl Harbor and was open

to both men and women students. Weekly discussion panels featuring faculty experts and devoted to objective fact-finding were held on campus. By 1944 the Postwar Council was composed of twenty women and nine men.[96] Doctors and nurses from the University Hospital staffed the U.S. Army's 298th General Hospital unit. This group left Ann Arbor for training in Arkansas in June 1942. It first established overseas operations near Bristol, England, and moved to France thirteen days after the Normandy landings of Allied troops. In the final winter of the war its hundred-bed tent hospital played an important role in treating casualties from the Battle of the Bulge. One woman on the hospital staff, Margaret K. Schaefer, became a lieutenant colonel and ultimately chief nurse in the Allied European Theater of Operations. Ann Hayes, a graduate of the Medical School, became a lieutenant commander in the U.S. Navy.[97]

By 1941 Michigan had graduated over sixteen hundred nurses, all of them women. In that year the Board of Regents added *professor of nursing* to the title of the director of the School of Nursing, and also created a new faculty for the school, thus upgrading its instructional staff to full university faculty status. When Rhoda Reddig was appointed dean of the School of Nursing in 1955, Michigan acquired its first female academic dean.[98]

Despite this increasing flexibility in gender roles, women's penetration of the university faculty was marginal at best. Women continued as the dominant group in nursing and were prominent in other fields such as music, social work, and library science; some women also played important parts in the language programs developed during the war years to train servicemen for intelligence work. Yet, aside from temporary appointments as lecturers or instructors (many of whom were wives of faculty members), no women made their way onto the regular university faculty in a non-traditional field.

Joseph K. Yamagiwa was responsible for organizing the Army Japanese Language Training Program that supplied hundreds of young intelligence officers for the war in the Pacific. His accomplishments, while considerable, would not have been possible without the help of two dedicated women. Yamagiwa's wife, Hanako, a native of Japan and a former Barbour Scholar at Michigan, had taken her new baby from Michigan to Japan to visit her parents in 1941. The increasingly belligerent Japanese government refused to grant her permission to return to the United States. Without President Ruthven's persistent and forceful intervention with the U.S. State Department, which in turn pressured the Japanese government on Hanako's behalf, she might well have been trapped in Japan for the duration of the war. Eventually, she was allowed to return to the United States, where she made a substantial contri-

bution to the preparation of teaching materials used by the Japanese Language School instructors, who were mostly Nisei. Joseph Yamagiwa's scholarly work to that time had been largely with the Michigan-based *Middle English Dictionary* project, and Hanako's knowledge of Japanese was much better than that of her husband.[99] The Yamagiwas were joined by Hide Shohara, who had previously been an assistant in the Speech Clinic. She began teaching Japanese in the Army Language School, and, as the university's interest in Japan broadened in the postwar period, she was appointed professor of Japanese language and literature.[100] After the war Kamar Aga-Oglu, an expert on Asian pottery, joined the staff of the Museum of Anthropology.[101] Another woman, Lila Parmentier, a Russian native who during World War I had briefly been an assistant instructor in the French department, became a faculty member when Russian was added to the university's rapidly expanding language programs.[102] Previously, Dr. Mary R. Haas of the University of Michigan had taught the only course in Russian language offered in the United States.[103] From these language programs grew the innovative area studies programs that increasingly marked the postwar American university and in whose development Michigan led the way.

Despite the shortage of trained men for faculty positions during the war, there were no women among the new tenure-track appointments for 1942–43, except in nursing and music. The next year a woman was promoted to assistant professor in Public Health, and another received professorial rank in the dental school.[104] In 1945 Hayward Keniston, dean of the College of Literature, Science and the Arts, wrote: "the number of women holding important posts on the faculty of the College has always been small. No one would propose that women should be appointed to the faculty merely because they are women. But there is an increasing number of women whose ability as teachers and scholars is fully the equal of that of men."[105] This was the first official recognition of the need for women faculty in LSA since the turn of the century. At that time, however, the initiative had come from students and organized alumnae rather than from university administration or faculty. The following year, 1946, Provost James Adams repeated the plea: "the Graduate School and most of the departments which carry on its work open their doors to women for the pursuit of study to the doctorate with the primary expectation that they find careers in academic life." The statement urged that the university be more welcoming to women on its own faculty.[106] Nothing substantive was done. The male faculty in the academic departments in which the actual recruiting and hiring to the faculty was done did not change their ways. Some improvements were made, however, in senior university staff. The first

appointment of a woman to an administrative committee outside the Dean of Women's office occurred in 1945, when the Institute for Human Adjustment was reorganized, and business school faculty member Margaret Elliot Tracy became a member of its executive committee.[107] Tracy also served on the Board of Governors of the residence halls.

Action was finally taken after the war on one of the endowed professorships for women. As the value of the Catharine Kellogg bequest approached $100,000, the figure the regents had deemed necessary to fund the chair, the Michigan Alumnae Council asked permission to raise money to bring the fund to the $100,000 goal.[108] It was not until two years later, in 1948, that the council was authorized to proceed. In 1955 Helen Peak, a faculty member in the psychology department since 1949, accepted the new chair; it had been assigned to the department that for years had been the most welcoming in the entire college to women faculty.[109]

Despite the construction of the new dormitories in the interwar period, housing for women students at the University of Michigan was very scarce during World War II. The army took over the East and West Quadrangles, Victor Vaughn Hall, and twelve fraternity houses. In February 1943 the university's already crowded women's dormitories were obliged to accommodate an additional seventy-five nurses sent to the campus for preclinical scientific training. To make room for them, other women students had to be moved out. The following year single rooms were converted to doubles, a cooperative house was established for women, and improvised rooms were added in the League.[110] In August 1944 the regents set a first-ever virtual cap on the number of women who could enroll at Michigan, ruling that the number of women admitted would have to be dependent on the availability of women's housing.[111] The University of Michigan, which had resisted a quota on women students in the early twentieth century, now had a de facto quota in place.

With the end of the war and the passage of the GI Bill, which provided funds for veterans to continue their education, including those veterans of non-traditional college age, the married undergraduate male appeared on campus in large numbers for the first time. Provision had to be made for family living quarters, and housing was in short supply in Ann Arbor. Little university housing except dormitories had been built during the depression and none during the war years. Thirty-nine barrack-style houses were moved from the wartime development near Willow Run and placed on vacant land near the Coliseum on Hill Street. Soon much of Willow Village, as it was known, was taken over by the university for married faculty and student housing, and buses ran frequently to and from the university campus. A number of perma-

nent brick apartment buildings were erected near the University Hospital when construction materials became available.[112] Eventually, an extensive complex of student apartments was built on the new North Campus. Wives of male students supplied a new pool of cheap labor in campus offices, and some of them joined their husbands in pursuing degrees. On the undergraduate level, however, the need for family housing was a relatively short-lived development. The older married male undergraduate had largely disappeared by the end of the 1950s, but family housing continued to be in demand because of the increasing numbers of married male graduate students.

In June 1946 the annual Alumni Reunion, which had not been held during the war, was christened the "Victory Reunion," a three-day celebration with an elaborate schedule of events emphasizing the university's contributions to the war effort. Margaret Ann Myers (A.B. 1938, A.M. 1940), who had served with the Red Cross during the war, including as club director for the Red Cross European Theater of Operations, was among the speakers at the Reunion dinner. A women's luncheon was held at the League honoring alumnae who had been in the armed services. All the women's dormitories and sororities held open houses, and the League concourse featured mannequins displaying the uniforms worn by Michigan alumnae and a gallery of photographs showing the war-related activities of women students on campus.[113]

The previous forty years had encompassed two world wars and a catastrophic depression. The world had been remade more than once. Despite some changes in the women's work that accompanied World War II, the pattern of gender relations established at the University of Michigan early in the century remained largely intact. Women were still few in number and not very welcome on the faculty except in certain feminized disciplines. Men and women were separated in living arrangements, campus government, and in many social clubs, and what integration had occurred during the recent war years virtually disappeared when male students returned to the campus. There remained few women students in most of the professional schools and fewer women faculty. The University of Michigan was coeducational, as it had been since 1870, but, as it had been since early in the twentieth century, Michigan was still largely gender segregated.

Chapter 5

From the Age of Conformity
to the Stirrings of Dissent

After World War II veterans and faculty returned to the University of Michigan campus in a slow stream that soon turned into a raging torrent. Many of these men had wives and perhaps a child or two and were somewhat older and much more mature than the generation of prewar students. New campus buildings sprouted almost immediately. Some were temporary structures moved from wartime installations, but a large new edifice across from Angell Hall, devoted entirely to administrative offices and services, was completed by 1948. In 1951 the university purchased three hundred acres of land across the Huron River north of the central campus, a site for a wholly new "North Campus" complex.[1]

The GI Bill, which helped fuel much of the university's expansion in the early postwar years, provided a virtually free education for all veterans, including women. Thus, economics and family income played a smaller role in who went to college. Yet students also lived under the shadow of the atom bomb and the revelations of the Nazi death camps. University students faced a new, changing, and not necessarily friendly world as the relationship between the Soviet Union and the United States changed from wartime allies to strategic competitors and the Chinese Communist Party established control over mainland China.

The end of World War II, however, did not greatly affect women's relationships to the university community. A few of the gains women made during men's absence from the campus were consolidated, but many others were abandoned in a hasty retreat to the status quo ante. Many student organizations, at least temporarily, continued to treat men and women more or less equally. Although the number of women on its staff decreased as men returned to the campus, the *Michigan Daily* continued to be gender integrated. During the 1945–46 academic year a woman was managing editor during the spring semester and another was editorial director during the fall

semester. Two women served as associate editors, but the *Daily* still had a separate Women's Department, largely concerned with social occasions and fashion. The *Michiganensian* staff remained all female that year, but the *Gargoyle*, a campus humor magazine, included men and women on its staff.[2] The *Technic*, the Engineering College's publication, which for many years was "strictly a man's newspaper" with an all-male staff, reflected the somewhat larger number of women engineers during the war and in the immediate postwar years by having a couple of women on its roster.[3] This was not to happen again until the 1970s. Six women were members of the American Institute of Chemical Engineers, and one became an officer. The Society of Women Engineers grew to fourteen members but soon disappeared.[4]

Student government was reorganized in 1946, and the all-male Student Council was replaced by an elected coeducational student legislature, the Student Government Council (SGC), on which women won seven seats out of fifty in 1948.[5] Ironically, the 1948 *Michiganensian* included a section entitled "Outstanding Michigan Men" that included three women: Betty Smith, author of *A Tree Grows in Brooklyn* and recipient of a prestigious Hopwood Award, and Ruth Hussey and Martha Scott, stage and screen actresses.[6] All was not lost when men began to return to campus in large numbers, but gender segregation certainly was not eliminated.

For whatever reason—pressure from faculty and administrators, discrimination in admissions, social custom, or personal choice—women also continued to be academically segregated by area of curricular concentration. In the 1952 LSA graduating class, women appear in greater numbers than men in botany, bacteriology, English, fine arts, French, Russian studies, social work, political science, Spanish, and speech. There were substantial numbers of women students in history, journalism, political science, and psychology, but there were no women in the pre-professional programs, and there were very few in chemistry, physics, mathematics, and economics.[7] In some colleges and schools of the university women far outnumbered men. They predominated in the School of Education and enrolled in greater numbers than men in music, social work, and public health. Women made up nearly 30 percent of the university's graduate student population. Nursing and dental hygiene were exclusively women's programs. No women graduated in dentistry, and only ten did in engineering, out of a student body of nearly fifteen hundred. Medicine and law did a little better. Twenty-six women studied in the Law School alongside nearly seven hundred and fifty men. Fifty-seven women made up a small part of the medical roster of nearly one thousand. Natural resources had one brave woman among its over two hundred students.[8]

With regard to university awards the picture is less clear. Undergraduate honorary societies were still composed exclusively of one sex. Three out of eight architecture awards went to women in 1952, but only one of the nine tuition scholarships was given to a woman.[9] Again, women were consistently discriminated against in financial aid as they had been during the depression. Undoubtedly, the reasoning was that men would have to earn their own livings and support families and therefore deserved the bulk of the available assistance.

There were a few glimmerings of change in the roles of women students in the 1950s. As early as 1953, Dean of Women Deborah Bacon reported that women were active in planning the new student activities building, which would not be gender segregated. She believed that "undergraduate women increasingly wish to become contributors to overall campus responsibilities and activities." Yet she added, "they will share, and help throughout, but they have no intention of being politically absorbed, or of losing [the League's] identity as one of the historic and vital University organizations."[10] Clearly, she did not envision that women would give up their separate institutions. In fact, the merger of the Women's League and the Michigan Union was not to become an issue for another decade. Meanwhile, for purposes of participation in the mechanisms of students government at the University of Michigan, women students joined with men in the campus-wide Student Government Council.

The number of gender-specific campus organizations was slowly declining. The Women's Glee Club, organized in 1902 as part of the separate women's community developing on campus at the turn of the century, ceased to exist in 1953, and its activities were absorbed by the Michigan Choir, Arts Chorale, and the Michigan Singers.[11] Women became members of the University Orchestra and Concert Band, but the University of Michigan Marching Band remained an all-male organization throughout the 1950s and 1960s.[12] Friday nights at the Intramural Building were reserved for open recreation for both sexes, and the ice skating club was coeducational. Michifish, the women's swim club, however, still had to practice in the tiny Barbour Gymnasium pool until the Women's Pool was completed in 1954, despite the fact that the whole club could not practice there at one time.[13]

The principle of in loco parentis remained basically intact, and restrictions on women's dormitory housing continued as before. Women students were required to live in dormitories, League Houses, sororities, or with their families. The shortage of housing for women intensified, despite the opening, in September 1949, of Alice Lloyd Hall, named for the outgoing dean of

women. In the early 1950s some of the houses in the men's quadrangles were converted to housing for women, and Victor Vaughn Hall, built as a dormitory for male medical students, was converted to housing for women. This displacement by women of men alarmed the university administration as well as male students. The only solution, arrived at in 1954, seemed to be formally "limiting the number of women accepted to only those who can be adequately housed in the women's residence halls."[14] Although regental policy had for some time dictated that no more women be admitted than there was women's housing available, for the first time quotas on the admission of women were to be enforced.

As a matter of policy, the dormitories in the 1950s accepted applications, including those from African American students, in the order of receipt. *Michiganensian* group photographs of dormitory students show a few African American students in the 1950s, but overall the dormitories served mostly white students, male and female. In part this was because the African American presence on campus was minuscule. Among the formal portraits of seniors in the *Michiganensian* for 1950, only sixteen were recognizably black, and only six of these were women. Interestingly, two of the women received degrees in law, one of the colleges least welcoming to women and minorities.[15] That same year the women's medical fraternity initiated an African American woman, and another resided at Palmer House.

Finding a comfortable niche on Michigan's campus was not easy for the atypical woman student. Novelist and poet Marge Piercy, who was working her way through the university in the early 1950s, resented being required to live in an expensive dormitory room and to pay for meals she did not eat. She worked at night, and the rigid sign-in/sign-out system penalized her for not keeping hours. She protested to the dean of women but was told that if she could not afford the university and its in loco parentis rules she should go home. She participated with a group of fellow students to organize a students' cooperative, refused to give the university administration racial information on the women who applied for membership in it, and became active in the Inter-Cooperative Council.[16]

Large formal dances still dominated the campus social scene, and conventional dating rituals remained intact. The women of the 1950s had grown up with comic books, television, and "Leave It to Beaver." Girls "went steady" in high school. They went off to college loaded with Pendleton skirts, Shetland sweaters, knee-length wool socks, boxes of penny loafers and high heel pumps, spandex panty girdles, and maybe a black-and-white television set. All of this was packed into a crowded dormitory

room that was shared with another woman or two, although it may well have originally been built as a single. Material things and conformity were high-status values.

During this period women were not rebellious. A survey of forty-one hundred undergraduate women by the Women's League in 1953 showed that 78 percent of respondents were satisfied with the university's rules on hours and restrictions on behavior.[17] What rebellion there was largely took the form of student pranks. One warm early spring night some one thousand men set off from West Quad for the women's dormitories "on the hill" overlooking Palmer Field. The first "panty raid" was under way. The men rambled through the women's forbidden sleeping quarters for awhile and collected a few pieces of lingerie. The whole thing seemed to have burned itself out fairly early in the evening. But the "victims" decided to retaliate, and droves of women marched on the Union building, entering through the front door and then moving on to West Quad. The university administration was alarmed, not because any real harm had been done but because, against the backdrop of the Korean War, with male students exempt from the draft, there was the possibility of a backlash of public opinion against the university that condoned such frivolities.[18]

It was not surprising that petty pranks rather than serious rebellion marked the 1950s. Students, men and women, who did not agree with prevailing values thought long and hard before making themselves heard. At the beginning of the decade Senator Joseph McCarthy's "red hunt" was in full swing, dominating headlines and silencing dissenters in government and to some extent in academia. There were pacifist students on campus who talked quietly among themselves, but most were afraid to take public stands. An injudicious word could pose a serious threat to future prospects and professional careers.[19]

Not all women, however, were dutiful conformists. Janet Malcolm, later writer of controversial material for the *New Yorker* magazine, and Anne Stevenson, poet and biographer of poet and feminist icon Sylvia Plath, were both on campus in the 1950s. Malcolm describes herself as a duplicitous, "faint-hearted" rebel, but when she was a student she believed Stevenson, a Hopwood Award winner already harboring serious literary ambitions, was much closer to identifying and accepting a meaningful, nonconformist role for women.[20] The first stirrings of a women's revolution that, like the civil rights and antiwar movements, was yet to emerge were nonetheless on campus in the late 1950s.

During the postwar period the numbers of new faculty, especially at the

junior levels, grew at a rapid rate, keeping pace with skyrocketing enrollment. Few women were among the new faculty hires. For the 1949–50 academic year approximately one hundred teaching fellows were replaced by seventy-four full time instructors. In the College of LSA, where most of the new appointments were made, only one instructorship went to a woman, and that was in psychology. Five women were appointed in nursing and public health and one each in business administration, music, and dentistry.[21] The admonitions of Provost Adams and Dean Keniston (LSA) at the end of the war to consider women for faculty positions were almost completely ignored. It became even harder for trained women who were married to faculty members to receive academic appointments because a new university regulation barred related persons from employment in the same department except in emergencies and then only for a term or two.[22]

The year 1950–51 saw another large group of new academic appointments. Psychology appointed seven women to junior ranks and one associate and one full professor. The English department appointed three women to posts as junior instructors and one woman as an assistant professor. This last was Deborah Bacon, who insisted upon an academic appointment as a condition of accepting the position of dean of women that year. Sociology appointed two women as lecturers, while the economics department added one woman lecturer.[23] Most of these appointments were not on the tenure track.

A third large hiring initiative came in 1953–54, when sixty-six additional teaching positions were added, forty of them in LSA; again, only a few women were added to the university faculty.[24] Nonetheless, small but significant changes were being made in hiring practices: by the early 1950s the formal qualifications for appointment and promotion of academic faculty in the College of Literature, Science and the Arts were altered so as to replace the word *man* with the word *person*.[25]

In the 1950s promotions for those women who were members of the university faculty came hard. In 1956 no women were among the promotions recommended to the regents by LSA.[26] The following year, however, Helen Dodson Prince was promoted to full professor in astronomy, and Mary Crowley was promoted from associate to full professor in dentistry.[27] That fall most of the new appointments of women continued to be in junior and untenurable ranks and were concentrated in music, nursing, physical education, and social work, fields in which women had traditionally found a place.[28] That same semester eighteen women received Ph.D. degrees from the university, many of them in the sciences.[29] But the university's hiring patterns continued to demonstrate that there was no room for them at Michigan's inn.

While the Alice Freeman Palmer Professorship finally was activated in 1957, every effort was made to avoid appointing a permanent, tenured woman in the history department. Despite the clear intent of the gift, university attorneys determined that appointments to the post could be made without tenure, and the history department was instructed to invite women historians to fill the post as visiting professors.[30] The first recipient of the Palmer chair was Caroline Robbins, an eminent scholar in English history, but her sojourn on campus was temporary and her influence limited. Women faculty had yet to find a secure niche on the University of Michigan faculty.

The 1960s marked the end of the "Age of Conformity" for women at the university and ushered in a tumultuous period in American life as a whole. Many women students became involved in social protest movements—civil rights, welfare rights, anti-Vietnam War, and, late in the decade, women's liberation. As more young women thought of themselves as activists and even revolutionaries, they were increasingly reluctant to accept traditional social strictures. Many of those who were not directly engaged in protests nonetheless participated in the cultural shift that endorsed greater personal freedom. Throughout the decade, male and female students on American campuses were angry, disillusioned, and demanding.

As one would expect, the 1960s saw much more rapid change than the 1950s in the relationship of the sexes on campus and in how women saw their roles. The Women's League and the Michigan Union merged administratively in 1964, and most of their facilities were opened to all;[31] each organization, however, maintained its own Board of Directors. In 1961 the J-Hop disappeared unmourned, and the *Michiganensian* commented that "times have changed and the day of the Stag Line seems gone forever."[32] Yet homecoming decorations and "Michigras" flourished, and the two athletic groups accepting both men and women were figure skating and the Riding Club.[33] Women were not allowed to join the Michigan Marching Band until 1972, but women became more prominent during the 1960s on the staff of the *Michigan Daily*,[34] and the Judiciary Council, which handled student discipline matters, included women.

In the 1959–60 academic year the Michigan League took on a new project. It sponsored "Women's Week," a series of panel discussions and speakers on the problems and dilemmas that faced women after graduation.[35] If a woman chose to pursue a career, she might feel unfulfilled because she did not have the security of a home and children. If she married, she could be frustrated by having to subordinate her intellectual and professional activities to the management of a family and home. The Women's Week event was the

university's first organized admission since early in the century that college-trained women might have a problem finding a place in the world of work.

The principle of in loco parentis disappeared very quickly in the 1960s. Students in large numbers began to grumble against restricted dormitory hours for women, the authority over behavior exercised by the deans of men and women, and the ban on students bringing cars to Ann Arbor. During the winter of 1961–62 President Harlan Hatcher (1951–67) appointed a committee under the direction of John Reed, of the Law School, to consider the relationship of the university's administration to its students. The committee recommended the abandonment of in loco parentis, the appointment of student members to university committees, and the abolition of the office of dean of women.[36] At its May 1962 meeting the regents reorganized the Office of Student Affairs, stipulating that a vice president for student affairs be appointed who would have jurisdiction over counseling services, discipline, housing, financial aid, student organizations, and the University Health Service.[37] The regents, in considering this action, were reminded that of the 8,200 women students on campus only 3,675 were unmarried women under the age of twenty-one. Tight control was hardly feasible.[38]

Residence rules changed immediately. Senior women in good standing were allowed to live off-campus in privately owned apartments. Coeducational dormitories were in demand, and the number of coed facilities increased. When Mary Markley dormitory opened in the autumn of 1963, it had five houses for women and four for men. South Quad had also become coeducational, including houses for both men and women students.[39]

Beginning in 1969–70 residence in university housing became optional for all students, even during the first year.[40] Apartment living also received direct university sponsorship. Cambridge Hall, a unit of the University Terrace Apartments, which had originally been constructed for married students, was converted in September 1960 to a small residence hall of twenty-three apartments housing seventy-three junior and senior women. This pioneering venture proved to be an unqualified success.[41] By 1964–65 nine thousand students were living in apartments and private dwellings.[42] While housemothers were still a prominent feature of men's housing units in the 1950s, in 1965 vice president for student affairs Richard Cutler reported that "social life on campus seems to be retreating into [private] apartments."[43] The traditional housemother was being replaced by younger, better-trained dormitory staff of both sexes. By 1969 all men and women could live in apartments, provided they had parental consent, even if they were under twenty-one.[44] At the same time,

the number of married student housing units on North Campus increased rapidly. Four hundred units were begun in 1966 alone.[45]

This breakdown of the in loco parentis principle was facilitated by the fact that it liberated men as much or more than it did women, although restrictions for women persisted after they had been abolished for men. Curfews for women over twenty-one were lifted in 1962 and later lifted experimentally for women twenty-one and under in 1968, provided they had their parents' permission. In 1970 the regents officially abolished the curfew requirement for women living in university residence halls.[46] Men applauded apartment living that made curfews and restrictions on automobiles unworkable. Women students also demanded and got independence from all the supports and constraints of a separate community that they had demanded and embraced generations earlier. The University of Michigan campus was largely gender integrated by the end of the 1960s, but it was not free of discrimination.

Meanwhile, the student protest movement erupted on the national scene with the "Free Speech Movement" at the University of California at Berkeley in the fall of 1963. While the Michigan student dissidents of the 1950s sat in Ann Arbor's living rooms discussing society's problems and general grievances, the student rebels of the 1960s organized. The creation of the Students for a Democratic Society (SDS) was in large part the result of a conference of radical Michigan students, led by Tom Hayden and Al Haber, which produced the *Port Huron Statement* in 1962.[47] When Hayden assumed leadership of the student movement, he had been married for several years, and his wife, Casey, worked alongside him in SDS, as did several other women. These women, however, soon saw themselves as "shitworkers" (their word) in the SDS offices. One woman remembers how she hated her job but for a long time did not realize that her gender had anything to do with her status. The male-dominated radical student movement took for granted that women were to provide a support system for the men, who did the real organizing and agitating.[48] One woman reported in an interview that "the reason [SDS] was weakened was because of the kind of power politics that men voiced . . . The men were just disgusting. For a long time SDS had been crawling with really macho leadership-type men who invalidated other people and just shut people down."[49] Barbara Haber, also an activist, agreed. She saw an undercurrent of rebellion developing among women SDS members at the University of Michigan.

The first term these women used in describing what they disliked was

male chauvinism, followed by *sexism,* and finally *patriarchy.* Women's resent-ment against this phenomenon was not limited to the Michigan campus. Women students walked out of an important SDS conference at Urbana, Illi-nois, in 1965 and held separate sessions of their own on women's issues. Bar-bara Haber believed that men's intransigence in giving full equality to women helped to pull SDS apart by the end of the 1960s.[50] An African American woman on Michigan's campus during the 1961–65 period who was active in the student movement said she personally never experienced any racial dis-crimination in movements organizations but felt the movement generally was very sexist and that women were ignored. Women were not heard or seen except as people who could type or make coffee. Women did most of the work, but the men made the decisions and received credit and recognition.[51] By 1966 women SDS members asked for more leadership responsibility and demanded that men help with typing and mailings. These demands were met by male activists with taunting and screaming. Activist Beth Oglesby recalled that the most radical faction of the Weathermen, a violent, extremist offshoot of SDS, was also the most antifeminist—even the section's female members.[52] The radical student movement had spawned a strong feminist movement in spite of, and perhaps in part because of, the chauvinism of its male leaders.

The greatest impetus for change in the status and role of women on cam-pus in the 1960s came from a quite different source. It resulted not so much from the rebellion of women students or the grievances of the rare female fac-ulty members but from the creative intervention of a trio of wives of Michigan faculty members who had spent part of their lives as volunteers in various community causes. Their volunteer work had centered on the League of Women Voters (LWV), the heir of the turn-of-the-century suffrage movement that had won the vote for women in 1918.

Louise Cain, president of the League of Women Voters of Michigan in the 1950s and an unsuccessful candidate for the Ann Arbor City Council in 1954, had taken a job in the University's Extension Division.[53] She was con-cerned about the unhappy frustration of women whose professional or aca-demic training had been interrupted by marriage but who were interested in returning to the work force. She saw Michigan's Extension Division as pro-viding a service for meeting the needs of these women. Her attempts to inter-est the division in developing programs for women whose education had been interrupted were unsuccessful.[54] Cain knew that several other colleges and universities had developed programs to support women's continuing educa-tion, including the University of Minnesota, Radcliffe College, and Sarah Lawrence College. During the summer of 1962 Cain drew up a proposal to

create a "Center for Continuing Education for Women" which would serve as mediator and facilitator for women whose education had been "interrupted," aiding them in their return to the Michigan campus. She placed the proposal on the desk of the new vice president for academic affairs, Roger Heyns, who also happened to be a personal friend of Cain's. Since she received no reply from Heyns, the matter seemed to be at an end. When the two met at an election party in November, however, Cain raised the proposal with Heyns. He confessed he had not yet read it. When they finally met at the end of the year to discuss the idea for a center for women's continuing education at the university, Heyns was supportive of the concept. He asked, "Where do we start?" and pointed to the need for concrete program ideas and proposals about sources of funding.

At Heyns' request Cain convened an informal committee of old friends and activist colleagues, including Jane Likert, Jean Campbell, and Allison Meyers, to help flesh out ideas for a women's center. She also began searching for financing. She visited and addressed the University of Michigan Alumnae Clubs, one after another, asking for support for a new center on campus that would help women students, especially those returning to higher education. The Alumnae Clubs raised fifteen thousand dollars to help launch the new center, and President Hatcher matched the gift with money from his discretionary funds. Hatcher's support for women's causes has often been overlooked, including his role in obtaining full funding for the Alice Freeman Palmer chair at the university. The founding of the Center for the Continuing Education of Women, or CEW as it became known, was solidified in 1963 by a university commitment of thirty thousand dollars. Although university support for CEW was initially organized on a precarious year-to-year basis, by the 1967–68 fiscal year the center's basic funding was incorporated into the university's general fund budget.

As Cain recalled many years later, the center initially made large concessions to the ruling patriarchy to insure its acceptance. Heyns originally told Cain he wanted her as director of the center, but when she protested that she was not qualified he appointed her instead as a special assistant to the vice president (paid at a rate of four dollars per hour). She functioned as the founding director of CEW in its early organizational period. Meanwhile, the university administration was placing increasing emphasis on the importance of women's continuing education within the framework of the nation's needs for more highly educated "manpower" in the increasingly technological American society. The United States had been shocked by the Soviet Union's ability to launch the Sputnik satellite in the 1950s, and since then many questions

were asked about how to meet the skills and training requirements for further rapid technological progress in the United States. The men involved in forming CEW emphasized its potential importance in meeting "manpower" needs rather than the needs of women students per se. The Academic Advisory Council, for example, studied continuing education for women as one way of meeting the pressing need for productive skilled labor and determined that the best underutilized source of such labor was the intelligent, educated, married woman, who would have to return to school to become fully marketable.[55]

In contrast, from the beginning CEW's female founders saw its mission as fostering equal opportunity for women and serving the needs of individual women as well as advocacy and research. The compelling need for that mission was illustrated by the hundreds of women who came to its tiny office in the League as soon as it opened its doors in the fall of 1964. Most of these "participants" told stories of educational and administrative obstacles placed in their way when they attempted to resume schooling. Louise Cain recommended that the new center provide information about the university's program requirements to returning women students, work with faculty and administrators to obtain flexibility in requirements and programs, and serve as a catalyst on campus to encourage young women who were already students at Michigan to complete their training and prepare for future careers.[56] Although she originally thought that the Extension Division could be the home for her ideas, Cain later emphatically resisted placing CEW under the administrative control of that division. She was certain that such a move would confine the center to second-class status within the university.

Despite her courage and vision, Louise Cain was also subject to family pressures. When, just as CEW was about to open, her husband was invited to Washington, DC, to become an assistant secretary of the interior in the Johnson Administration, it did not occur to her not to accompany him there. She believed that her obligations to CEW could be carried on by someone else. Jean Campbell, Cain's closest associate, was appointed acting director. The following summer Campbell's title was changed to director, a post she held with great distinction for over twenty years, until her retirement.[57]

From its origins CEW served as an insistent, if fragile, goad to the university bureaucracy. The Office of Affirmative Action did not yet exist, Betty Friedan's powerful book *The Feminine Mystique* was yet to be published, and the Women's Studies Program was still several years in the future. Most of the early achievements of CEW were informal, often temporary, and had to be fought for again and again. The Office of Admissions repeatedly informed

returning and nontraditional women students that the university did not accept part-time students. Departments had to be cajoled into accepting nontraditional doctoral candidates. With the assistance of LSA, CEW arranged for evening classes to accommodate mothers with young children and working women. Beginning in 1969 with a single course in the humanities, the program expanded to enroll over three thousand students.[58] In opening and developing paths to higher education for women at the University of Michigan, CEW identified an important need: by 1970, six years after it opened, nearly three thousand women had received advice and assistance from the center on their educational plans and job prospects.[59] CEW stood almost alone on Michigan's campus as an organized and institutionalized advocate for women, providing a new space for women students that was uniquely their own. Moreover, it served as a national model that would influence the developments of similar efforts at a wide range of other institutions of higher education.

Chapter 6

Change and Resistance

When President Robben Fleming (1968–79) reminisced at the end of his tenure as University of Michigan's president about the campus he had inherited in 1969, he described the main issues as being the Vietnam War and civil rights, "encumbered with a whole range of side issues. Life styles were changing rapidly: . . . Young people annoyed their elders by deliberately remaining unwashed, uncombed and often undressed! Drugs, both mild and dangerous, became part of the campus scene. Language hitherto unused in public places became prevalent . . . and the political extremists of both the left and the right did their best to exploit and exacerbate the situation."[1]

The 1970 *Michiganensian*, eschewing its middle-class hardcover, glossy-paged origins, appeared as a two-volume populist paperback. It painted much the same picture as did the president several years later: students with headbands, ethnic garb, shaved heads, either nude or arrayed in clothing made from American flags. Foul language did not translate easily into pictures, but the yearbook loudly proclaimed a whole new scene: anything goes, except the Vietnam War and the Washtenaw County Sheriff's riot squad. Students, it was thought, have every right to enjoy a bit of rowdy fun on South University Avenue, even on the president's front lawn. Joan Baez appeared on campus in a concert sponsored by the Tenants' Union, there was a "People's Parade," and the John Sinclair Freedom Rally drew thousands of students in support of the reform of marijuana laws. Nonetheless, the Michigan football team still played on Saturdays in the fall, homecoming rites survived, and on campus there were still as many conventionally dressed women as there were those clothed in artistic rags. The 1970 yearbook, however, did not provide the usual series of posed fraternity and sorority photographs. Instead, it included whole sections of candid shots from the campus. By 1972 the venerable *Michiganensian* was back to its old format, including fraternity and sorority photos. In accordance with the new mores, however, the Greeks' photographs were self-consciously informal. One way or another the clothes, the poses, and the hairstyles had changed. Indeed, the change since the early 1960s was remarkable.

Both President Fleming's and the *Michiganensian*'s assessments of the campus scene were essentially correct. Underneath this delightful, exuberant, and often exasperating rebellion ran a sincere and desperate streak of youthful idealism and hunger for change. Students were deeply involved in opposition to the Vietnam War and in the realization of freer sexual and behavioral mores. President Fleming's description of the times makes no mention, however, of gender issues as a part of campus concerns, despite the CEW's heroic but poorly supported efforts to produce change. As far as the university's senior administration was concerned, these were still largely parochial matters within academic departments or administrative units.

In the early 1960s campus social concerns emphasized ethnic and racial minorities rather than the "second sex." In 1962 the regents had adopted a nondiscrimination policy, formally welcoming members of all races and religions as students and faculty members but saying not a word about women.[2] On 27 May 1970, however, a catalyst was thrown into the largely inert cauldron of the university's policies on women. A group of women in Ann Arbor filed a complaint with the U.S. Department of Health, Education and Welfare (HEW), against the university, claiming that the University of Michigan was not in compliance with the Civil Rights Act of 1965 and a related Executive Order mandating nondiscriminatory hiring by government contractors.[3] These mandates, it was argued, applied to women as well as to ethnic minorities. As a major research university, Michigan had over sixty-five million dollars in federal research and other contracts; payment to the university on these contracts was jeopardized by the women's complaint.

Ironically, Michigan was at this time marking the centennial anniversary of the admission of women students to the university. Much of the actual commemoration was the work of CEW. In addition to publishing *A Dangerous Experiment*, CEW also sponsored a well-attended "teach-in," organized a Conference on Women, and established the CEW Scholarship Program for Returning Women. The university itself awarded Professor Elizabeth Crosby, the neuroanatomist, the long-overdue attention of an honorary degree, sponsored an exhibition of photographs by alumna Margaret Bourke-White, organized a fashion show of women's clothing styles over the past century, and held a reception for women faculty members. All of these events called attention to women in a way the university had seldom seen before.

The background to the complaint lodged with HEW in May 1970 helped set the context for these campus celebrations. In January 1970 a group known

as "FOCUS on Equal Employment for Women" was founded at the national level to mobilize women in opposition to President Richard Nixon's nomination of G. Harold Carswell to the U.S. Supreme Court; the members of FOCUS saw Carswell as flagrantly sexist. A local FOCUS chapter was soon organized in Ann Arbor.[4] A month later CEW arranged a visit to Michigan by Bernice Sandler, an academic from the University of Maryland who was seeking new strategies for improving the status of women on American university campuses. In a speech on campus Sandler suggested that women already possessed a powerful weapon in the form of Presidential Executive Order 11246, which had been signed by President Johnson in 1968. This order prohibited federal contractors from practicing sex discrimination. The Ann Arbor chapter of FOCUS decided to explore possible actions under Order 11246 and spent three months assembling evidence of discrimination against women at the University of Michigan.

In May 1970 FOCUS filed a comprehensive complaint with HEW. The complaint included indictments of the University of Michigan's treatment of women faculty, staff, and support personnel as well as the management of women's applications for admission, scholarships, financial aid, and varsity sports participation. FOCUS not only filed the complaint but also lobbied intensively and effectively with Michigan's congressional delegation in Washington, DC, to put pressure on HEW. To create support and awareness on campus, FOCUS members posted notices inside women's toilet stalls on campus. In this way the group acquired a captive audience for its appeals, and its notices could not be removed by unsympathetic men.

The complaint filed with HEW was one of the first sex discrimination complaints against an academic institution under Order 11246, the first to be investigated by HEW, and the first under which the execution of government contracts was delayed. Many complaints against other colleges and universities were subsequently filed. Ironically, the contract with the University of Michigan, which HEW suspended when the administration failed to develop an adequate affirmative action program for women, was one with Michigan's Center for Population Planning, which would provide and evaluate birth control services for women in Nepal.

The university responded to the women's complaint by creating a broadly based Commission for Women in late 1970. It was given official status in January 1971, when the assistant to the president, Barbara Newell, was appointed as the commission's chair by President Fleming. The commission, which

included representatives from academic departments, technical staff, clerical workers, students, and service personnel, had no supporting staff of its own except its part-time chair and a full-time secretary. Most of its work was done on a volunteer basis by women and men employed elsewhere in the university.[5] Nonetheless, the commission collected data and applied pressure to improve women's status at all levels of the university. Its most important work may well have been on salaries. Following Newell's departure, in 1971, Virginia Nordin, a researcher and administrator in the Law School, became chair of the commission. By November of that year the commission had completed a file review and found that, despite some unscheduled salary increases during 1971, many of which were also the result of the HEW investigation, salaries for men and women in comparable professional ranks at the University of Michigan varied by as much as six thousand dollars in some departments. Overall, women with ten to twenty years of service to Michigan earned only 64 percent of comparable men's salaries. In the Law School the figure was 45 percent, in the School of Business Administration it was 54 percent, and in the physical sciences it was 60 percent. In the so-called feminized fields women did better: women's salaries were 93 percent of men's in nursing, 90 percent in music, and 82 percent in library science. Those salaries that fell more than 10 percent below the average male salary level were subject to immediate adjustment under the university's new affirmative action plan.[6]

Overall, the disparity in opportunities between men and women working at the university remained unavoidably clear. At the time the Commission for Women was formed, one-half of all male but three-quarters of all female faculty held nontenured positions. Four out of every ten males earned over $1,600 per month, while only one in ten females received so high a salary. Among graduate students working for the university, women were more likely to be teaching assistants (70 percent compared to 58 percent), and men were more likely to obtain desirable research posts.[7] At the time, women made up 6.6 percent of the faculty, less than 5 percent of all full professors, less than 10 percent of associate professors, and 7.3 percent of assistant professors. In part to address these imbalances, the university in early 1971 established the Office of Affirmative Action (OAA) and in the fall of 1972 appointed Nellie Varner, a Michigan graduate and member of the university's political science faculty, to be the university's Affirmative Action director.[8] That fall the university proposed to HEW that it would initiate action to improve the numerical representation of women on both the staff and the faculty and would equalize salaries; HEW approved the proposal in 1973.

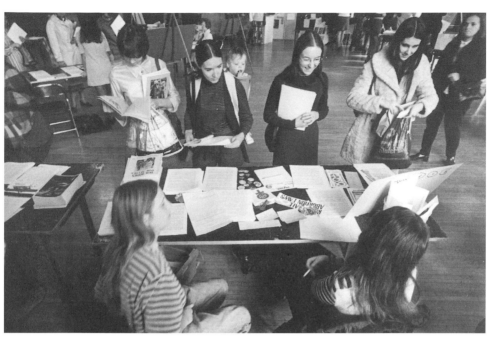

Students active in the women's liberation movement in the early 1970s used grassroots organization methods and informal exchanges to publicize their cause. *(News and Information Services, BHL.)*

An early meeting of the Commission for Women, established in 1971; chair Barbara Newell, left, also served as acting vice president for student affairs and was the first woman to sit at the executive officers' table. *(News and Information Services, BHL.)*

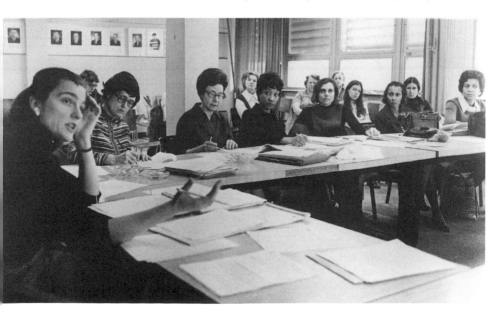

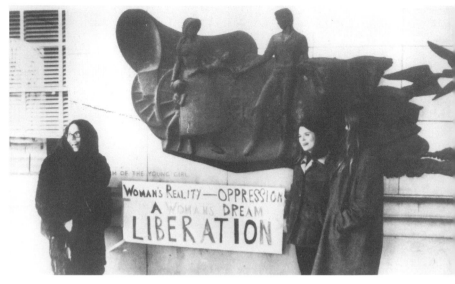

In the early 1970s women protested the "Dream of Young Girl," a bas-relief still on the front of the LSA building. *(CEW.)*

The university's program to enhance the hiring and promotion of women staff and faculty in the early 1970s drew protests from employees claiming it was too narrow in scope. In a meeting in the Regents' Room, Kathleen Shortridge points out that appointments in the School of Nursing accounted for a large proportion of the new faculty women hires. *(News and Information Services, BHL.)*

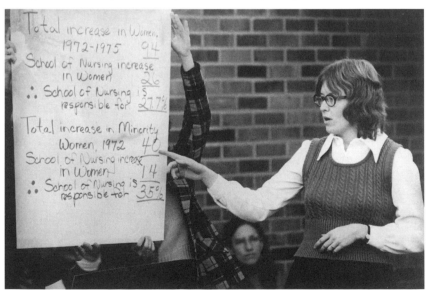

Faculty members Elizabeth Douvan, Kathryn Sklar, Margaret Lourie (standing), Lois Hoffman, and Norma Diamond, among the founders of the Women's Studies Program, speaking at the 1973 "New Research on Women" conference organized for CEW by Dorothy McGuigan. *(Courtesy Margaret Lourie.)*

Under pressure, the Athletic Department inaugurated intercollegiate athletics for women in 1973–74. Early women's teams included basketball, field hockey, swimming and diving, synchronized swimming, tennis, track, and volleyball. *(Athletic Department Records, Box 60, BHL.)*

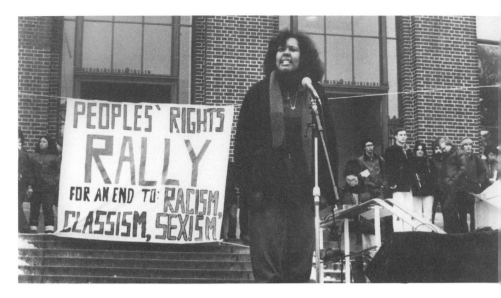

Student activism, while less than in previous decades, continued into the 1980s, as this picture of the Graduate Employees Organization People's Rights Rally illustrates. *(Daniel Chun Tuen Tsang, BHL.)*

Sarah Goddard Power demonstrated her commitment to university women, first as staff to the Women's Commission, and later as regent of the university (1975–87). *(Sarah Goddard Power Collection, Box 7, BHL.)*

In 1985 Linda Wilson was appointed vice president for research, the first time a woman had been named an executive officer of the university except in an interim capacity. *(Illini Studios.)*

Nellie Varner, the first African American woman to serve on the University of Michigan Board of Regents, being sworn in by Judge Daman Keith in 1981. *(Regents Collection, Box B18, BHL.)*

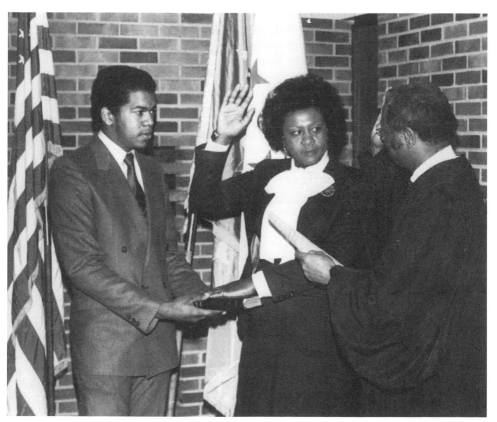

Center for the Education of Women founders in 1989 at the Center's twenty-fifth anniversary celebration. (*From left to right*: CEW director Carol Hollenshead and founders Jane Likert, Louise Cain, Marjorie Lansing, Jean Campbell, and Helen Tanner.) (*CEW.*)

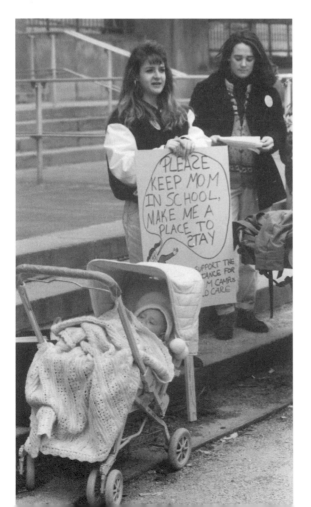

Students rallying on the steps of the graduate library in 1990 for improved child-care facilities. (*UM News and Information Services.*)

In the 1980s and 1990s computer literacy became a central element in the educational experience of women students in all fields. *(News and Information Services, BHL.)*

Blenda Wilson, University of Michigan Dearborn chancellor, appointed in 1988, speaks at commencement. *(UM News and Information Services.)*

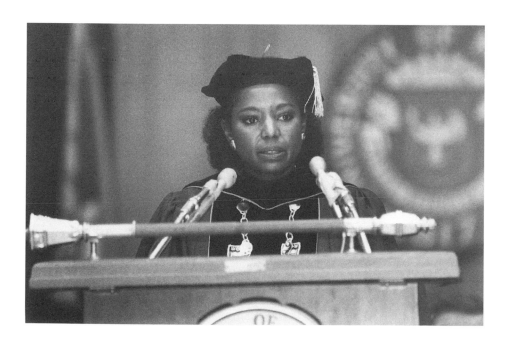

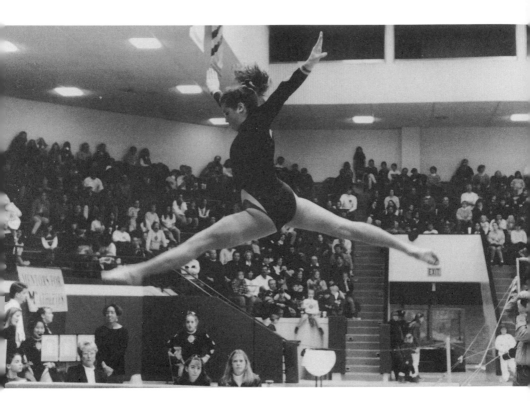

By the 1990s many of Michigan's women athletes had gained national prominence. Beth Wymer, shown here on the balance beam, was a three-time NCAA champion on the uneven bars. The women's gymnastics team won the Big Ten title for six consecutive years. *(News and Information Services, BHL.)*

Nancy Cantor, professor of psychology and dean of the Horace H. Rackham School of Graduate Studies, was appointed provost and executive vice president for academic affairs in 1997, another first for women of the university. *(UM News and Information Services.)*

President Fleming pointed out that both federal and state laws required equality of treatment for men and women employees. He promised a vigorous recruiting program to increase the number of women faculty at Michigan. Academic positions were advertised in appropriate journals, and additional efforts were made to identify both ethnic minority and women candidates. Fleming acknowledged that he did not believe in quotas for hiring but emphasized that he did believe in "preference in order to redress past discrimination."[9] In addition to active recruitment, Fleming favored achieving salary equity through payment of back pay, appointing women to university committees, and modifying Michigan's nepotism rules, as well as establishing a well-organized grievance procedure.[10] Administrative support for improving women's status, especially on the university faculty, seemed vigorous and sincere.

Yet, when compliance with the university's stated goals was left to voluntary efforts of the university community, it was incomplete at best. Action depended on the commitment of a number of independent colleges, schools, departments, institutes, and other administrative units, some of which went through the motions of ending discrimination but with very limited results. For the next several years, until its site visit to Michigan in 1977, HEW largely ignored the university's compliance reports, which would have revealed the true state of affairs for women at Michigan.[11] Of twenty-three new faculty appointments made at the January 1971 meeting of the Board of Regents, all were men, except for one woman in nursing.[12] In May 1972 only one woman was promoted to professorial rank.[13] Promotions at lower faculty ranks that year were a bit more encouraging, in that twelve of eighty-two posts went to women.[14]

In 1971–72 the College of Literature, Science and the Arts sounded an optimistic note when it reported that it had made substantial progress toward its affirmative action goals. Of the thirty-five regular instructional positions filled that year, six went to women, and the next year women were appointed to nine of the forty-five new instructional positions. The dean boasted that for the first time LSA had appointed a woman to a deanship.[15] The "deanship," however, was the relatively lowly one of heading the Office of Academic Counseling in the college. There were no tenured women on the political science faculty in 1971, when a senior position became available. According to Virginia Nordin, the search committee looking for candidates for the vacancy refused to consider qualified women. The committee replied, however, that it was being unfairly maligned, and in any event no women candidates met its standards.[16] This reply was typical of the excuses given to explain poor performance: for example, departments and colleges regularly argued

that the demand for women exceeded the supply or that women candidates could be found who were willing to accept part-time adjunct positions but not full-time, tenure-track faculty posts.

Although women were underrepresented on the faculty of the College of Education, making up only 21 percent of the total, the enrollment of women students had always been high. The college appointed its own internal Commission on Women in 1970 with the goal of recruiting women to its faculty when funds were available.[17] At the same time the Law School made its first female professorial appointments.[18]

The case of Anne Cowley is a vivid example of how difficult it was in the 1970s for women to be appointed to professorial rank. Cowley received a doctorate in astronomy in 1963 and took a faculty position at the University of Chicago. In 1967 both she and her husband were offered professorial appointments at Michigan. When they arrived in Ann Arbor, Anne's position had evaporated, and she was told she must obtain research grants to support her work for a year until departmental money could be found. Her salary, although paid by a research grant, was set ridiculously low by her department, and year after year her regular faculty appointment remained illusory. In 1973 she appealed to the Commission for Women, which agreed that her complaint had merit. Yet her department still refused to change her status. The federal Equal Economic Opportunity Commission (EEOC) offered to help her in court. She decided, however, that the time and emotional energy required to pursue the case were more than she cared to expend. Instead, she continued her research, and eventually she accepted a faculty position at another university. Only after her acceptance of this post did Cowley finally receive a promotion to full professor at Michigan—but the promotion came too late. In 1983, after she had left the university, Anne Cowley and two other researchers discovered a "black hole" in space, only the second such discovery and more credible than the first. Cowley had become a notable, highly respected scientist with an international reputation. Regent Sarah Goddard Power, always an activist for women's causes, bemoaned the university's loss of this truly important woman faculty member and her superb scientific achievements.[19]

Cowley's case may have been one of the most flagrant, but she was not alone. Anthropologist and art historian Kamar Aga-Oglu, who was trained at the Universities of Vienna, Jena, and Berlin, as well as at Michigan, joined the University of Michigan as a research assistant in 1938. She was appointed as a lecturer four years later but did not receive an assistant professorship for another twenty years. Thirty years after her first appointment she finally

became a full professor, just two years before she retired.[20] Aga-Oglu's case is typical of women who joined the faculty before the HEW investigation in 1970. Occasionally, a woman did receive her due, but such recognition was always belated. In 1951, just after she earned a doctorate, Eva Mueller was appointed to the research staff of Michigan's Institute for Social Research. Six years later, in 1957, she became an assistant professor of economics and was promoted to full professor in 1964. She also became an associate dean of LSA in the 1970s.[21] But Mueller, in moving up as quickly as she did, was the exception. By 1979, nearly ten years after HEW's investigation, only 16 percent of the university's regular faculty were women, and most of them were in junior and untenured positions.[22]

Women on the staff and faculty, especially younger women, had been growing increasingly dissatisfied with the university's affirmative action efforts. More dramatic and personal techniques were tried by the Commission for Women. A small unofficial group, composed chiefly of female staff, was concerned that President Fleming rarely met with women. This group sat outside the president's office for five days in April 1972 and recorded information on his visitors, who included 124 men and only 21 women; it was noted that the women were most often part of mixed male and female groups seeing the president. The only woman with whom the president met alone was Virginia Nordin, chair of the Commission for Women; 26 men, all white, met one-on-one with the president in the same period.[23] One could argue that so few women in the university community occupied positions of power that for Fleming to see as many as he did indicated that women, rather than men, enjoyed disproportionate access to the president. The activist women involved in the study, of course, did not see it that way.

Just after the HEW investigation in 1970 and the resulting push for affirmative action for women, the university's financial support from the State of Michigan was abruptly curtailed. In the scramble to replace these funds, tuition was raised so sharply that out-of-state enrollment declined, further reducing the university's tuition income.[24] Even in the face of these difficulties the Commission for Women managed to redress important sources of inequality, most notably the disparity in salaries between men and women at the same rank. The Office of Affirmative Action also highlighted the university's failure to recruit women faculty members. The University of Michigan faced a financial situation in which innovation was fiscally difficult and not likely to be welcome. Budgets were tight. Perhaps women's stories in the 1970s would have had a happier ending if the pressure for more women faculty and

equity in rank and salary had occurred during the economic expansion of the 1950s and early 1960s, when the university's enrollments and budgets were rapidly increasing.

Given their positions on the faculty, it is not surprising that women played little part in the governance of the university in the 1970s. The first woman to serve as an executive officer of the university was Barbara Newell, who was appointed acting vice president for student affairs in 1968 and later chaired the Commission for Women. Newell's appointment as acting vice president came about, however, as a consequence of her long friendship with President Fleming while both were at the University of Wisconsin–Madison and did not reflect a new commitment to gender equity within Michigan's senior administration. Although she served admirably from 1968 to 1970, during a period of intense student activism and protests unparalleled in university history, Newell's status as "acting" vice president was never changed. She was eventually replaced by a man and resumed her previous post as assistant to the president.[25] She left Michigan soon thereafter and later became president of Wellesley College, U.S. ambassador to UNESCO, and chancellor of the Florida State University system.

In 1970–71, at the time of HEW's investigation of the university's hiring practices, the only woman serving as a chair or director of a department within LSA was the head of the Kelsey Museum of Archaeology, who was not a member of the regular instructional faculty.[26] In 1974 Carolyne Davis, dean of the School of Nursing, was appointed associate vice president for academic affairs and thereby became the first woman to hold a permanent post in the University of Michigan's senior administration.[27]

The following year the Board of Regents offered the position of dean of the College of Literature, Science and the Arts to a female African American scholar, cell biologist Jewell Cobb. The offer, however, was quite unusual in that it did not include tenure and a full faculty appointment in an academic department of the college, and, instead of the standard five-year contract, Cobb was asked to accept the post for two years.[28] The zoology department refused to extend an offer of appointment with tenure to Cobb on the grounds that she did not meet its criteria for a professorial position. Women students, faculty, and staff protested, calling the offer "insulting," believing it was not made in good faith. Many thought that the administration had in mind its own male candidate, to whom it would offer a more appealing proposal after Cobb had declined the offer presented to her. In the end Billy Frye, a member of the zoology department faculty, not Cobb, was appointed dean of LSA.[29] It was not until two years later, in 1977, that Joan Stark became dean of

the School of Education, one of four women deans and directors appointed that year and the first to lead any college or school at Michigan other than the School of Nursing.[30]

Until the 1950s the faculty had had little say in university decisions. As late as the 1940s the university president firmly controlled policy-making, and the only faculty governing body that could possibly influence the president was the University Senate, which met only a few times each year. Chairs controlled their departments; deans made decisions for their colleges and schools. But in the 1950s a crisis of confidence developed that shook the university community. Concern over the U.S. House of Representatives' McCarthy Committee investigation of communism on U.S. university faculties led the Michigan faculty to demand more input into the decision-making process. By the 1970s faculty governance and control over salaries, promotions, and appointments was exercised by a multitude of committees at the departmental and college levels. In large measure the complex Michigan committee system, including executive committees of departments, colleges, institutes, and libraries, dates from those years.

During the 1970s women's inclusion in governing bodies varied widely. Of the twenty-seven appointments to university committees by the Board of Regents during the 1967 calendar year, none were women.[31] Small inroads were made, however, in the early 1970s. Ann Larimore of the geography department was appointed to the executive committee of Rackham Graduate School in July 1971 for a three-year term, and Mary Bromage was appointed to the Rackham Divisional Board in the Social Sciences and Education.[32] In the spring of 1972 seven women joined thirteen men as new appointees to university committees.[33] Less than a quarter of all regental committee appointments, however, were women.[34] By 1977 the number of women on such committees had dropped to 16 percent.[35] Nonetheless, women had made some progress toward greater representation in faculty governance structures, and, as women's influence grew, the pressure to increase the number of women faculty at Michigan also grew.

In her 1974–75 report Nellie Varner, director of the university's Office of Affirmative Action, summed up women's position on the University of Michigan campus. She saw two major problems. First, on the university staff, women dominated the lower ranks as clerks and administrative assistants. Second, academic women faced a parallel problem; they were usually lecturers, instructors, or, at best, assistant professors. Varner also found that women's employment at the university terminated at a disproportionate rate. The number of women in the research area had actually declined. Eighty-eight percent

of all positions were held by white men. Varner reiterated that positions for women on the LSA faculty posed the most serious problem. During 1973–74 twelve LSA departments had not met their own projections for adding women to the faculty, and eleven departments had not even taken the trouble to set goals. The oft-repeated excuse that there was a shortage of trained and qualified women was again advanced. Varner pointed out that there were women around the country who would be happy to come to the University of Michigan if they received reasonable offers.[36]

By the mid-1970s, the scope and mission of the Commission for Women were changing. In 1975 the Academic Women's Caucus, which had been a subcommittee of the Commission, spun off as a separate organization, leaving the Commission focused primarily on staff issues. In 1977 the Commission ceased reporting directly to the president and lost its independent status, paid chair, and staff position. Instead, the Affirmative Action Office was charged to provide support to a variety of constituency groups, including the Commission for Women, the Academic Women's Caucus, and the organization that later became the Women of Color Task Force, which began to coalesce in 1979 to address staff concerns and provide opportunities for professional development.

The university, however reluctant to hire and promote women, was quick to respond to symbolic changes. A committee was appointed in 1975 to plan for the International Women's Year. Ti Grace Atkinson and Betty Friedan, popular feminist writers, were invited to speak on campus, and exhibits of women's art and concerts by women performers were held. Honorary degrees were awarded to women, and the university's awareness of the changing roles of women was sung and resung.[37] But concrete progress on faculty and staff employment goals was minimal.

Even though change came slowly for women faculty and staff, the 1970s ushered in a sea of change for the university's women students. They rapidly moved into academic areas in which there had been very few women students during previous decades. By 1975–76, 28 percent of the Medical School class was female.[38] By 1976–77 nearly a quarter of the Law School student population was women, an increase of 400 percent in seven years.[39] By the mid-1970s the School of Dentistry admitted women as one-sixth of its entering class.[40] The School of Business Administration, which in 1970 had included women as only 6 percent of its entering class, raised that to 10 percent by 1972–73 through a program of active recruiting.[41] Three years later one-sixth of its students were women, in part as a result of the school's vigorous support for affirmative action under Dean Floyd Bond.[42] The Reserve Officer Training

Corps (ROTC) was at least symbolically integrated in the fall of 1970, with the acceptance of a woman student majoring in aerospace engineering.[43] The army commissioned two women students as officers in 1978, while the navy conferred special awards on women cadets and commissioned one woman officer.[44]

The College of Literature, Science and the Arts changed more slowly. Women's enrollment was still concentrated in areas such as English and foreign languages, and women faced formidable obstacles in the Rackham Graduate School. Part of the problem was lack of support for nontraditional students. The CEW provided some financial support for graduate women through scholarships, but it was not enough. In 1972 Rackham formed a study committee on the status of women in graduate education. At that time only about 13 percent of the university's doctoral degrees were awarded to women. The study showed women were discriminated against and lacked institutional support to allow simultaneous management of education, marriage, and children. In 1975 a program of awards was established to provide financial aid to returning students; applications for these awards were submitted directly to the dean of the Graduate School rather than to departments, to avoid possible discrimination against nontraditional students.[45] The Rackham committee on the status of women students agreed to disband in 1978 because its members felt that it was basically impotent; most decisions were still made at the department level. Fortunately, by that time some departments had established semiofficial women's caucuses to carry on the fight.[46]

Small numbers of women were admitted to the College of Engineering, in which for the most part they did well. By 1977–78 eight women students were on the Engineering Council of the College, and Amy Hancock was selected as the outstanding undergraduate student and received the college humanities department's technical writing award.[47]

In some other Michigan colleges women also made tremendous inroads during the 1970s. Although there had been no female pharmacy students in the mid-1950s, by 1973–74 almost 53 percent of undergraduates in the College of Pharmacy were women. Michigan's was the first College of Pharmacy in the mainland United States to enroll more than half women.[48] The College of Architecture and Urban Planning continued to be dominated by men, but nearly one-third of the students of urban planning were women, and in the Department of Art women made up 72 percent of incoming students.[49] Education, which had always welcomed women as students, developed new courses on sexism in education, sponsored workshops on sexism, and assem-

bled a bibliography and guidelines on nonsexist language.[50] The elimination
of gender segregation spread to the School of Nursing, which admitted men
to its student body for the first time in 1970. By mid-decade, however, the
number of men in the school remained small, reaching only about 3 percent
of undergraduates.[51]

At least some of the credit for the advances by women students must go to
the Center for the Education of Women. Women were eager to explore new
academic areas and to prepare for nontraditional careers, but administrators
in colleges and departments were still wary of change. CEW fought many
grassroots battles with department heads and deans on behalf of individual
women and, in doing so, helped prepare the way for the growing number of
women who followed. From 1970 on, CEW established an increasing number
of scholarships, many of which went to women treading new paths. In the
long run this support for change in the distribution of women students helped
pave the way for women faculty and staff in larger numbers. The 1980 *Michi-
ganensian* took note of CEW's pioneering contribution in a two-page article
emphasizing CEW's special mission in aiding the nontraditional student. Not
only had CEW counseled hundreds of individual women annually, but it had
also pressed for the introduction of night classes; supported special instruction
in writing, mathematics, study skills, interviewing techniques, and building
job skills; researched women's experiences; and acted as a voice for institu-
tional change at the university.[52]

The University of Michigan campus accommodated women's growing
role in other ways as well. In 1970 a Women's Advocate Office was created
under the vice president for student services to work toward further changes
for women in the university community. Under the guidance of Claire
Jeanette and her successors, it tackled everything from permitting women to
join the University of Michigan Marching Band to advocating for the intro-
duction of a Women's Studies Program.[53] The Office of Career Planning and
Placement initiated job-search workshops to assist women with resume writ-
ing and interviewing techniques. Recruiters coming to campus were told that
they must interview women as well as men, and an annual Women's Career
Fair was held at which hundreds of women, both students and staff of the uni-
versity, explored the job market and career opportunities.[54]

Other areas of social and gender relations among women at Michigan
were also changing. Intense homosocial relationships among women had
flourished on campus from the 1870s. For example, Alice Freeman and Lucy
Andrews considered themselves "a Boston marriage," a term frequently used
in the nineteenth century to describe emotional commitment between

women. They lived together while both were at Michigan as undergraduates, and their deeply committed friendship, or "love," as they often called it, continued for years after they left the campus.[55] Since during the late nineteenth century such relationships were not seen as sexual, they were fully tolerated. But by 1900 intense same-sex relationships were increasingly seen as "perverted," and soon they were met on campus with complete intolerance. One lesbian, a student during the 1940s, revealed only in the late 1980s her fear when, as a Michigan student, she had struggled to maintain her privacy about her sexual orientation.[56]

Not until the 1970s was homosexuality openly acknowledged on campus. At that time Gayle Rubin, a student activist and member of the Student Government Council, formed a campus organization of lesbian students. This was the beginning of the radical lesbian student movement at Michigan, which over time consisted of several different groups of varying organizational coherence and social militancy.[57] In 1971 the Human Sexuality Office opened with Cynthia Gair serving as the first lesbian advocate. It offered counseling for students and served as an advocate for gay and lesbian rights on and off campus. The office, which later became the Lesbian and Gay Male Programs Office and subsequently the Lesbian, Gay, Bisexual, Transgender Affairs Office, was the first of its kind at an American university.[58]

The use of the Michigan Union underwent fundamental changes. Women had finally been allowed to enter through the front door in 1954, but during 1977–79 a plan was implemented to convert the building into a student activities center. The hotel rooms were eliminated. Management was placed under the vice president for student affairs, replacing the old Board of Directors, which largely reflected the interests of male alumni. Food and other services were redesigned to meet the needs of both male and female students.[59] The Student Activities Building had long since been outgrown, and the Union was now slated to provide a new focus for student activities on the central campus.

Students also began to participate in limited ways in university governance. The LSA faculty code had been revised in 1968–69, authorizing students to serve on university committees, and faculty meetings were opened to students. In the College of Pharmacy two students were elected to the six-member curriculum committee, with the same responsibilities and vote as faculty members; elected students made up the majority on the discipline committee. In the School of Public Health six student members joined the core curriculum committee.[60] As a result of a heated controversy in 1967–68 about the appropriateness of classified government-sponsored research in a university setting, a faculty-student committee was created and charged with

reviewing all proposed classified research at the University of Michigan. In one year sixty-four proposals were reviewed.[61] Students were entering the inner sanctum of the university establishment. While none of these committees were concerned particularly with women's issues, women students served on all of them, and inevitably the parochial male point of view that had prevailed for so long was faced with some challenges.

The Michigan social scene continued to emphasize gender integration and independence. Although the fraternity/sorority lifestyle did not disappear, it attracted only about 5 percent of the students.[62] Most undergraduates chose to live in coed dorms or apartment buildings and maintain an independent focus. More and more student organizations included both men and women. In 1977 Mortar Board, formerly the preeminent women's honor society, initiated eight male members.[63] Men's honoraries with their time-honored bizarre rituals were less quick to embrace gender integration. Twenty-two out of thirty-three campus recreational sports clubs included both men and women students.[64]

While intercollegiate athletics did not embrace gender-integrated teams, the Athletic Department, under pressure, inaugurated a women's varsity athletics program. In 1972 Congress enacted Title IX, which prohibits sex discrimination in educational programs that receive or benefit from federal funds. Under Title IX schools are required to provide equal athletic opportunities for men and women. In order to respond to the requirements of Title IX, president Robben Fleming created the Committee to Study Intercollegiate Athletics for Women, headed by Eunice Burns who was then also the chair of the Commission for Women. In response to the committee's recommendations, varsity level competition was instituted under the aegis of the Athletic Department in 1973–74, and Marie Hartwig was appointed associate director for women's intercollegiate athletics. By 1974 seven women's sports teams were in place: basketball, field hockey, swimming and diving, synchronized swimming, tennis, track, and volleyball.[65]

The demolition in 1977–78 of the Barbour Gymnasium symbolized the changing campus atmosphere. The gym, originally built in 1896, had served as a center for women's separate activities on Michigan's increasingly gender segregated campus; it had amply filled its mission as the center of a strong women's community. By the 1970s sites for new construction on the central campus were at a premium, and plans were in place to greatly enlarge the chemistry department's facilities, a goal that was not to be realized for over ten years. To make room the regents decided to raze the Barbour Gymnasium; an easy decision, they thought. One of the regents commented that the gym had

not been "of great significance" to the university's history.[66] He was wrong, of course, and the regents' decision met with some opposition and protest. Many members of the university community felt the building's architecture alone merited its survival, and as the walls went down during its demolition many an alumna picked up bits of memorabilia from the old building. By now the Michigan League building had been almost totally converted to meeting rooms, restaurants, hotel rooms, and catering services, and its function as a center of women's activities was largely lost. For the first time in seventy years, with the exception of CEW, women had no building of their own on campus. They wanted something more that belonged to them, and perhaps they found it in a new variety of academic curricula rather than in physical space.

While women students began to enroll in instructional areas in which they had been unwelcome for decades, they also found new curricular initiatives that specifically met their needs and eventually provided a special space for women on campus. In the entire United States a mere seventeen courses in women's studies were taught in 1970. By 1980 over three hundred and fifty women's studies programs were operating nationwide, and the number continued to grow throughout the 1980s.[67] This growth coincided with an exploding body of scholarship and research on women, an expansion that affected many disciplines but especially those in the social sciences and humanities. Much of this scholarship was generously supported by private foundations and federal research funds, and it had a profound effect on the conventional curriculum developed by the existing departmental structures.

Unlike a noninstructional service and research and advocacy unit such as CEW, the initiative for a women's studies program was an academic and curricular program that had to be lodged within the university's academic structure. If it was to develop a viable course list and program requirements, it had to be placed within the College of Literature, Science and the Arts, where most of the faculty who could constitute its instructional staff were already teaching. By 1972 a grassroots movement to establish women's studies at Michigan resulted in an ad hoc committee, composed of students, faculty, staff, and women from the Ann Arbor community, which developed the first version of a basic introductory course. Diverse in interests and status, the committee crafted a proposal to create a women's studies program built on the premise that feminist questions could inform scholarly work to produce new theory and knowledge. Key to the successful creation of the program, as well as its evolution and institutionalization, was the involvement of senior faculty, including Louise Tilly in history, Norma Diamond in anthropology, and Elizabeth Douvan and Lois Hoffman in psychology. In the spring of 1973 LSA's

Executive Committee approved the ad hoc committee's work, and the follow-ing fall the first five women's studies courses were introduced. A quarter-time director and half-time secretary were budgeted to support the new program. An undergraduate major in women's studies was approved in 1975, and Mar-garet Lourie became the first director of the Women's Studies Program.[68] Instruction in the program was undertaken by faculty on loan from other departments, but in 1980 two half-time faculty positions (one shared with a humanities department and one with a social science department) were cre-ated in Women's Studies. Graduate courses were added in 1984, with the cre-ation of the graduate certificate program.

Support from the LSA administration itself was not generous, and the Women's Studies Program continued to rely almost entirely upon other departments for its faculty. By 1992 only two and a quarter full-time equivalent faculty appointments were budgeted for the program; therefore faculty who taught in the program also had major commitments in other departments, in which decisions on tenure, salary, and promotion were largely made. Budgets for women's studies faculty grew very slowly, and support for and recruitment of graduate students was limited. In 1991 the Rackham Graduate School com-mitted itself to providing one dissertation fellowship per year to the Women's Studies Program.[69] In the fall of 1994 the Women's Studies Program launched an interdepartmental doctoral degree program, in cooperation with the En-glish and psychology departments, and by 1988 seventeen students were enrolled.[70] The faculty associated with the Women's Studies Program have had a great impact on the direction of social sciences and humanities scholar-ship at the University of Michigan. These scholars have deeply shaken the standard conceptual and methodological conventions of these disciplines. As a result, course offerings in many LSA departments have been expanded and enriched.

By the end of the 1970s the long-established constraints on women stu-dents' academic fields at Michigan had for the most part disappeared. Women studied law, dentistry, medicine, business, and, less often, engineering along-side male students. Women on the university's staff had made important breakthroughs in salary equity and in gaining administrative positions. As fac-ulty, however, women's position at Michigan was still precarious. Equality was still a long way away.

Chapter 7

Victory or Accommodation

By 1980, as we have seen, the status of women students at Michigan had changed once again. Undergraduate and professional programs admitted women with few if any restrictions and, most of the time, welcomed them. Graduate school curricula were open to women, although in certain areas women could expect to be received with less than genuine enthusiasm. Student activities were largely coeducational. Women students had regained the position they held at the University of Michigan in the 1870s and lost at the turn of the century.

It is also tempting to view the 1980s and 1990s as a period of unmitigated progress, a time when women bridged the final gap and assumed an equal place on the faculty, in university governance, and in administration. In 1980 women still had a long way to travel on this road, but in the following fifteen years women faculty chaired departments in the LSA, including the Departments of Psychology and Political Science, in which a large majority of the faculty were men, and the Department of English, in which women had always clustered as students but earlier had been unwelcome as faculty members. In 1989 Edie Goldenberg, a professor of political science, became the dean of LSA, which for many decades had been a bastion of male hegemony at Michigan.

The College of Literature, Science and the Arts is the core of the university. Not only does it embrace widely disparate disciplines in both the sciences and humanities, but it is also the division of the university with the longest history. At the turn of the century it had been the Literature Department that feared feminization as female enrollment increased, and in the 1970s LSA fiercely resisted the imposition of HEW department guidelines on faculty hiring and graduate admissions. Its many baronies provided a decentralized feudal system in which pockets of conservatism could hold out almost indefinitely. Did the 1980s and 1990s at long last see the appointment of women in equitable numbers to faculty and administrative positions in LSA? To be sure, some progress was made. But did the appointment of Edie Gold-

enberg as dean signal a transition to a gender-blind university, or did it merely signify a concession to the times that could well be followed by new obstacles to women's equality?

By the late 1980s the opening of university academic programs previously closed to women was almost revolutionary in scope. For example, in the School of Dentistry the proportion of women earning degrees had increased from little more than 1 percent to 32 percent. Nearly half (44 percent) of the Business School's undergraduate students were female, as were 26 percent of its doctoral degree recipients.[1] Also by the late 1980s women constituted 35 percent of the Law School's degree recipients and 28 percent of Medical School graduates as well as 12 percent of master's degree recipients from the College of Engineering.[2] While still relevant, gender was becoming less important with regard to access to the university's classrooms.

The place women students had won in student leadership in the 1970s was strengthened during the following decade. Women editors figured prominently on the staffs of the *Michigan Daily* and the *Michiganensian*. In 1991 over a third of the *Daily*'s editorial staff were women, as were over two-thirds of the *Michiganensian*'s staff.[3] When the Michigan Union was remodeled, restructured, and revitalized in the 1980s, it was designed as a coeducational facility. The coed University Activities Center was by that time the largest student-run organization on campus, sponsoring films, theatrical productions, lectures, parties, and special events. In 1982–83 its president was a woman, as was one of its vice presidents.[4] The women's glee club went on its first national tour in 1987, emulating the men's glee clubs, which had been touring for years.[5] The student branch of the American Institute of Industrial Engineers also finally included women engineering students.[6]

Women's athletics received considerable attention on campus. The *Michiganensian* and the *Daily* often gave women's intercollegiate softball, basketball, tennis, track, golf, gymnastics, swimming, and field hockey teams as much coverage as the men's teams.[7] The *Daily*, however, continued to slight women's sports when pressure for space was great, for example if the Michigan football team went to the Rose Bowl. But, overall, women were becoming more prominent in student athletics and intramural sports at all levels.

In the 1980s housing continued to be gender integrated; most dormitories housed both men and women. There were exceptions, like Stockwell, Martha Cook, and Betsy Barbour Halls, whose sponsoring donors had stipulated that they house only women. Similarly, two all-male houses remained in the West Quadrangle. Several minority housing programs, such as Abatana in South Quad, Abeng in East Quad, and Macs at Markley Hall, included both men

and women. At the same time fraternities and sororities, which were gender segregated, grew rapidly.[8] Student housing near the central campus was plentiful in the early 1980s, but by the fall of 1986 the vacancy rate was .076 percent, permitting students no leverage against rapacious landlords and rapidly rising rents. University dormitories were at full capacity.[9] A Tenants' Union, originally formed in the 1970s, attempted to provide student renters with some bargaining power.

Women did continue to demand and receive some separate spaces of their own. The Women in Science (WIS) program (later named Women in Science and Engineering [WISE]) was founded by a group of women faculty and staff and incorporated into the Center for the Education of Women in 1980, under the direction of Barbara Sloat. In 1993 the CEW WISE program, in collaboration with the Office of Student Affairs and the Housing Division, opened the WISE Residential Program. This "living-learning" initiative was designed to reduce the high attrition rate among women students during their first year of study in the sciences and engineering.[10]

As the sexual freedom of the 1960s and 1970s gave way to campuswide concern about women's physical safety, sexual harassment and rape became major student issues. The old in loco parentis rules had become unenforceable, which provided both an opportunity for greater exploitation of women and a genuine opportunity to acknowledge the exploitation. In 1986 an anti-rape sit-in took place in Vice President Henry Johnson's office, and a list of demands—including better lighting on campus walkways, emergency telephones throughout the campus, "Nite Owl" bus services, and a rape and sexual assault counseling facility—was presented to university officials. All the demands were eventually met, and the Sexual Assault Prevention and Awareness Center (SAPAC) was created.

Campus women found the new campuswide concern with gender and sexuality issues a source of strength. One LSA junior was quoted by the *Michiganensian* as saying that the "Take Back the Night" rally, which began in 1980 and included a nighttime march of large numbers of women through midtown Ann Arbor, had been the most empowering experience she had as a student at Michigan.[11]

In 1980, under President Harold Shapiro (1980–87), the university adopted specific guidelines to protect all university employees and students from sexual harassment.[12] The Affirmative Action Office set up an extensive training program to combat sexual harassment and developed a training package extensively used within the university.[13] The new policies were aimed not only at faculty-student relationships but also at university staff employees.[14] In

1994 the university elaborated on the 1980 harassment guidelines by establishing formal procedures for students and university employees to pursue complaints of sexual harassment.[15] Incidents of sexual harassment were not eliminated from the campus, however, and women's complaints were still sometimes ignored or belittled.[16]

Child care remained a pressing issue for parents within the university community—especially women. Based on the recommendations of the 1988 Dependent Care Task Force, the Family Care Resources Program was established in 1990 within Human Resources with Leslie De Pietro as its director. At first it served only faculty and staff, but in 1992 students were included. The program was charged with providing referrals for child care, elder care, and care for disabled adults as well as sponsoring educational programs and promoting family-responsive policies and practices.

By 1991 a variety of student groups were challenging the conventional definitions of what constitutes a "family," and gay and lesbian students and couples challenged the university to accept them as qualified applicants for university family housing facilities. When the issue was first brought before the regents, the board opposed the student demands, but in 1993 it issued a decision prohibiting discrimination on the basis of sexual orientation and provided university students and employees at least declaratory protection from bias on campus. By 1994 the regents were committed to implementing this new nondiscrimination policy, although political and religious opposition to the new policy continued.[17]

Graduate students have often occupied the anomalous position of being not only students at the university but also, in many cases, classroom instructors and staff members. In 1991 women made up 41 percent of the graduate students at Michigan, and they held approximately the same proportion of Teaching Assistantships (TAs, later known as Graduate Student Instructorships, or GSIs) as men. The fact that more of the coveted Research Assistantships (RAs) were held by men than by women graduate students is due in large part to the fact that more RA positions are available in engineering and the sciences, in which there are far fewer women than men graduate students.[18] Women graduate students in these male-dominated fields continued to be "at risk." According to surveys developed by the Center for the Education of Women, women graduate students in the physical sciences and engineering disciplines were less likely than women in other fields to believe that they would complete their degrees. They were also less likely to say that they enjoyed their classes, indicating at least in part that the old sexist classroom dynamics and prejudices remained in the science and engineering disciplines.[19]

Women graduate students in general wished that they could interact with more women faculty, and they noted inappropriate mentoring and misguided advising more frequently than their male counterparts. Women graduate students were also much more likely than men to feel belittled or ignored. As one woman student reported, "the professor consistently put down women's comments."[20]

CEW survey data also indicated that, by the early 1990s, 20 percent of women graduate students at Michigan had children. This figure was remarkably consistent across the disciplines, except in education, in which the number of women graduate students with children rose to 42 percent. Responsibilities for raising children greatly complicated these women's lives. They had more difficulty coordinating parental, academic, and work demands and schedules than did male graduate students with children, and women sometimes felt departmental disfavor on account of having children. They cited the lack of flexibility in course or laboratory scheduling to accommodate their family responsibilities, and they bemoaned the limited availability of on-campus daycare facilities and the high costs of child-care services.[21]

Nonetheless, women were finding a place on the university faculty and in its administrative structure during the 1980s and early 1990s, although they were still heavily outnumbered by men. By the early 1990s women constituted half the student body, one-fifth of the faculty, and one-twelfth of the administration.[22] Almost fifteen years elapsed between the departure of Barbara Newell from the university's executive officer corps and the appointment of another woman to Michigan's top administration. In 1985 Linda Wilson, a science policy and research administration specialist and dean of the Graduate College of the University of Illinois at Urbana-Champaign, was appointed Michigan's vice president for research. This was indeed a breakthrough; it was the first time a woman had been appointed as an executive officer of the university, except in an interim capacity. At the Dearborn campus Blenda Wilson was appointed chancellor in 1988, the first African American woman to hold an executive officer position at the university. In nonacademic administrative staff positions women outnumbered men. By 1990 women held two-thirds of the senior line positions in Student Affairs, while at the same time there was not a single woman administrator in the Business and Finance or Development offices or in the Office of President.[23] Maureen Hartford was appointed vice president for student affairs in 1991, the first woman to hold that position except in a temporary, or "acting," capacity. The School of Social Work appointed its first woman dean in 1992. In 1994 Rhetaugh Graves Dumas, who had been dean of the School of Nursing, was appointed vice provost for health

affairs, a position that included administrative responsibility for the University Hospital and the Medical School. Women were also appointed as deans at the College of Literature, Science and the Arts, as we have seen, and at the Schools of Art and Public Health, and women were considered for deanships at other schools, including the Law School.[24] In 1996 Nancy Cantor, a professor of psychology, was appointed dean of the Rackham School of Graduate Studies as well as vice provost for academic affairs.

As the 1980s began, women were still underrepresented throughout Michigan's faculty ranks. Two factors, however, were working in their favor. The inroads women had made into the university's committee and governance structures were maintained, and for the first time women faculty and women's issues had strong and vocal female advocates on the University Board of Regents. Early in the decade regents Sarah Goddard Power and Nellie Varner repeatedly questioned the paucity of women faculty in an institution in which half the students were women. They consistently argued that the university was not aggressively seeking women candidates for tenure-track faculty positions.[25] Power questioned whether affirmative action remained (or perhaps ever was) a priority of the leadership of the university's schools and colleges and asked for a meeting with the LSA Executive Committee because of its poor showing in hiring women faculty members.[26] She also insisted that more women be appointed to school- and college-level executive committees so as to be in a position to influence faculty promotion and tenure decisions.[27]

In 1985 Virginia Nordby, director of the university's Office of Affirmative Action, echoed Power's discontent. While she commended Engineering, Law, Architecture, and the Departments of Sociology, Urban Planning, and Internal Medicine for recruiting women, she contended that overall the university was not tapping the available pool of qualified women and that the number of women appointed to the assistant professor rank had actually dropped.[28] Two years later, in 1987, only 179 women, constituting just over 11 percent of the total, served in the senior ranks of the university's regular instructional faculty.[29]

In spite of the progress of the 1970s, by the late 1980s it had become clear that further action was needed. In the summer of 1988 an ad hoc group of women staff and faculty leaders, convened by Carol Hollenshead, who had recently been appointed director of CEW, met with provost James J. Duderstadt to discuss the status of women at the university. Duderstadt had just been chosen by the regents to be inaugurated as the university's eleventh president. By the end of the meeting it was agreed that the group would prepare a document reviewing progress and recommending actions the new president could take to advance equality for women.

That December the "Women's Agenda for the 1990s" was submitted to the president. It urged the university to "make a commitment to providing national leadership" and "an institutional commitment to women and women's efforts to participate fully and to achieve and contribute."[30] The agenda called for attention to mentoring, workload balance, and institutional responsiveness to work/family issues as well as to reinvigorated programs for targeted hiring and salary equity. It also emphasized the need for special efforts to address the "double jeopardy" of race and sex discrimination experienced by women of color.[31] Noting that the majority of staff were women (largely in positions of lower pay and status), the agenda recommended improved programs for staff development and recognition, as well as the creation of a leadership institute and improved dependent care policies. Student concerns included equity in financial aid, increasing the proportion of women in Ph.D. programs and in nontraditional fields, and the need to mainstream gender issues in the curriculum.[32] In an attempt to reinvigorate reform efforts and to provide leadership in institutional policy development, the report called for the creation of a presidentially-appointed body composed of a cross-section of the community to advise the president about "issues, policies and practices which affect women faculty, staff and students."[33]

With a standing-room-only audience of over 300 in the Michigan League, President Duderstadt responded to the committee by announcing the appointment of the President's Advisory Commission on Women's Issues, to be chaired by Carol Hollenshead. Over the next decade the commission successfully pressed for policy revisions and the development of new programs benefiting women. Many of these addressed dependent care issues confronting faculty and students as well as staff. Special hiring programs were created and career development awards for women faculty were initiated. Increased attention was given to improving campus safety for women and to ameliorating sexual harassment.

In 1990 the Women's Studies Program was reorganized and given additional resources and support following an external review that built on an internal review chaired by psychology professor Patricia Gurin. This process led to a new executive committee governance structure for the program and a dean-appointed director, replacing the program's collective style of governance and rotating directorship that had been in place since its inception. The program's budget, faculty size, and student enrollment grew after implementation of these changes.

Overall, progress in hiring and retaining women faculty continued to be minimal. Between 1980 and 1990 women's presence on the tenured and tenure track faculty grew by a mere 1 percent—from 17 to 18 percent of the fac-

ulty. By 1990 women represented 30 percent of instructors and assistant professors but only 23 percent of associate professors and a paltry 9 percent of full professors. At the same time 47 percent of the lecturers were women.[34] "The higher the fewer" was still an apt description of women's status on the University of Michigan faculty.

Across the university, while 52 percent of the men hired as assistant professors for the academic years 1982–88 had been promoted to tenured positions by the fall of 1995, only 42 percent of the women starting in the same rank at the same time had achieved tenure in the same period. For members of the faculty who were people of color, 53 percent of men and only 38 percent of women received tenure over the same period.[35]

In 1994, in response to the university's dismal record of promoting and retaining women of color faculty (in 1996 only 4 percent of the faculty), CEW and the Women's Studies Program launched the Women of Color in the Academy Project. Supported by the university's central administration, the project was designed to highlight the contributions of women of color and to advocate for needed institutional change. Perhaps the greatest contribution of the project has been to build a network of women of color faculty across campus, reducing isolation and creating community.

While their numbers remained relatively small, women faculty at Michigan received a share of such national honors as the prestigious John D. and Catherine T. MacArthur Foundation "genius" grants. They also received internal university prizes. Two women received Distinguished Faculty Awards for teaching and research in the fall of 1980, for example, and in 1981–82 two of the eight Business School faculty awards were given to women.[36] In 1994 professor of psychology Elizabeth Douvan delivered the university's Henry Russell Distinguished Lecture, only the second woman in the university's history to be so honored. Women also served on or chaired Michigan's faculty governance panel, the Senate Advisory Committee for University Affairs (SACUA).

Affirmative action for women at the university had worked, albeit imperfectly. It did not bring full equality, but it worked well enough to bring substantial and noticeable changes. Many on campus could well remember when women were expected to function as faculty wives, secretaries, and occasionally as overtrained professional underlings. A brief vignette from the late 1980s perhaps exemplifies the important changes at Michigan as well as any statistics. On a beautiful spring day in Ann Arbor three women were walking down State Street, talking earnestly together: one was the chair of an LSA

department, another was the director of a major U-M unit, and the third was a dean of a college. This was progress indeed.

But there was still much work to be done. In April 1994 President James J. Duderstadt (1988–96) announced the new "Michigan Agenda for Women," a policy statement on university goals that included a commitment to create at the University of Michigan a climate "that foster(s) the success of women faculty, students and staff."[37] To implement this goal a number of promises were made by the university administration. These ranged from new faculty hiring programs for women, frequent reassessment of salaries and the allocation of university resources, to making the University of Michigan a national leader in the study of women and gender issues. By 1996 the proportion of tenured and tenure-track women on the faculty had increased slightly to 22 percent.[38]

That same year the university established the Institute for Research on Women and Gender with Abigail Stewart, professor of psychology and women's studies, as its founding director. The institute was established to stimulate interdisciplinary research on women and gender and serve as an institutional umbrella for many ongoing research efforts.

In 1997 another historic step was taken when President Lee C. Bollinger announced the appointment of Dean Nancy Cantor to the position of provost and executive vice president for academic affairs. In 1998 President Bollinger and the regents named Susan Feagin the new university vice president for development, Cynthia Wilbanks as vice president for government relations, and Lisa Tedesco as vice president and secretary of the university. For the first time, five women were sitting at the executive officers' table on the Ann Arbor campus of the University of Michigan. With the new institute in place, the Center for the Education of Women continuing its work, the Women's Studies Program maintaining its growth, a woman provost at the helm, four other women executive officers at the table, and a renewed university commitment to women's equality, was the promise of 1870 finally being fulfilled? Only time will provide the answer.

Appendixes

Appendix A: Tenured and Tenure-Track Appointments Held by Women
on Regular Instructional Faculty—University of Michigan, Ann Arbor
(in percentages)

	1980	1990	1996
College of Architecture and Urban Planning	8	16	19
School of Art	23	34	23
School of Business Administration	7	15	20
School of Dentistry	8	11	19
School of Education	21	23	43
College of Engineering	2	5	8
School of Information	32	50	30
Division of Kinesiology	26	32	38
School of Law	4	12	15
College of Literature, Science and the Arts	11	16	23
Medical School	14	16	18
School of Music	19	20	29
School of Natural Resources and Environment	7	15	24
School of Nursing	96	94	93
College of Pharmacy	17	25	21
School of Public Health	14	20	25
School of Public Policy	NA	NA	25
School of Social Work	23	46	47
Total	17	18	22

Source: Center for the Education of Women, *Women at the University of Michigan,*
vol. 3 (Ann Arbor: CEW, 1996), 2.5–22.; Office of the President, *Climate and Charac-
ter* (Ann Arbor: University of Michigan Press, 1997), 47–83.
Note: NA = not available

Appendix B: Tenured and Tenure-Track Appointments Held by Women in the College of Literature, Science and the Arts—University of Michigan, Ann Arbor (in percentages)

	1980	1990	1995
Anthropology	21	18	28
Asian Language and Culture	20	18	24
Astronomy	0	0	0
Biology	6	11	17
Chemistry	3	5	12
Classics	13	12	25
Communication	7	20	0
Economics	7	8	7
English Language and Literature	13	23	40
Geological Sciences	0	4	8
Germanic Language and Literature	25	24	31
History	5	21	35
History of Art	39	53	48
Linguistics	25	31	38
Mathematics	0	4	4
Near Eastern Studies	11	6	6
Philosophy	12	6	15
Physics	0	3	4
Political Science	9	15	23
Psychology	17	27	33
Romance Language and Literature	21	25	40
Slavic Languages and Literature	8	18	27
Sociology	14	30	36
Statistics	0	14	13

Source: Center for the Education of Women, *Women at the University of Michigan,* vol. 3 (Ann Arbor: CEW, 1996), 2.23–50.

Notes

Chapter 1

1. Letter from Frieda Blackenburg to F. Clever Bald, 1 December 1954, Madelon Stockwell Papers, Bentley Historical Library (hereafter BHL), University of Michigan.

2. Autograph book, Stockwell Papers, BHL.

3. Howard Peckham, *The Making of the University of Michigan* (Ann Arbor: University of Michigan Press, 1967), 65, 82.

4. The best discussion of women's initial push into American higher education is found in Barbara Miller Solomon, *In the Company of Educated Women* (New Haven: Yale University Press, 1985). Earlier analyses include Mabel Newcomer, *A Century of Higher Education for Women* (New York: Harper Bros., 1959); and Thomas Woody, *A History of Women's Education in the United States* (New York: Science Press, 1929).

5. John Mack Faragher and Florence Howe, eds., *Women and Higher Education in American History: Essays from the Mount Holyoke College Sesquicentennial Symposium* (New York: W. W. Norton and Co., 1988), 109.

6. Colin B. Burke, *American College Populations: A Test of the Traditional View* (New York: New York University Press, 1982), 54–55, 215.

7. Solomon, *Educated Women*, xviii.

8. See Sara M. Evans, *Born for Liberty: A History of Women in America* (New York: Free Press, 1989), chap. 3, for a discussion of the role of Revolutionary dogma in promoting women's education. See also Linda Kerber, *Women of the Republic: Intellect and Ideology in Revolutionary America* (Chapel Hill: University of North Carolina Press, 1980), chap. 1; Ruth H. Block, "The Gendered Meanings of Virtue in Revolutionary America," *Signs* 13 (autumn 1987); and Mary Beth Norton, *Liberty's Daughters: The Revolutionary Experience of American Women, 1750–1800* (Boston: Little, Brown and Co., 1980).

9. Newcomer, *Century of Higher Education*, 15.

10. Solomon, *Educated Women*, 45. For evidence of the effect of the Civil War on women's later lives, see Anne Firor Scott, *Natural Allies: Women's Associations in American History* (Urbana: University of Illinois Press, 1991), chap. 3.

11. Ruth Bordin, *Woman and Temperance: The Quest for Power and Liberty, 1873–1903* (Philadelphia: Temple University Press, 1981), chap. 1.

12. Solomon, *Educated Women*, 44–45.

13. U.S. Office of Education, *Report of the Commission of Education for the Year 1874* (Washington, DC: U.S. Government Printing Office, 1975), 559–63. The data reported by a small number of normal schools did not include the gender of their students, but the figure given is generally representative of the large number of women attending normal schools. Barbara Solomon reports that women made up nearly 21

percent of the student body in all U.S. institutions of higher learning (*Educated Women*, 63).

14. Solomon, *Educated Women*, 44–45.

15. Newcomer, *Century of Higher Education*, 29–30; and Nevins, *State Universities*, vi, 65–66, 73.

16. Solomon, *Educated Women*, 52–53.

17. Hope College became a coeducational institution in 1878.

18. Dorothy Gies McGuigan, *A Dangerous Experiment: 100 Years of Women at the University of Michigan* (Ann Arbor: Center for the Continuing Education of Women, 1970), 15–16.

19. *Michigan Journal of Education*, 2:139.

20. *Regents' Proceedings*, 24 June 1858; and McGuigan, *Dangerous Experiment*, chap. 3.

21. Peckham, *Making of the University*, 16–22.

22. Belle McArthur Perry, *Lucinda Hinsdale Stone* (Detroit: Blinn Publishing Co., 1902), chap. 5.

23. Alexander Winchell Papers, BHL.

24. *Regents' Proceedings*, September 1867.

25. Frieze used the admission of women to plead with the regents for better facilities for the University's Department of Literature, Science and the Arts. His arguments were accepted, and the state legislature appropriated $75,000 for the University; University Hall was built with these funds. See Henry S. Frieze Papers, BHL.

26. *Regents' Proceedings*, September 1867. See also Ruth Bordin, *Frances Willard: A Biography* (Chapel Hill: University of North Carolina Press, 1986), 55–60.

Chapter 2

President James B. Angell used the phrase "a most hopeful experiment" to describe the admission of women in his 1871 report to the Board of Regents.

1. One of the best general accounts of the academic revolution is to be found in Laurence R. Veysey, *The Emergence of the American University* (Chicago: University of Chicago Press, 1965).

2. Noah Porter, "Inaugural Address," in *Addresses at the Inauguration of Professor Noah Porter as President of Yale College* (New York: n.p., 1871), 27, quoted in Veysey, *Emergence*, 1.

3. Newcomer, *Century of Higher Education*, 71–73.

4. James Henry, *Charles W. Eliot, President of Harvard University, 1869–1909* (New York: Houghton Mifflin, 1930), 259–60.

5. Louise Stevenson, *Scholarly Means to Evangelical Ends* (Baltimore: Johns Hopkins University Press, 1986), 140.

6. Veysey, *Emergence*, 50.

7. See Ruth Bordin, *Alice Freeman Palmer: The Evolution of a New Woman* (Ann Arbor: University of Michigan Press, 1993).

8. Veysey, *Emergence*, 48.

9. Stevenson, *Scholarly Means*, 50–58.

10. Louise Fargo Brown, *Apostle of Democracy: The Life of Lucy Maynard Salmon* (New York: Harper Bros., 1943), 78.

11. Ibid.

12. Earl D. Babst and Lewis G. Vander Velde, eds., *Michigan and the Cleveland Era* (Ann Arbor: University of Michigan Press, 1948), 91. See also *A Short History and Some of the Graduates of the Department of Law of the University of Michigan* (Ann Arbor: Ann Arbor Press, 1908), 8–18.

13. *Chronicle* (Ann Arbor), 25 January 1873, 91.

14. James B. Angell, *The Reminiscences of James Burrill Angell* (New York: Longmans, Green and Co., 1912), 227.

15. *Chronicle*, 5 October 1872, 10.

16. Peckham, *Making of the University*, chap. 5.

17. *Regents' Proceedings 1870–76*, 200–201.

18. *Chronicle*, 9 October 1869, 29 January 1870.

19. *Chronicle*, 3 March 1871, 200.

20. Alumnae Questionnaire, M. A. Boughton, in UM Alumnae Association Records, BHL.

21. Letter from M. C. Thomas to Anna Shipley, 21 November 1875, quoted in Marjorie Housepian Dobkin, ed., *The Making of a Feminist: Early Letters and Journals of M. Carey Thomas* (Kent, OH: Kent State University Press, 1979).

22. UM. Class of 1872 Papers, BHL.

23. Minutes, 25 June 1872, Class of 1872 Papers, BHL.

24. Letter from Stockwell to Lucinda Stone, quoted in Perry, *Lucinda Hinsdale Stone*, 116.

25. Patricia Ann Palmieri, "From Republican Motherhood to Race Suicide: Arguments on the Higher Education of Women in the United States, 1820–1920," in *Educating Men and Women Together: Coeducation in a Changing World*, ed. Carol Lasser (Urbana: University of Illinois Press, 1987), 53–54.

26. Solomon, *Educated Women*, 56.

27. *Regents' Proceedings 1870–76*, 200.

28. Barbara J. Harris, *Beyond Her Sphere: Women and the Professions in American History* (Westport, CT: Greenwood Press, 1978), 57–59. See also Rosalind Rosenberg, *Beyond Separate Spheres: The Intellectual Roots of Modern Feminism* (New Haven: Yale University Press, 1982), 5–12.

29. McGuigan, *Dangerous Experiment*, chap. 8.

30. *Regents' Proceedings 1870–76*, 200.

31. *Chronicle*, 2 February 1878, 117–18.

32. Brown, *Apostle of Democracy*, 53–54.

33. Ibid., 59.

34. *Regents' Proceedings 1870–76*, 392. Angell first publicly refuted Clarke in *Woman's Journal*, 23 August 1873, 267.

35. Julia Ward Howe, *Sex and Education: A Reply to Dr. Clarke's "Sex in Education"* (Boston: Roberts, 1974). See also Eliza B. Duffey, *No Sex in Education* (Philadelphia: J. M. Stoddart and Co., 1874).

36. Howe, *Sex and Education*, 199–201.

37. Ibid.

38. I have researched this issue in Alice Freeman Palmer's papers and have discussed it in my biography of her; see Bordin, *Alice Freeman Palmer*.

39. Lynn Gordon's pathbreaking study relies heavily upon Olive San Louie Anderson's work; see Gordon, *Gender and Higher Education in the Progressive Era* (New Haven: Yale University Press, 1990).

40. *Chronicle*, 16 March 1878.

41. Ibid.

42. *Inlander* (Ann Arbor), 16 April 1861.

43. Letter from Lucy Salmon to James Angell, 29 April 1896, in James Burrill Angell Papers, BHL.

44. Dobkin, *Making of a Feminist*, 107.

45. Perry, *Lucinda Hinsdale Stone*, 116.

46. University of Michigan, *Annual Calendar*, 1872–76.

47. Peckham, *Making of the University*, 77.

48. James C. Albisetti, *Schooling German Girls and Women: Secondary and Higher Education in the Nineteenth Century* (Princeton: Princeton University Press, 1988), 125.

49. *Regents' Proceedings 1870–76*, 51–52.

50. Ibid, 52.

51. Wilfred B. Shaw, ed. *The University of Michigan: An Encyclopedic Survey* (Ann Arbor: University of Michigan Press, 1942), 2:794–95, 811. For an account of women's experience in the Michigan Medical School, see Thomas Neville Bonner, *To the Ends of the Earth: Women's Search for Education in Medicine* (Cambridge: Harvard University Press, 1992), 140–42.

52. Bordin, *Alice Freeman Palmer*, 46.

53. Brown, *Apostle of Democracy*, 49.

54. Ibid., 63.

55. Bordin, *Alice Freeman Palmer*, 46.

56. The *Palladium* and the *Castalian*, student publications of the 1870s, contain lists of officers for all recognized student organizations at the University of Michigan.

57. Brown, *Apostle of Democracy*, 50.

58. Lynn Gordon mistakenly writes of Lucy Salmon at Michigan in the 1870s, "There she found the social life consisting of class rushes and competitions restricted to men." This is a manifestly inaccurate assessment if one examines the records of student life for the period. Salmon herself was an active participant in student life as well as a serious scholar. See Gordon, *Gender and Higher Education*, 130.

59. Ibid.

60. Ibid., 51–61.

61. *Chronicle* 30 June 1876, 216–17.

62. Bordin, *Alice Freeman Palmer*, 54–56; Brown, *Apostle of Democracy*, 73.

63. Brown, *Apostle of Democracy*, 73.

64. Bordin, *Alice Freeman Palmer*, chap.3.

65. *Chronicle* 31 May 1879, 243.

66. *Palladium*, 1877.

Chapter 3

1. Alumnae Questionnaire, M. A. Boughton, in UM Alumnae Association Records, BHL.

2. Alumnae Questionnaire, Ora Ross, in UM Alumnae Association Records, BHL.

3. Alumnae Questionnaire, Lady Willie Forbus, in UM Alumnae Association Records, BHL.

4. Alumnae Questionnaire, Elsie White, in UM Alumnae Association Records, BHL.

5. Letter from R. D. Parker to Mortimer Cooley, 20 January 1923, in Marion Burton Papers, BHL.

6. Gordon, *Gender and Higher Education*, 42–44.

7. Burke, *American College Populations*, 13.

8. Gordon, *Gender and Higher Education*, 112; and Minutes, Phi Beta Kappa, 24 March 1910, in Phi Beta Kappa Papers, BHL.

9. Edwin Slosson, *Great American Universities* (Norfolk, VA: Macmillan, 1910).

10. Gordon, *Gender in Higher Education*, chap.1. Gender segregation also arose in U.S. high schools: whereas between 1870 and 1900 women studied the same subjects as men, after 1900 secondary schools became more vocationally oriented and the curricula increasingly gender segregated; see John L. Rory, *Education and Women's Work: Female Schooling and the Division of Labor in Urban America* (Albany: State University of New York Press, 1991), 6–7.

11. *Regents' Proceedings*, 18 October 1893.

12. Alumnae Questionnaire, Florence Baker White, in UM Alumnae Association Records, BHL.

13. *Regents' Proceedings*, 17 October 1900.

14. Ibid., 9 September 1903.

15. *Michiganensian*, 1920, 490ff., 556ff.

16. Helen Lefkowitz Horowitz, *Campus Life: Undergraduate Cultures from the End of the Eighteenth Century to the Present* (New York: Alfred A. Knopf, 1987), 37–38. See also Veysey, *Emergence*, 292–93. Membership numbers were obtained by counting the rosters in the *Palladium*.

17. Charlotte Williams Connable, *Women at Cornell: The Myth of Equal Education* (Ithaca: Cornell University Press, 1967), 116–17; and David B. Potts, *Wesleyan University, 1831–1910* (New Haven: Yale University Press, 1992), 200, 210–12.

18. Veysey, *Emergence*, 268, 433; and Gordon, *Gender in Higher Education*, 38.

19. Alumnae Questionnaire, Susan Anderson, in UM Alumnae Association Records, BHL.

20. Gloria Moldrow, *Women Doctors in Gilded Age Washington: Race, Gender, and Professionalization* (Urbana: University of Illinois Press, 1987), 162–68.

21. *Regents' Proceedings*, 21 October 1891.

22. Gordon, *Gender in Higher Education*, 34.

23. Ibid.

24. Students had seen college as preparing them for community responsibilities even earlier: Mary Barnes Hudson (Lit. 1895) remembered that at her baccalaureate

service President Angell had said, "Because of the advantages given to you as students, you owe something to your community" (Alumnae Questionnaire, Mary Hudson, in UM Alumnae Association Records, BHL).

25. Connable, *Women at Cornell*, 112–15.

26. Gordon, *Gender and Higher Education*, 68.

27. Peckham, *Making of the University*, 160.

28. Ibid.

29. *Regents' Proceedings 1870–76*, 345.

30. Freeman received a Ph.D. degree when she became president of Wellesley College in 1881; see Bordin, *Alice Freeman Palmer*, 130–31.

31. Brown, *Apostle of Democracy*, 92–94. Salmon completed her Ph.D. degree at Bryn Mawr.

32. Degree Lists—Field of Study—1890–91 to June 1953, Box 144, Rackham School of Graduate Studies Records, BHL. Cornell University awarded its first Ph.D. degree to a woman in 1880, and, like Michigan, it trained women whom it would not employ on its own faculty; see Connable, *Women at Cornell*, 85–87.

33. *Regents' Proceedings*, 22 December 1897.

34. Ibid., 16 June 1903.

35. Barbara Sicherman, *Alice Hamilton: A Life in Letters* (Cambridge: Harvard University Press, 1984).

36. Peckham, *Making of the University*, 32.

37. Alumnae Questionnaire, Olive Sawyer Ashwork, in UM Alumnae Association Papers, BHL.

38. *Palladium*, 1885, 45, 71, 73, 75, 78.

39. *Michiganensian*, 1910, 50.

40. Ibid., 157.

41. Ibid., 96, 183, 128.

42. *Castalian*, 1891, 187.

43. *Chronicle*, 3 February 1883, 130–31.

44. *Regents' Proceedings*, 16 October 1895, 517.

45. *Chronicle*, 13 February 1886, 150, and 13 March 1886, 185.

46. *Inlander*, April 1896, 260.

47. *Regents' Proceedings*, 16 October 1895, 505, 517, and September 1896, 648; and *Inlander*, April 1896, 260–63.

48. Barbour gave $25,000 and Hebard $10,000. When the state legislature by a narrow vote refused to make an appropriation, nearly half the sum had to be raised from other sources, largely from Michigan women. See *Regents' Proceedings*, 16 October 1895, 517; and *Inlander*, April 1896, 260–63.

49. Katrina Mary Caughey Scrapbook, BHL.

50. McGuigan, *Dangerous Experiment*, 6.

51. Alumnae Questionnaire, Fannie Dunn Quain, in UM Alumnae Association Records, BHL.

52. Caughey Scrapbook, BHL; and *Michiganensian*, 1900–20.

53. Letter from Alice Freeman to Lucy Salmon, 29 December 1874, in Alice Freeman Papers, Wellesley College Archives.

54. Shaw, *University of Michigan*, 2:418.

55. When I came as a faculty wife to Michigan in 1948, faculty wives were still expected to assist at the president's wife's teas for students, but these events were coeducational. When I was a student at the University of Minnesota, in the 1930s, faculty wives befriended women students as members of advisory boards of the YWCA, the Women's Self-Government Association, sororities, and women's honorary societies. They also presided at purely social events for women.

56. Alumnae Questionnaire, Juliette Sessions, in UM Alumnae Association Records, BHL.

57. Alumnae Questionnaire, Isabel Ballou, in UM Alumnae Association records, BHL.

58. Alumnae Questionnaire, Edith Petee, in UM Alumnae Association Records, BHL.

59. Angela Simeone, *Academic Women Working toward Equality* (New York: Bergin and Garvey, 1987), 5.

60. Connable, *Women at Cornell*, 126–28. Michigan had a woman professor of anatomy in 1936

61. Brown, *Apostle of Democracy*, 131.

62. Gordon, *Gender in Higher Education*, 58–62. The tendency to try to find new fields not already saturated was universal in academia. Professors would often try to develop subspecialties into new fields, but the window of opportunity for such innovation existed only briefly at the turn of the century. After 1900 existing departments grew powerful enough to keep subspecialties attached, and, as we have seen, the new women's fields never played much part at Michigan, further limiting opportunities for women; see Veysey, *Emergence*, 321–22.

63. Stowell appeared on the faculty roster in 1877 as Louisa Reed. She had married an instructor in her physiology laboratory that year; he eventually became a professor of histology. She continued to teach as long as they were at Michigan, but she never advanced in rank.

64. *Palladium*, 1885, 39.

65. *Castalian*, 1890, 114; and *Palladium*, 1890, 44ff.

66. Alumnae Questionnaire, Lillian Wycoff Johnson, in UM Alumnae Association Records, BHL.

67. Alumnae Questionnaire, Fanny Cook, in UM Alumnae Association records, BHL.

68. *Regents' Proceedings*, 23 June 1896.

69. Shaw, *University of Michigan*, 1:420.

70. *Regents' Proceedings*, 18 May 1892.

71. Letter from James H. Ganfield to James B. Angell, 11 January 1892, in Angell Papers, BHL.

72. Letter from Mrs. T. W. Palmer to James Angell, 11 November 1894, in Angell Papers, BHL.

73. *Castalian*, 1895–96, 43–48.

74. Letter from George Herbert Palmer to James Angell, 31 March 1895, in Angell Papers, BHL. There is no mention of this offer in Alice Freeman Palmer's papers at either Michigan or Wellesley. The Palmers visited Ann Arbor together in January 1895 and were house guests of the Angells. Surely the matter was discussed at that time.

Alice Palmer's reaction has not survived. She was dean at the University of Chicago at the time, spending several months of the year in Chicago and commuting to Cambridge, where her husband was on the faculty of Harvard.

75. Letter from Katharine Coman to James Angell, 8 June 1895, in Angell Papers, BHL.

76. President Angell handled his own correspondence in longhand without a secretary, so most of his letters are not found in the collection of his papers at the Bentley Historical Library, University of Michigan.

77. Letter from Katharine Coman to James Angell, 10 July 1895, in Angell Papers, BHL.

78. Victor C. Vaughn, *A Doctor's Memories* (Indianapolis: Bobbs-Merrill Co., 1926).

79. Letter from James Angell to Eliza Mosher, 30 October 1895, in Angell Papers, BHL.

80. Letter from Katharine Coman to James Angell, 6 January 1896, in Angell Papers, BHL.

81. Letter from Eliza Mosher to James Angell, 11 January 1896, in Angell Papers, BHL.

82. *Regents' Proceedings*, 1897, 139; see also McGuigan, *A Dangerous Experiment*, chap. 9; and Florence Woolsey Hazard, "Heart of Oak: The Story of Eliza Mosher," MS, BHL.

83. *Regents' Proceedings*, 1899, 360–61; and letter from Catharine A. Kellogg to Levi Barbour, 31 July 1899, in Angell Papers, BHL.

84. Perry, *Lucinda Hinsdale Stone*, 25–26; and *Michiganensian*, 1900.

85. *Regents' Proceedings*, 1903, 234–37.

86. *Michiganensian*, 1915, 42–43.

87. For example, at the University of Chicago science courses were routinely cross-listed in the Department of Household Administration. Women in home economics were thus exposed to the same science courses as graduates in the traditional academic programs; see Geraldine Clifford, *Lone Voyagers: Academic Women in Coeducational Universities, 1870–1937* (New York: Feminist Press at the City University of New York, 1989).

88. In loco parentis already existed in women's colleges; see Horowitz, *Campus Life*, 111.

89. Connable, *Women at Cornell*, 100–110.

90. Gordon, *Gender in Higher Education*, 98–99.

91. *Castalian*, 1896, 149–51.

92. Ibid., 151.

93. Alumnae Questionnaire, Emma Ackerman, in UM Alumnae Association Records, BHL.

94. Letter from Edith Sarnton to James Angell, 6 August 1900, in Angell Papers, BHL.

95. Letter from Eliza Mosher to James Angell, 14 January 1902, in Angell Papers, BHL.

96. Letter from E. A. Birge to James Angell, 3 June 1902, in Angell Papers, BHL.

97. Letter from Mosher to Angell, 14 January 1902.

98. Peckham, *Making of the University*, 121; and Shaw, *University of Michigan*, 4:1793–94.

99. *Regents' Proceedings*, 13 May 1898, 9 June 1898, 30 September 1898, 16 November 1898, 11 October 1899, and 17 October 1900.

100. It has been suggested that Michigan's medical school pursued coeducation more seriously than comparable institutions during this time; see Regina Markell Morantz-Sanchez, *Sympathy and Science: Women Physicians in American Medicine* (New York: Oxford University Press, 1985), 60, 67, 232.

101. Shaw, *University of Michigan*, 2:866–67, 4:1850–59.

102. McGuigan, *Dangerous Experiment*, unpaginated errata.

103. Charles C. Kelsey, "Ida Gray, Class of 1890," *Alumni Bulletin, School of Dentistry*, 1976–77.

104. Alumnae Questionnaire, Emily Harper Williams, in UM Alumnae Association Records, BHL.

105. Ibid.

106. Ruth Bordin, "Levi Lewis Barbour: Benefactor of Michigan Women," *Michigan Quarterly Review* (winter 1963): 36–39.

107. The Department of Literature, Science and the Arts became a College on January 1, 1916.

Chapter 4

1. Alumnae Questionnaire, Isabel Ballou, in UM Alumnae Association Records, BHL.

2. Shaw, *University of Michigan*, 1:197.

3. Rebecca Shelley Papers, BHL.

4. Shaw, *University of Michigan*, 1:197.

5. *Regents' Proceedings*, 12 October 1918; and Peckham, *Making of the University*, 132.

6. Peckham, *Making of the University*, 132. The drop in enrollment was typical of most universities. It has been observed that "German courses, in essence, dropped from American campuses" during the war years; see Willis Rudy, *Total War and Twentieth-Century Higher Learning: Universities of the Western World in the First and Second World Wars* (Rutherford, NJ: Farleigh Dickinson University Press, 1991), 30.

7. *Regents' Proceedings*, February 1918.

8. Alumnae Questionnaire, Grace Bacon, in UM Alumnae Association Records, BHL.

9. Alumnae Questionnaire, Muriel Babcock, in UM Alumnae Association Records, BHL.

10. Arthur Lyons Cross, "The University of Michigan and the Training of Our Students," *Michigan History Magazine* 4 (1920): 127.

11. Shaw, *University of Michigan*, 1:199–202.

12. Peckham, *Making of the University*, 118.

13. *Regents' Proceedings*, April 1918.

14. "The Michigan Ambulance Section in France," *Michigan Alumnus* 25 (June 1919).

15. "Michigan Men in Service," *Michigan Alumnus* 25 (June 1919).
16. Alumnae Questionnaire, Muriel Babcock.
17. Alumnae Questionnaire, Marion Christiancy Harr, in UM Alumnae Association Records, BHL.
18. Ibid.
19. *Regents' Proceedings*, 21 February 1918.
20. Peckham, *Making of the University*, 134–35; and Michigan Historical Collections, *Pictorial History of Ann Arbor, 1824–74* (Ann Arbor: Michigan Historical Collections / Bentley Historical Library, Ann Arbor Sesquicentennial Committee, 1974), 60.
21. *Regents' Proceedings*, April 1918.
22. Unidentified clipping, dated 20 June 1919, in Council of National Defense Women's Committee Records, BHL.
23. Alumnae Questionnaire, May Carson, in UM Alumnae Association Records, BHL.
24. Ibid.; see also Alumnae Questionnaires, Catherine B. Heller, Caroline Walker, Fannie Dunn Quain, Lady Willie Forbus, and Ruth Emery, in UM Alumnae Association Records, BHL.
25. Alumnae Questionnaire, Nora Deardoff, in UM Alumnae Association Records, BHL.
26. Shaw, *University of Michigan*, 1:418.
27. Ibid., 88–90.
28. Peckham, *Making of the University*, 158.
29. Elizabeth Crosby Papers, BHL.
30. Eliza Mosher had of course been the first female full professor at the University of Michigan. Margaret Bell became professor of physical education for women in 1929, and in 1933 her title was changed to professor of hygiene and physical education.
31. Letter from Elizabeth Crosby to A. C. Furstenberg, 21 February 1935, in Crosby Papers, BHL.
32. Taped interview with Elizabeth Crosby, 1980, in Crosby Papers, BHL.
33. It was not until 1994 that a second woman faculty member would be selected to deliver the prestigious Russell Lecture; see chapter 7.
34. Minutes, 16 May 1956, in Research Club Records, BHL.
35. University of Michigan, *President's Report*, 1927–28, 39, BHL.
36. Ibid., 1936–37, 307–8.
37. Ibid., 923–24, 53.
38. *Regents' Proceedings*, May 1938.
39. Ibid., December 1920.
40. Shaw, *University of Michigan*, 3:1154–55, 4:2000.
41. *President's Report*, 1936–37, 350.
42. *Regents' Proceedings*, September 1924.
43. Ibid., September 1925.
44. Ibid., October 1925.
45. Ibid., April 1957, 1501.
46. Ibid., November 1926. The records do not indicate whether such a request was made of Palmer, who was still alive.

47. Alumnae Questionnaire, Florence Abbott, in UM Alumnae Association Records, BHL.

48. Alumnae Questionnaire, Helen Aaron, in UM Alumnae Association Records, BHL.

49. *Regents' Proceedings*, October 1929; and *Michiganensian*, 1935, 17.

50. Alumnae Questionnaire, Florence White, in UM Alumnae Association Records, BHL.

51. Henry V. Davis, "From Colored to African American: A History of the Struggle for Educational Equity at the University of Michigan and as Agenda for the Pluralistic Multicultural University of the Twenty-first Century," *Sankofa: The University since BAM* (Ann Arbor: Office of Minority Affairs, University of Michigan, 1991), 33.

52. *President's Report*, 1928–29, 132.

53. Ibid.

54. *President's Report*, 1931–32, 40.

55. Ibid., 1940–41, 45.

56. Davis, "From Colored to African American," 33

57. Ibid.

58. *President's Report*, 1931–32, 401.

59. *Michiganensian*, 1923, 504, 508.

60. *President's Report*, 1945–46, 17.

61. Ibid., 1922–23, 81.

62. Ibid., 1924–25, 165.

63. Ibid., 1921–22, 278–79.

64. Ibid., 1926–27, 34.

65. Ibid., 1929–30, 245–46; 1930–31, 67; 1932–33, 25.

66. Ibid., 1934–35, 64.

67. *Regents' Proceedings*, February 1921.

68. *President's Report*, 1926–27, 1, 67–68.

69. *Michigan Daily* (Ann Arbor), 13 October 1930, 5.

70. *President's Report*, 1931–32, 43.

71. Nicholas A. Shufro, "The Great Depression's Effects on Enrollment Patterns" (Senior Honor thesis, University of Michigan, 1984), 2, 53.

72. Ruth Bordin, *Washtenaw County: An Illustrated History* (Northridge, CA: Windsor Publications, in cooperation with the Washtenaw County Historical Society, 1988), 77, 69.

73. This paragraph is based on the *Michigan Daily* and the *Michiganensian* for those years.

74. Peckham, *Making of the University*, 76.

75. Ibid., 186–87.

76. *President's Report*, 1936–37, 32–33, 55.

77. Ibid., 1937–38, 46; and 1938–39, 58–59.

78. Peckham, *Making of the University*, 189.

79. Ibid., 189–90.

80. Ibid., 196–97.

81. See Peter E. Van de Water, *Alexander G. Ruthven of Michigan: Biography of a University President* (Grand Rapids, MI: Eerdmans Publishing Co., 1977); John R.

Bellefleur, *Citizen-Educator: Alexander Ruthven of Michigan's Higher Education: An Essay* (Bloomfield Hills, MI: J. R. Bellefleur, 1993); and A. G. Ruthven, *Naturalist in Two Worlds: Random Recollections of a University President* (Ann Arbor: University of Michigan Press, 1963).

82. Peckham, *Making of the University*, 209; and F. Clever Bald, "The University at War," MS, BHL.

83. For a general account of women's roles in World War II, see Sara M. Evans, *Born for Liberty: A History of Women in America* (New York: Free Press, 1989), 221–22.

84. Evans, *Born for Liberty*, 222.

85. F. Clever Bald, "The University in the War," *Program of the Victory Reunion and One Hundred Second Commencement of the University of Michigan* (Ann Arbor: Ann Arbor Press, 1946), 24.

86. *Michiganensian*, 1942, 61–62.

87. The material in this paragraph was gleaned from the *Michiganensian* for these years.

88. Bald, "The University in the War," 24; and *Michiganensian*, 1943, 24.

89. *President's Report*, 1941–42, 43; 1942–43, 48.

90. *Michiganensian*, 1944, 212.

91. Ibid., 1943, 102.

92. Ibid., 1944, 120.

93. Bald, "The University in the War," 24.

94. Official Publications of the University of Michigan, *The War Training Program*, 20 December 1941, BHL.

95. Bald, "The University in the War," 2, 6, 157–59.

96. *Michiganensian*, 1944, 47.

97. Bald, "The University in the War," 23–25; and Peckham, *Making of the University*, 205.

98. *Michiganensian*, 1941, 169. The earlier history of the School of Nursing is reviewed in Shaw, *University of Michigan*, 2:997–98.

99. Peckham, *Making of the University*, 206–7. In the 1950s the author discussed Hanako Yamagiwa's role in the Japanese Language Training Program with both Yamagiwas.

100. *Regents' Proceedings*, February 1943, 206; March 1944, 540; October 1944, 732.

101. Ibid., July 1949, 439.

102. *Regents' Proceedings*, November 1918; and *President's Report*, 1946–47, 446.

103. Bald, "The University in the War," 82.

104. *President's Report*, 1942–43, 346; 1943–44, 334–35.

105. Ibid., 1945–46, 83.

106. Ibid., 1946–47, 12.

107. Ibid., 1945–46, 12.

108. *Regents' Proceedings*, December 1946.

109. *President's Report*, 1949–50, 437.

110. Ibid., 1942–43, 36; 1943–44, 47, 50.

111. *Regents' Proceedings*, August 1944.

112. Bald, "The University in the War," 25.

113. *Official Program*, The Victory Reunion, 20–22 June 1946, BHL.

Chapter 5

1. Peckham, *Making of the University*, 216.

2. *Michiganensian*, 1946, 53–58.

3. Ibid., 63.

4. Ibid., 201, 205.

5. *Michiganensian*, 1948, 298–99.

6. Ibid., 54–56.

7. *President's Report*, 1951–52, 228–29, 234.

8. Ibid., 191, 228–29, 234–36.

9. Ibid., 130–31.

10. *President's Report*, 1953–54, 66.

11. Shaw, *University of Michigan*, 4:1868–69.

12. *Michiganensian*, 1950, 155. The women's glee club formed again in 1976. Rosalee Edwards, director of the club from 1978 to 1991, recalled that, although there were rarely music majors in the group, its shows were always successful (author's interview with Rosalee Edwards, June 1994).

13. *Michiganensian*, 1950, 192–93; and *President's Report*, 1953–54, 66–67.

14. *Michiganensian*, 1954, 244. The director of admissions was reported to have said as late as April 1970 that he routinely admitted 55 percent men and 45 percent women to Michigan's entering classes, regardless of the students' grade point averages or other factors (letter from Jean King to Ruth Bordin, 19 May, 1994).

15. *Michiganensian*, 1950, 320, 367, 372.

16. Interview with Marge Piercy, 6 December 1978, in Contemporary History Project Records, BHL.

17. *President's Report*, 1953–54, 66.

18. *Michigan Daily*, 21 March 1952; and *President's Report*, 1951–52, 37.

19. For a vivid description of the campus atmosphere in the 1950s, see interview with Elise Boulding, December 1978, in Contemporary History Project Records, BHL.

20. Janet Malcolm, "The Silent Woman," *New Yorker*, 23 and 30 August 1993.

21. *Regents' Proceedings*, September 1949, 451, 474–77.

22. Minutes, Executive Committee, 9 February 1951, in College of Literature, Science and the Arts, Records, BHL.

23. Minutes, Executive Committee, 2 August 1950, 5 September 1950, 5 October 1950, 5 December 1950, 7 June 1951, in College of Literature, Science and the Arts, Records, BHL.

24. *President's Report*, 1953–54, 23.

25. Minutes, Executive Committee, 1 February 1952, in College of Literature, Science and the Arts, Records, BHL.

26. Minutes, Executive Committee, 24 January 1956, in College of Literature, Science and the Arts, Records, BHL.

27. *Regents' Proceedings*, September 1957.

28. Ibid., October 1957.

29. Ibid.

30. Minutes, Executive Committee, 16 November 1955, in College of Literature, Science and the Arts, Records, BHL.

31. *Michiganensian*, 1965, 32.

32. Ibid., 1961, 12.

33. Ibid., 1963, 296, 305, 411.

34. Ibid., 1969, 162–63.

35. Ibid., 1960, 340–41; and *Michigan Daily*, 1 November 1959, 5; 4 November 1959, 4; 5 November 1959, 1; 7 November 1959, 1.

36. The history of the Office of the Dean of Women is reviewed in Shaw, *University of Michigan*, 1:283–85.

37. *Regents' Proceedings*, May 1962.

38. Ibid.

39. Ibid., March 1962; and *President's Report*, 1962–63, 190–91.

40. *President's Report*, 1968–69, 3.

41. Ibid., 1962–63, 190–91.

42. Ibid., 1964–65, 13. There are no figures on how many of these students were women.

43. Ibid., 1964–65, 211.

44. *Michiganensian*, 1969, 100.

45. *Regents' Proceedings*, April 1966.

46. News and Information Services Press Release, 19 March, 197, Box 8, UM Housing Office Records, BHL.

47. Tom Hayden, *Reunion: A Memoir* (New York: Random House, 1988), 73.

48. Interview with Barbara Haber, 1980, in Contemporary History Project Records, BHL.

49. Interview with Nais Raulet, 1978, Contemporary History Project Records, BHL.

50. Interview with Barbara Haber, 1980.

51. Interview with Martha Prescod Norman, 1980, and interview with Beth Oglesby, 1978, in Contemporary History Project Records, BHL.

52. Interview with Beth Oglesby, 1978.

53. *Ann Arbor News*, 6 April 1954, 13.

54. Unless otherwise noted, all material on the origins of the Center for the Continuing Education of Women (CEW) is from oral interviews by the author with Louise Cain, Jean Campbell, and Jane Likert in 1985. In the course of an internal university review of CEW conducted in 1982 it was discovered that the center had never been officially established by the Board of Regents; the oversight was remedied at that time. See *Regents' Proceedings*, November 1982.

55. *President's Report*, 1962–63, 17.

56. Ibid., 18.

57. *Regents' Proceedings*, July 1985.

58. Center for the Education of Women, *Cornerstone* (winter 1994): 3.

59. McGuigan, *Dangerous Experiment,* 111ff.

Chapter 6

1. *President's Report,* 1977–78, 2.

2. Ibid., 1962–63, 4–5.

3. *Regents' Proceedings,* November 1970.

4. Unless otherwise noted, all material on FOCUS is from a letter from Jean King to Carol Hollenshead and Virginia Nordby, 12 March 1994. The letter, with enclosures, was made available to me by Jean King and Carol Hollenshead.

5. Commission on Women file, in UM President, Records, box 104; see also *President's Report,* 1971–72, 10.

6. Memorandum from Virginia Nordin to Robben Fleming, 15 November 1971, in UM President, Records, box 32, BHL; see also *Michigan Daily,* 20 April 1972, 1.

7. Mary Frank Fox, "Sex-Related Income Differentials among Academic Employees at the University of Michigan," in UM President, Records, box 39, BHL.

8. Office of Affirmative Action file, in UM President, Records, box 39, BHL.

9. *President's Report,* 1971–72, 8–9.

10. Memorandum from Robben Fleming to Virginia Nordin, 9 February 1972 in UM President, Records, box 32, BHL.

11. *Regents' Proceedings,* January 1978.

12. *President's Report,* 1971–72, 16–17.

13. *Regents' Proceedings,* May 1972.

14. Ibid.

15. *President's Report,* 1971–72, 1972–73.

16. Memorandum from Virginia Nordin to A. F. Smith, 5 November 1971, in UM President, Record, box 32.

17. *President's Report,* 1973–74, 10, 37.

18. Ibid., 1975–76, 1.

19. *Regents' Proceedings,* July 1983.

20. Ibid., July 1974.

21. Ibid., December 1988.

22. *President's Report,* 1979–80.

23. Topical file on women, in UM President, Records, box 32, BHL.

24. *President's Report,* 1970–71.

25. *Regents' Proceedings,* September 1970.

26. *President's Report,* 1970–71.

27. Ibid., 1974–75.

28. *Michigan Daily,* 29 and 30 January 1975.

29. *President's Report,* 1975–76. Minutes, Affirmative Action Committee, 1975, Wilbur Cohen Papers, box 14, BHL.

30. *President's Report,* 1977–78.

31. *Regents' Proceedings,* June 1969.

32. *President's Report*, 1971–72.

33. *Regents' Proceedings*, May 1972, June 1972.

34. *Regents' Proceedings*, July 1975; September 1975; October 1975; November 1975; December 1975.

35. *Regents' Proceedings*, 1977.

36. *President's Report*, 1974–75.

37. Ibid., 1975–76.

38. Ibid., 1973–74.

39. Ibid., 1976–77.

40. Ibid., 1975–76.

41. Ibid., 1970–71; 1972–73.

42. Ibid., 1975–76.

43. *Michigan Daily*, 14 November 1970.

44. *President's Report*, 1975–76.

45. Ibid., 1972–73; 1973–74; 1975–76; and *Regents' Proceedings*, February 1972; April 1972.

46. *President's Report*, 1978–79.

47. Ibid., 1977–78; and *Michiganensian*, 1977–78, 197.

48. *President's Report*, 1973–74.

49. Ibid., 1969–70.

50. Ibid., 1977–78.

51. *Regents' Proceedings*, September 1970; and *President's Report*, 1976–77. The School of Nursing hired its first male professor the previous year; see *Regents' Proceedings*, May 1974.

52. *Michiganensian*, 1983.

53. *President's Report*, 1971–72.

54. Ibid., 1973–74; 1974–75; 1978–79.

55. Bordin, *Alice Freeman Palmer*, 71.

56. *University Record*, issues for March–April 1994.

57. Interview with Gayle Rubin, 1979, in Contemporary History Project Records, BHL.

58. From "Invisibility to Inclusion: Opening the Doors for Lesbians and Gay Men at the University of Michigan," report, University of Michigan Affirmative Action Office, June 1991, 65.

59. *Regents' Proceedings*, October 1979; and *President's Report*, 1978–79.

60. *President's Report*, 1968–69.

61. Ibid.

62. *Michiganensian*, 1974, 64.

63. Ibid., 1978, 183.

64. *President's Report*, 1975–76.

65. "Report of the Committee to Study Intercollegiate Athletics for Women," 1 November 1973, BHL; Finding Aid, University of Michigan Athletic Department Records, 2, BHL.

66. *Regents' Proceedings*, January 1977.

67. Catherine R. Stimpson and Nina Cobb, *Women's Studies in the United States* (New York: Ford Foundation, 1986), 4.

68. *President's Report*, 1974–75.

69. University of Michigan Women's Studies Program, "A History of Women's Studies," MS, 1992.

70. *University Record*, 31 January 1994, 4.

Chapter 7

1. University of Michigan Center for the Education of Women, *Women at the University of Michigan* (Ann Arbor: Center for the Education of Women, February 1992), 11–12.

2. Ibid., 14, 17, 19.

3. *Michiganensian*, 1991, 166–67.

4. Ibid., 1983, 296.

5. Ibid., 1988, 171.

6. Ibid., 1981, 361.

7 Ibid , 1983, 114–73; and *Michigan Daily*, 9 September 1982, 13, 17.

8. *Michiganensian*, 1981, 214, 293, 306–8.

9. Ibid., 1987, 41, 43; 1988, 38.

10. *Detroit Free Press*, 13 April 1994, E1, E4.

11. *Michiganesian*, 1990, 28.

12. Memorandum to University of Michigan personnel, 9 September 1980 (author's files).

13. *President's Report*, 1982–83; and *Michiganensian*, 1987, 48–55.

14. Memorandum from Harold Shapiro to Deans, Directors and Department Heads, 15 September 1980 (author's files).

15. *University Record*, 14 March 1994, 8.

16. *Michigan Daily*, 17 July 1988, 7–8, reports one such case at East Quad.

17. *University Record*, 12 May 1994, 1.

18. Center for the Education of Women, *Women at the University of Michigan* (Ann Arbor: Center for the Education of Women, December 1993), 2:77–93.

19. Jean Manis, Susan Frazier-Kouassi, Carol Hollenshead, and David Burkham, *A Survey of the Graduate Experience: Sources of Satisfaction and Dissatisfaction among Graduate Students at the University of Michigan* (Ann Arbor: Center for the Education of Women, 1992), 24.

20. Ibid, 6, 11, 19, 48.

21. Ibid., 25, 27.

22. Center for the Education of Women, *Women at the University of Michigan*, February 1992, 3.

23. Ibid., 2:11.

24. *New York Times*, 11 March 1994, B18.

25. See, for example, *Regents' Proceedings*, July 1982, 383–88; May 1982, 333–34; May 1983, 667. Regent Power's work and her importance for women at the University of Michigan were commemorated after her death through the establishment of the Sarah Goddard Power Award, an honor given annually by the Academic Women's

Caucus to women faculty who make outstanding contributions to the betterment of
women's status at Michigan.

26. Ibid., July 1982.

27. Ibid., June 1983.

28. Ibid., April 1985.

29. *Regents' Proceedings*, 14 April 1988, 226.

30. "Women's Agenda for the 1990s," Report of the Ad Hoc Committee on
Women's Issues, December 1988, i–ii.

31. Ibid., 3, 5, 7.

32. Ibid., 9–10, 12–13.

33. Ibid., 1.

34. Center for the Education of Women, *Women at the University of Michigan*,
vol. 3 (Ann Arbor: Center for the Education of Women, May 1996), 2.1.

35. Ibid., 4.1–4.5.

36. *President's Report*, 1981–82; and *Michiganensian*, 1981, 76.

37. UM, Office of the President, "Agenda for Women," 1994.

38. *Women at the University of Michigan*, vol. 3, 2.1.

Selected Bibliography

Anderson, Olive San Louie. *An American Girl and Her Four Years in a Boy's College.* New York: D. Appleton, 1878.

Anter, Joyce, and Sari Knopp Bilken. *Changing Education: Women as Radicals and Conservators.* Albany: State University of New York Press, 1990.

Austin, Corey G. *A Century of Religion at the University of Michigan.* Ann Arbor: University of Michigan Press, 1957.

Babst, Earl D., and Lewis Vander Velde, eds. *Michigan and the Cleveland Era.* Ann Arbor: University of Michigan Press, 1948.

Bald, F. Clever. "The University in the War." *Program of the Victory Reunion and One Hundred Second Commencement of the University of Michigan.* Ann Arbor: Ann Arbor Press, 1946.

Bartlett, Nancy R. *More than a Handsome Box: Education in Architecture at the University of Michigan.* Ann Arbor: University of Michigan College of Architecture and Urban Planning, 1995.

Blair, Karen J. *The Clubwoman as Feminist: True Womanhood Redefined, 1868–1914.* New York: Holmes and Meier, 1980.

Bordin, Ruth. "Levi Lewis Barbour—Benefactor of University of Michigan Woman," *Michigan Quarterly Review* (winter 1963).

———. *Alice Freeman Palmer: The Evolution of a New Woman.* Ann Arbor: University of Michigan Press, 1993.

———. *Frances Willard: A Biography.* Chapel Hill: University of North Carolina Press, 1986.

———. *The University of Michigan: A Pictorial History.* Ann Arbor: University of Michigan Press, 1967.

———. *Washtenaw County: An Illustrated History.* Northridge, CA: Windsor Publications, in cooperation with the Washtenaw County Historical Society, 1988.

———. *Woman and Temperance: The Quest for Power and Liberty, 1873–1900.* Philadelphia: Temple University Press, 1981.

Brown, Louise Fargo. *Apostle of Democracy: The Life of Lucy Maynard Salmon.* New York and London: Harper Bros., 1943.

Burke, Colin B. *American College Populations: A Test of the Traditional View.* New York: New York University Press, 1982.

Clarke, Edward. *Sex in Education; Or, a Fair Chance for the Girls.* Boston: Osgood, 1873.

Conable, Charlotte W. *Women at Cornell: The Myth of Equal Education.* Ithaca: Cornell University Press, 1977.

Dobkin, Marjorie H., ed. *The Making of a Feminist: Early Journals and Letters of M. Carey Thomas*. Kent, OH: Kent State University Press, 1979.

Drachman, Virginia G. "Female Solidarity and Professional Success: The Dilemma of Woman Doctors in Late Nineteenth Century America," *Journal of Social History* (summer 1982).

———. *Women Lawyers and the Origins of Professional Identity in America: The Letters of the Equity Club, 1887 to 1890*. Ann Arbor: University of Michigan Press, 1993.

Evans, Sara M. *Born for Liberty: A History of Women in America*. New York: Free Press, 1989.

Ferrand, Elizabeth M. *History of the University of Michigan*. Ann Arbor: University of Michigan, 1885.

Frankfort, Roberta. *Collegiate Women: Domesticity and Career in Turn-of-the-Century America*. New York: New York University Press, 1977.

Friedan, Betty. *The Feminine Mystique*. New York: W. W. Norton, 1963.

Gordon, Lynn. "Coeducation on Two Campuses: Berkeley and Chicago, 1890–1912." In *Woman's Being, Woman's Place: Female Identity and Vocation in American History*, ed. Mary Kelley. Boston: G. K. Hall, 1979.

———. *Gender and Higher Education in the Progressive Era*. New Haven: Yale University Press, 1990.

Graham, Patricia A. "Expansion and Exclusion: A History of Women in Higher Education," *Signs* (summer 1978).

———. *Community and Class in American Education, 1865–1918*. New York: Wiley, 1974.

Hamilton, Alice. *Exploring the Dangerous Trades: The Autobiography of Alice Hamilton, M.D.* New York: Little, Brown and Co., 1943.

Harris, Barbara J. *Beyond Her Sphere: Women and the Professions in American History*. Westport, CT: Greenwood Press, 1978.

Henderson, John W. *The University of Michigan Department of Ophthalmology: A Proud Heritage*. Ann Arbor: Department of Ophthalmology, University of Michigan Medical School, 1986.

Hinsdale, Burke A. *History of the University of Michigan*. Ann Arbor: University of Michigan, 1906.

Horowitz, Helen Lefkowitz. *Alma Mater: Design and Experience in the Women's Colleges from Their Nineteenth-Century Beginnings to the 1930s*. New York: Knopf, 1984.

———. *Campus Life: Undergraduate Cultures from the End of the Eighteenth Century to the Present*. New York: Knopf, 1987.

———. *The Power and Passion of M. Carey Thomas*. New York: Knopf, 1994.

Howe, Florence, and John Mack Faragher, eds. *Women and Higher Education in American History: Essays from the Mount Holyoke College Sesquicentennial Symposium*. New York: W. W. Norton and Co., 1988.

Howe, Julia Ward, ed. *Sex and Education: A Reply to Dr. Clarke's "Sex in Education."* Boston: Roberts, 1874.

Howell, Joel, ed. *Medical Lives and Scientific Medicine at Michigan, 1891–1969*. Ann Arbor: University of Michigan Press, 1993.

Kerber, Linda. *Women of the Republic: Intellect and Ideology in Revolutionary America*. Chapel Hill: University of North Carolina Press, 1980.

Komarovsky, Mirra. *Women in the Modern World: Their Education and Their Dilemmas*. Boston: Little, Brown and Co., 1953.

Marantz-Sanchez, Regina M. *Sympathy and Science: Women Physicians in American Medicine*. New York: Oxford University Press, 1985.

Marwil, Jonathan. *A History of Ann Arbor*. Ann Arbor: University of Michigan Press, 1987.

McGuigan, Dorothy Gies. *A Dangerous Experiment: 100 Years of Women at the University of Michigan*. Ann Arbor: Center for the Continuing Education of Women, 1970.

Moldrow, Gloria. *Women Doctors in Gilded Age Washington: Race, Gender, and Professionalization*. Urbana: University of Illinois Press, 1987.

Murphy, William Michael, and D. J. R. Bruckner, eds. *The Idea of the University of Chicago*. Chicago: University of Chicago Press, 1976.

Nevins, Allan. *The State Universities and Democracy*. Urbana: University of Illinois Press, 1962.

Newcomer, Mabel. *A Century of Higher Education for American Women*. New York: Harper Bros., 1959.

Office of the President. *Climate and Character* (Ann Arbor: University of Michigan, 1997), 47–83.

Palmer, George Herbert. *The Life of Alice Freeman Palmer*. Boston: Houghton Mifflin and Co., 1908.

Palmieri, Patricia Ann. *In Adamless Eden: The Community of Women Faculty at Wellesley*. New Haven: Yale University Press, 1995.

Peckham, Howard H. *The Making of the University of Michigan 1817–1992*. Ed. Margaret L. and Nicholas H. Steneck. Ann Arbor: University of Michigan Bentley Historical Library, 1994.

Rosenberg, Rosalind. *Beyond Separate Spheres: The Intellectual Roots of Modern Feminism*. New Haven: Yale University Press, 1982.

Rossiter, Margaret W. *Women Scientists in America: Before Affirmative Action, 1940–72*. Baltimore: Johns Hopkins University Press, 1994.

———. *Women Scientists in America: Struggles and Strategies to 1940*. Baltimore: Johns Hopkins University Press, 1982.

Salmon, Lucy Maynard. "Education in Michigan during the Territorial Period." *Michigan Pioneer and Historical Collections*, vol. 7, 1885.

Schneider, Dorothy, and Carl J. *American Women in the Progressive Era, 1900–1920: Change, Challenge and the Struggle for Women's Rights*. New York: Doubleday, 1993.

Scott, Anne Firor. *Natural Allies: Women's Associations in American History*. Urbana: University of Illinois Press, 1991.

Shaw, Wilfred B. *A Short History of the University of Michigan*. Ann Arbor: George Wahr, 1934.

———. *The University of Michigan: An Encyclopedic Survey*. 4 vols. Ann Arbor: University of Michigan Press, 1942.

Sicherman, Barbara. *Notable American Women: The Modern Period. A Biographical Dictionary*. Cambridge: Belknap Press of the Harvard University Press, 1980.

———. *Recent United States Scholarship on the History of Women*. Washington, DC: American Historical Association, 1980.

————. *Alice Hamilton: A Life in Letters*. Cambridge: Harvard University Press, 1984.

Smith-Rosenberg, Carol. "The Female World of Love and Ritual: Relations between Women in Nineteenth Century America." *Signs* (autumn 1975).

Solomon, Barbara Miller. *In the Company of Educated Women*. New Haven: Yale University Press, 1985.

Veysey, Laurence R. *The Emergence of the American University*. Chicago: University of Chicago Press, 1965.

Index

Note: University presidents' names are followed by the dates of their term of office. Graduates are identified by degree and year.

Women's League: activities of, 29; build-
ing for, 46, 57; development of, 27;
and faculty wives, 30; fund-raising by,
28; merger with Michigan Union, 65,
69, 70; officers of, 51; 1953 survey of
undergraduate women, 67
women's liberation movement, 69
women's medical fraternity, 66
Women's Pool, 65
Women's Research Club, 32
women's studies, 34, 91
Women's Studies Program, 74, 88,
90–92, 99–101
"Women's War Council," 57
"Women's Week," 69–70

Wood, Gen. Leonard, 43
World War I, 41–45
World War II, 41, 55–60

Yale University, 8
Yamagiwa, Hanako, 58–59
Yamagiwa, Joseph K., 58–59
Young, Arlisle, 17
Young Men's Christian Association
(YMCA), 26, 46
Young Women's Christian Association
(YWCA), 26, 44, 46

zoology department: women faculty in,
84